GAIA LIGHT
ALESSANDRO COSMELLI

BROOKLYN BUZZ

TEXTS

JAMES WELLFORD
MARION DURAND
GAVIN KEENEY

DAMIANI

For Brooklyn

"...The Bus carries me thru the City, I look out the window, I look at the people on the street, the Sun and the Traffic Lights. It has to do with desperation and endurance - I have always felt that about living in New York. Compassion and probably some understanding for New York's Concrete and its people,
walking... waiting... standing up... holding hands... the summer of 1958...".

Robert Frank, *From the Bus*, New York 1958

BUZZ
JAMES WELLFORD
MARION DURAND

In "Brooklyn Buzz", Gaia and Alessandro take us on a moving visual journey through the crossroads of Brooklyn, a densely populated world of 2 million that juts into the Atlantic Ocean and which nestles at the tip of a very long island between its better known neighbor across the East River, Manhattan and the borough of Queens. Vast and intimate, Brooklyn is an infinitely complex stage where the vibrancy of life is enraptured by the spirits and sounds from the past and where the variables of experience and emotion are endless and constantly evolving. It can be unfathomable, alienating, and cold but more often is deeply receptive, welcoming, and warm. It is a place that embraces you and that you come back to because deep in your human experience and sensibility you have never left. Brooklyn yells at you but most often murmurs very beautifully and gently an agitated, familiar, even comforting hum that echoes image and sound from a shared past, a chronic present, and an oddly familiar and cyclical future. For all the anonymity of the vast metropolis, Brooklyn gives one enormous intimacy and sense of place and constantly reminds you that your presence in its environs reflects the shared experience of all those who have spent time in the borough. G and A capture a most essential quality of this very intricate and special place. If you look and stare directly at it, you may never see it and certainly will never know it. What you feel and what Brooklyn is, when its many layers avail themselves to you, when you become a part of it, is when you sense and perceive through peripheral vision and experience the dynamic wonder of the city. In Buzz, G and A capture this essential flow and presence of the city through the windows of buses. The photographs have a stunning transience and luminosity that wonderfully represent in a metaphorical way our own passage and journey through life. All the images are delicate interludes that tap feeling and emotion in the constantly altering landscapes of the animate and inanimate turmoil and tenderness that is Brooklyn. You hear and smell and feel in these photographs. The pictures all expand well beyond the limits of bus windows and photographic frames to immerse the viewer into the inexhaustible dimensions of an always metabolizing metropolis that warps from historical venue to current moment and beyond into the always hazy but thrilling future.

Jamie Wellford

"Brooklyn Buzz" takes off in the deafening noise of a subway overpass, rays of sun flicker at the beat of the train, a stroboscope for a daylight party that catches dancers half movement. Families hurry on the sidewalk, kids gather, people run down the stairs. Subjects occupy all grounds and blossom in vivid and muted colors in the urban jungle that Alessandro Cosmelli and Gaia Light explore. During a hot summer in Brooklyn they took a bus and never stepped out of it, yet you smell the melting asphalt, the perspiration, the spicy waft from a Dominican deli. They operate behind the double glass of a bus window and the camera, yet you always feel part of the street, part of a morphing Brooklyn that's rooted in the moment and borrows from the aesthetics and style of 1970's movies. The resulting work follows a tradition of documentary photography as it's been done in the US, since Frank's *Americans* but it kicks you in the face with a surprising vigor. Alessandro and Gaia touch a very raw set of emotions and stay true to a soulful and edgy Brooklyn that never stops moving.

Marion Durand

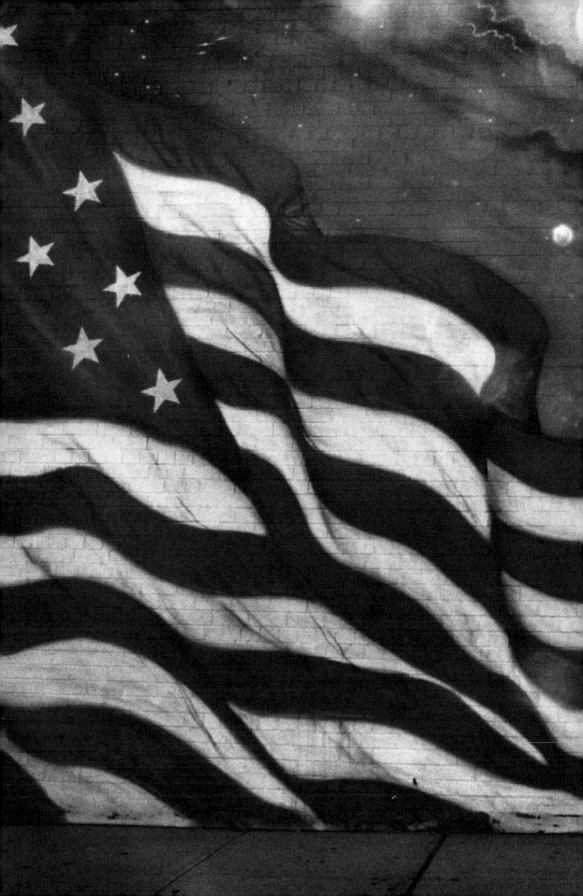

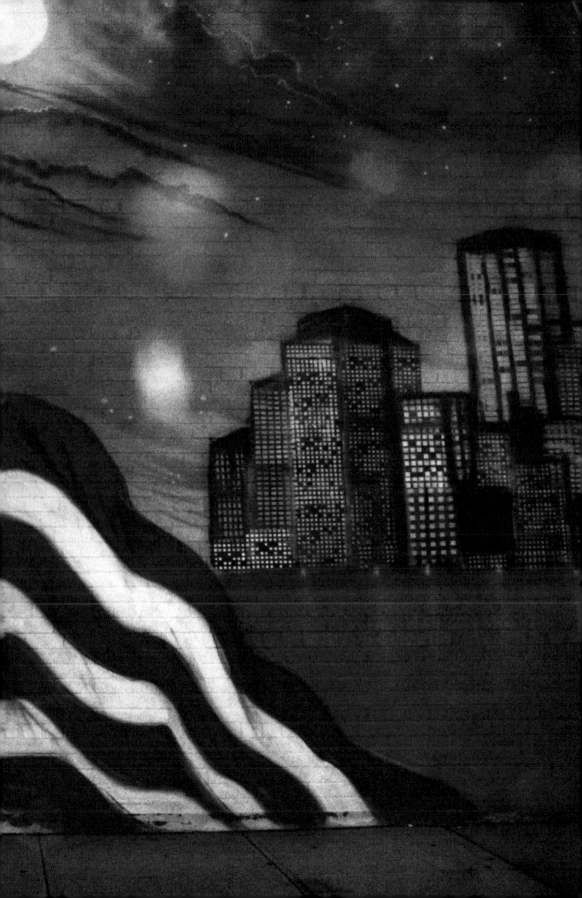

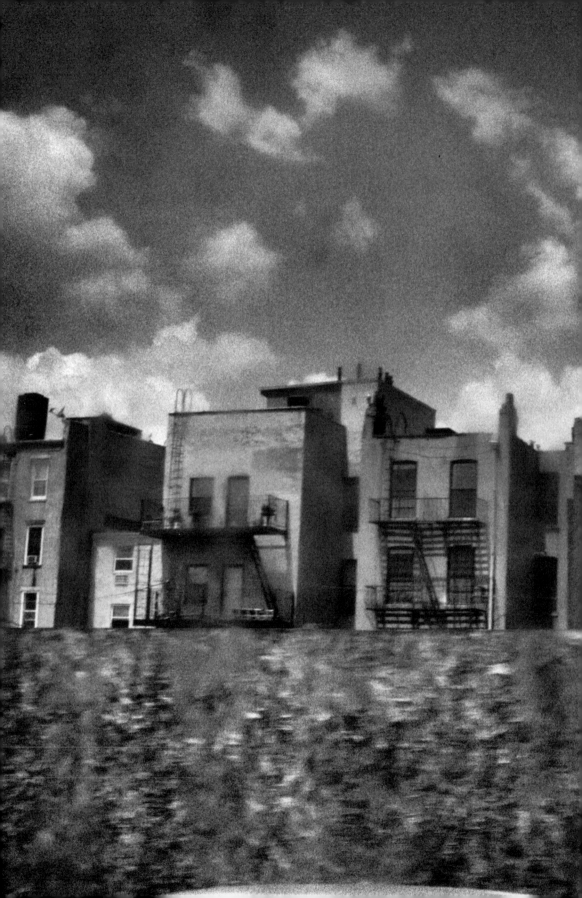

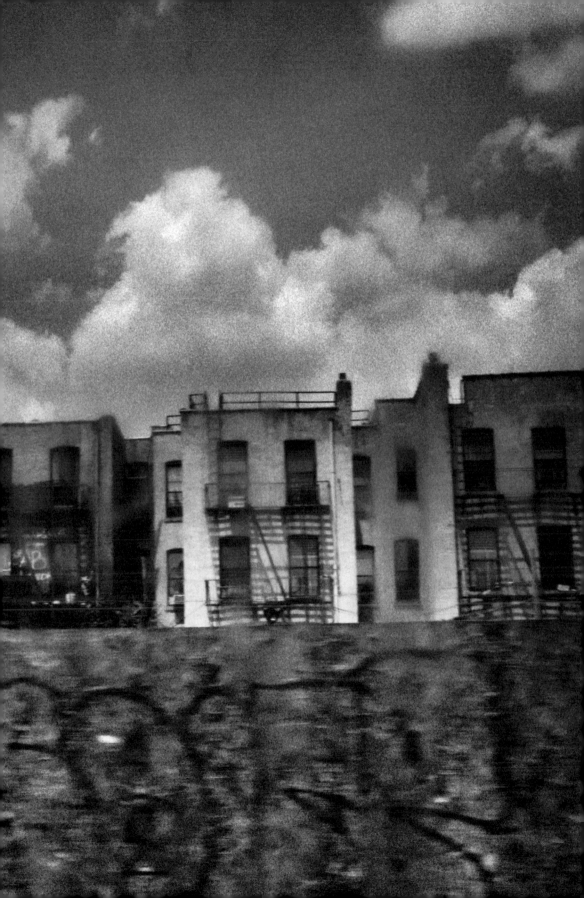

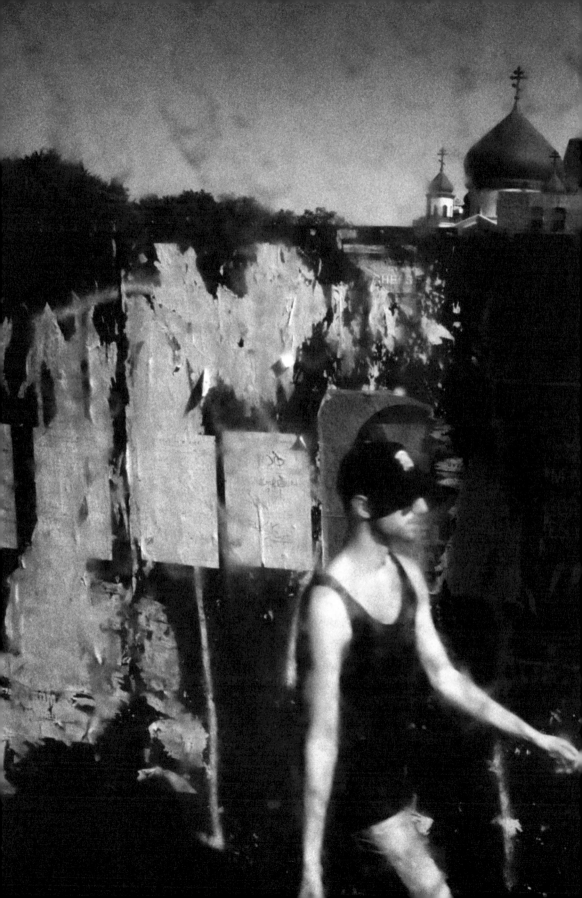

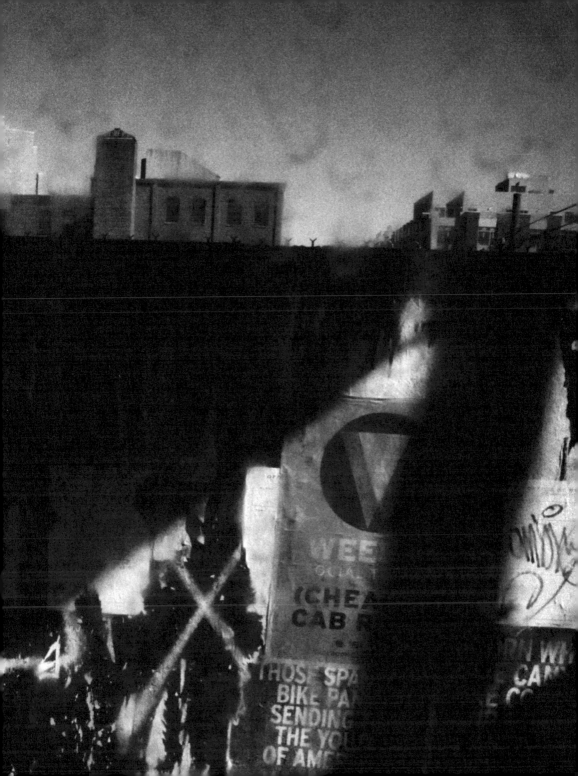

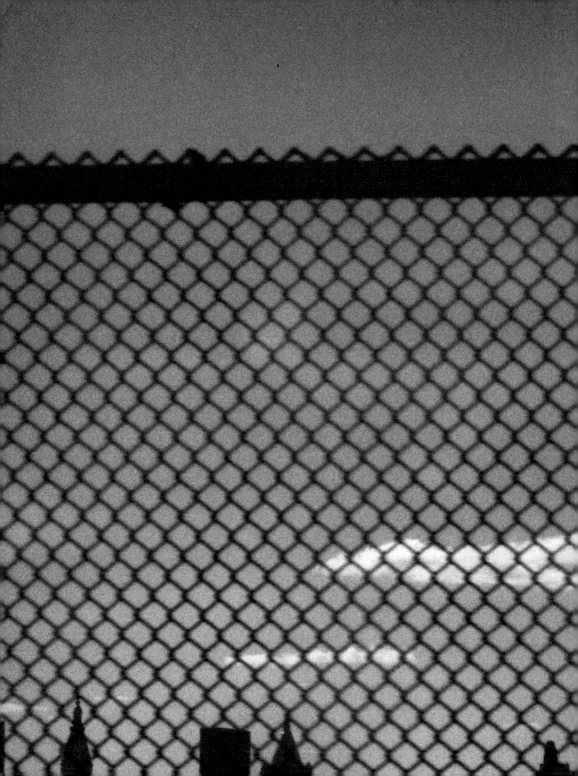

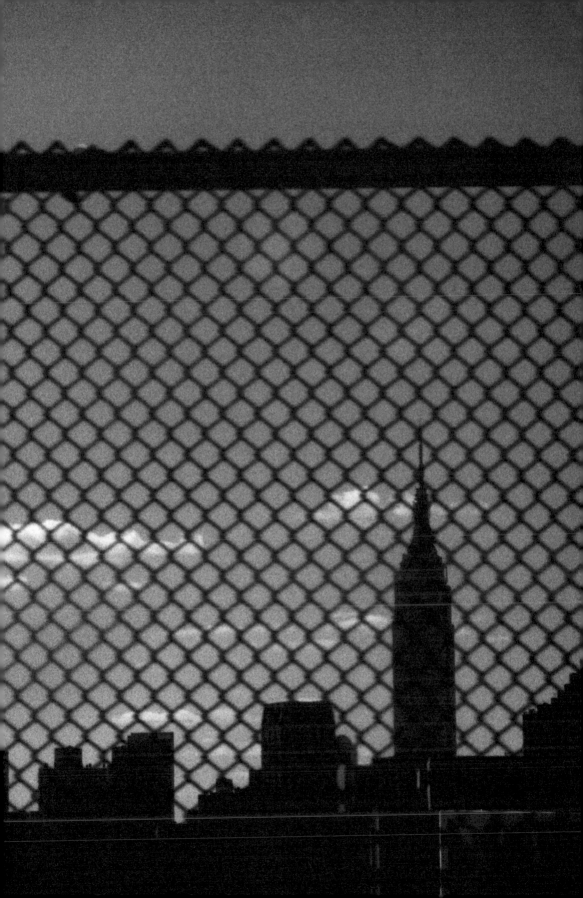

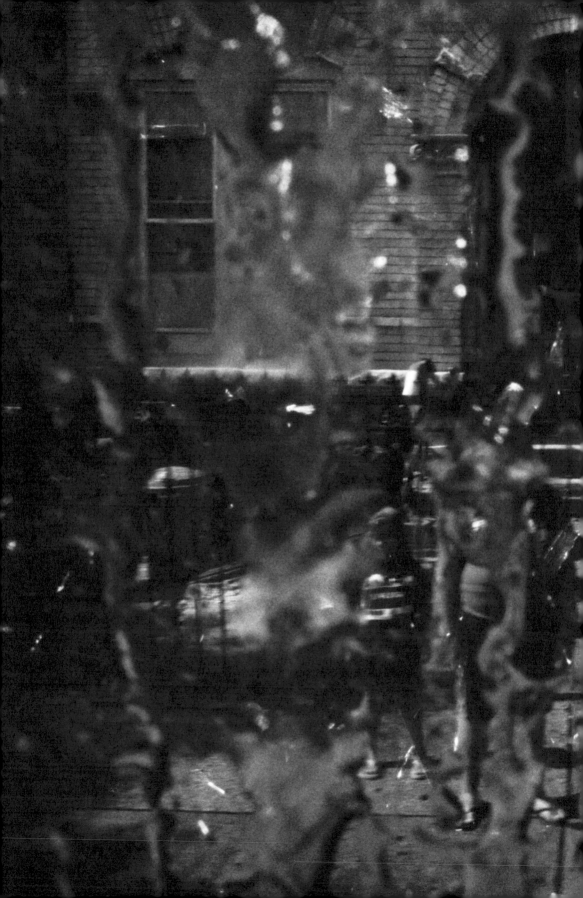

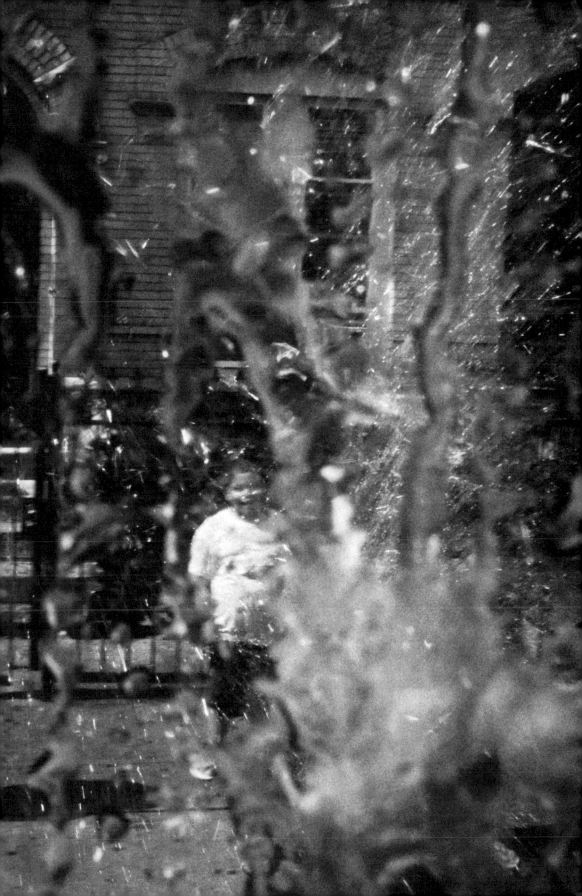

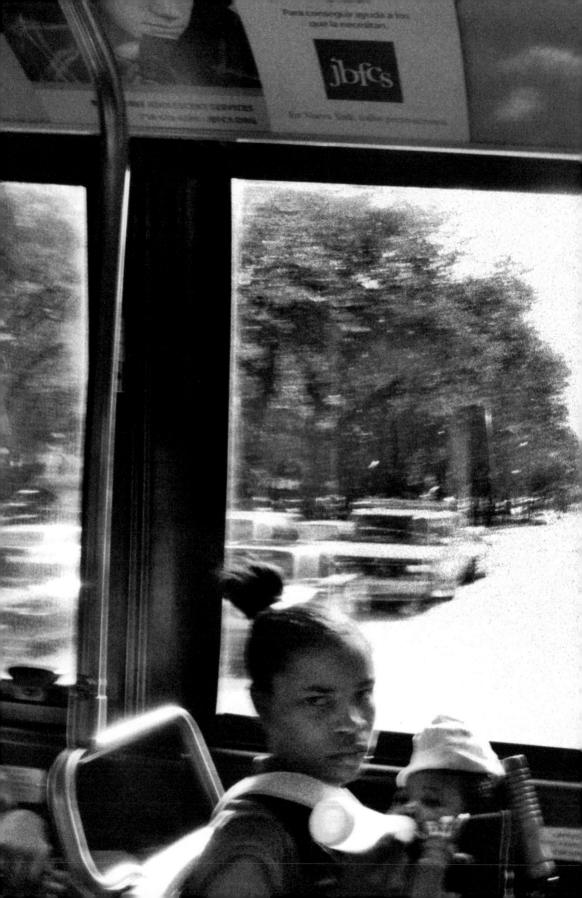

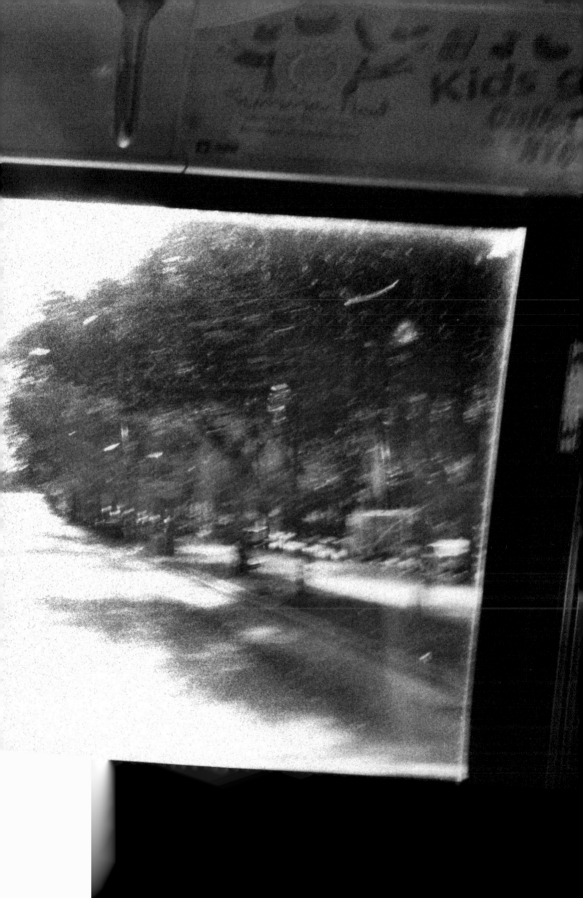

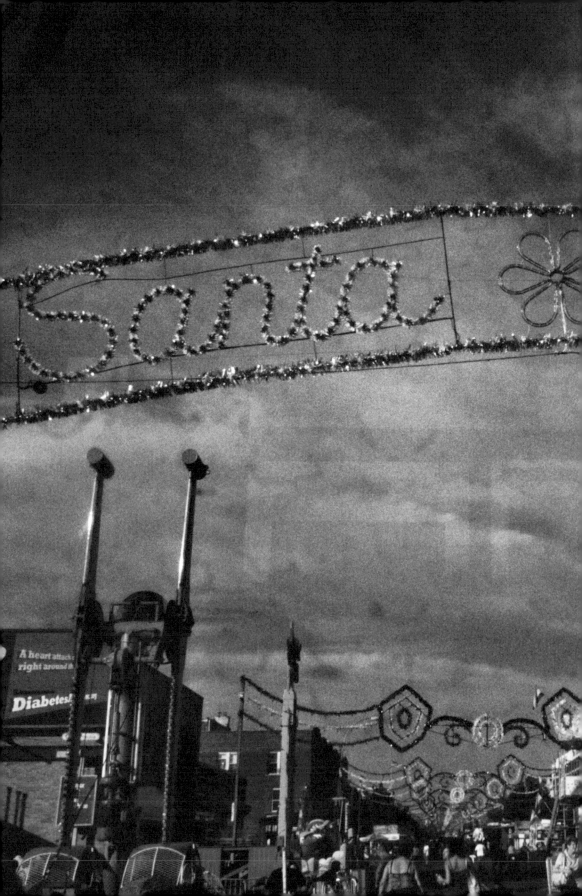

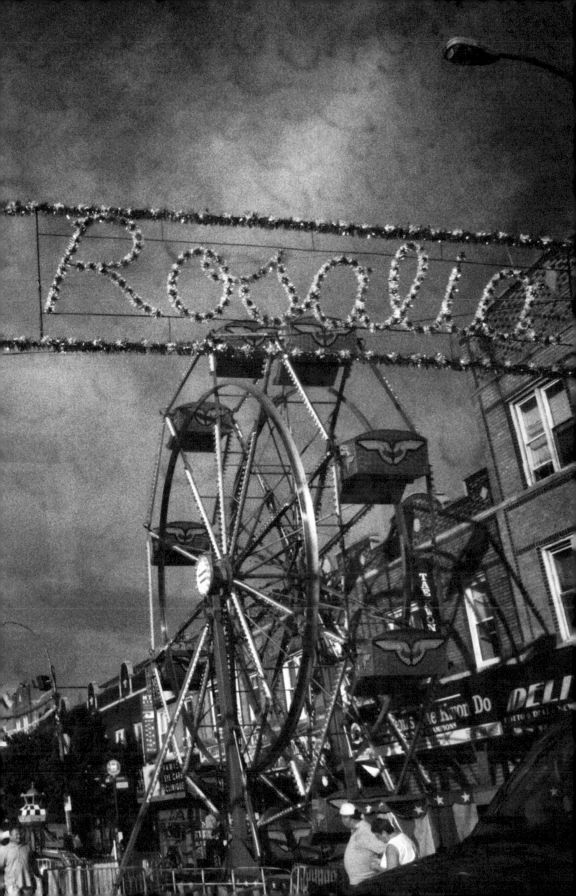

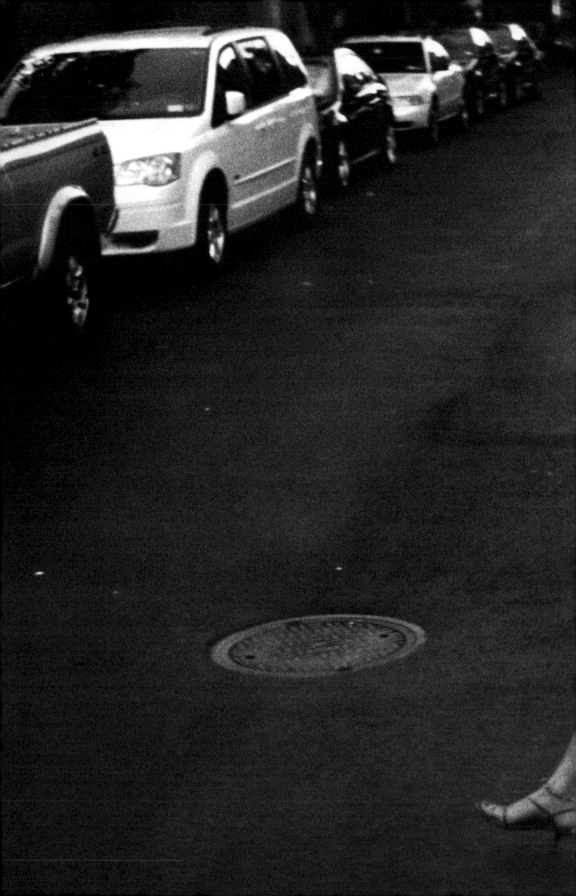

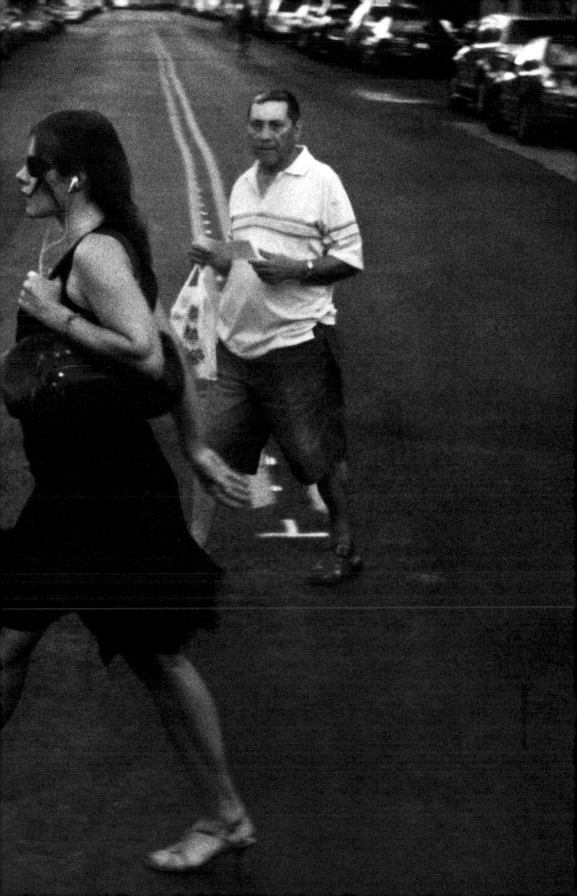

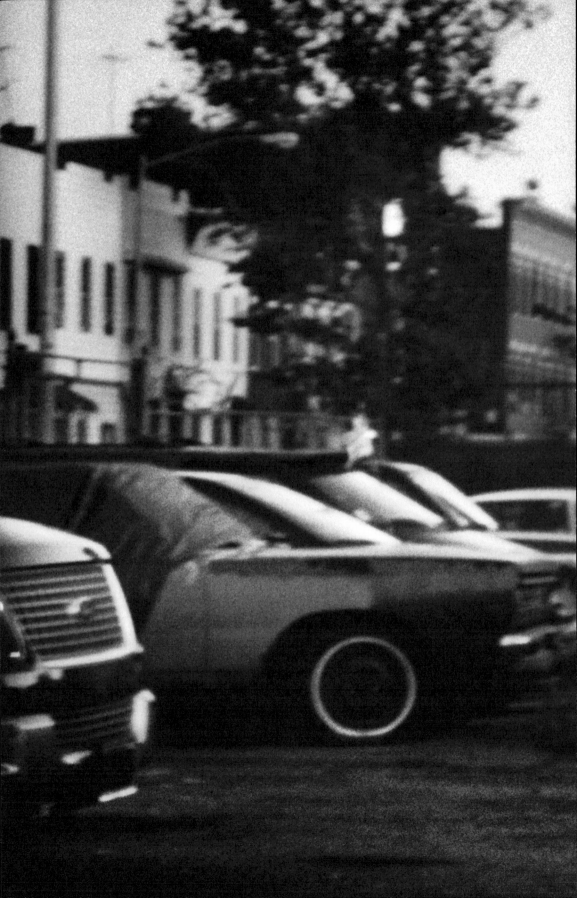

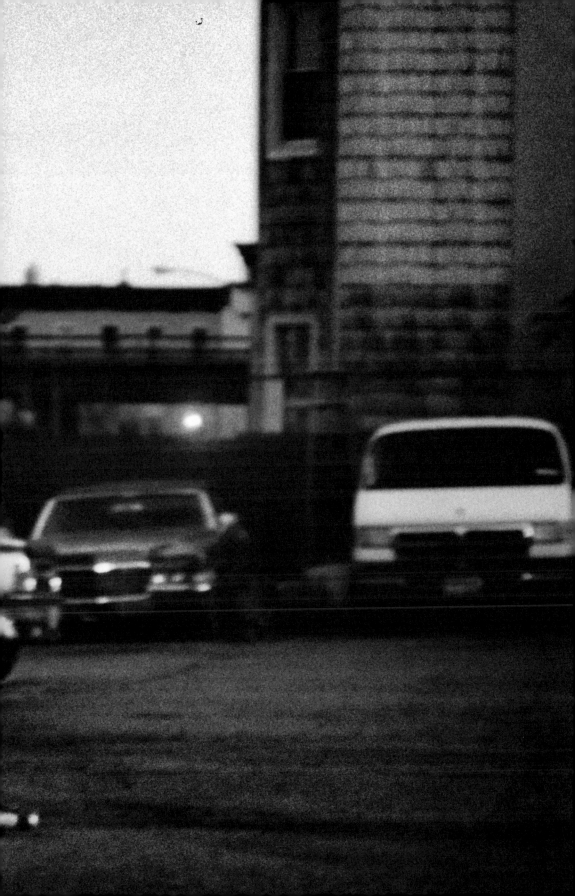

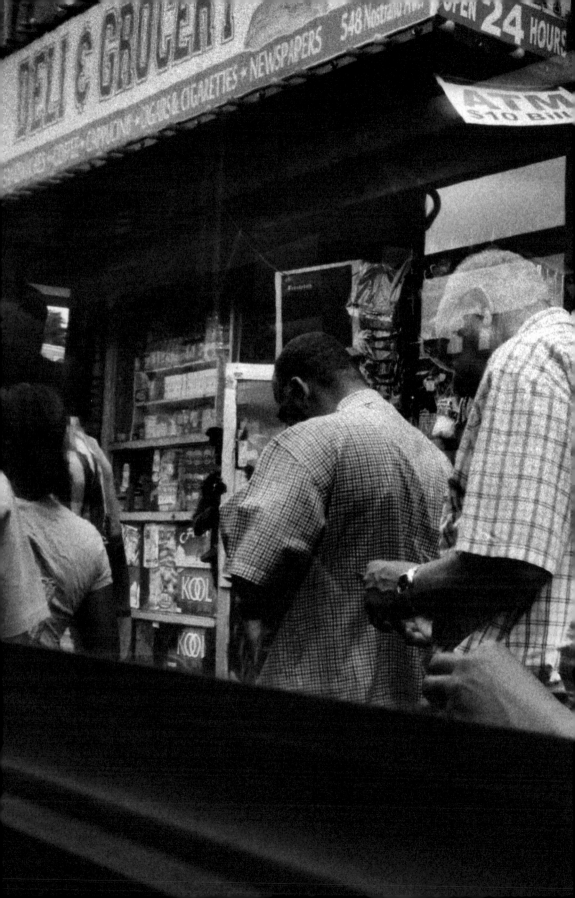

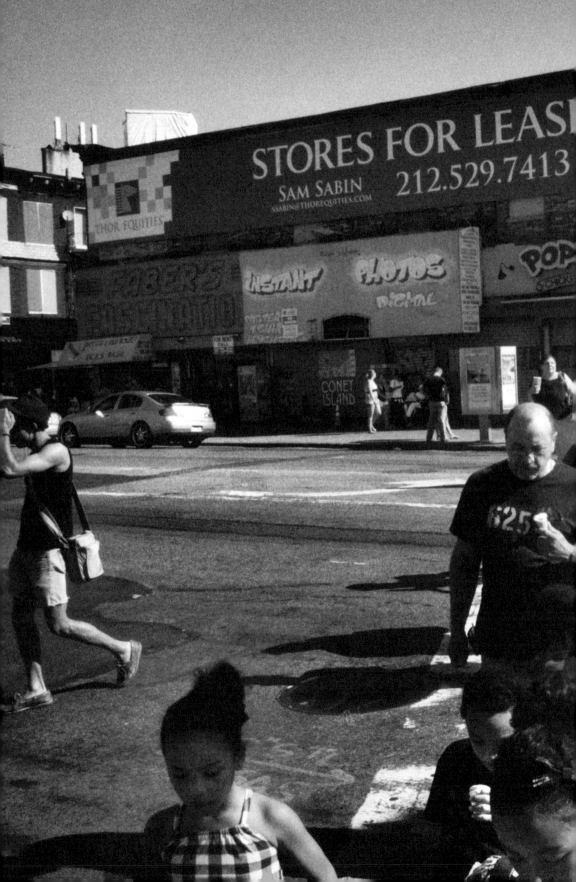

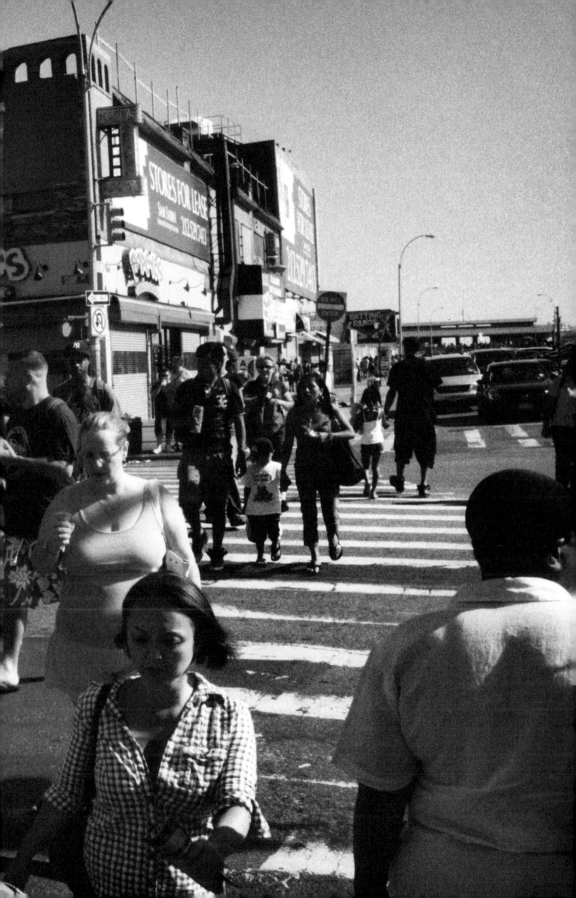

SPRINKLERS
ON FLOORS
8, 9, 11, 12,
13, 14 & 15

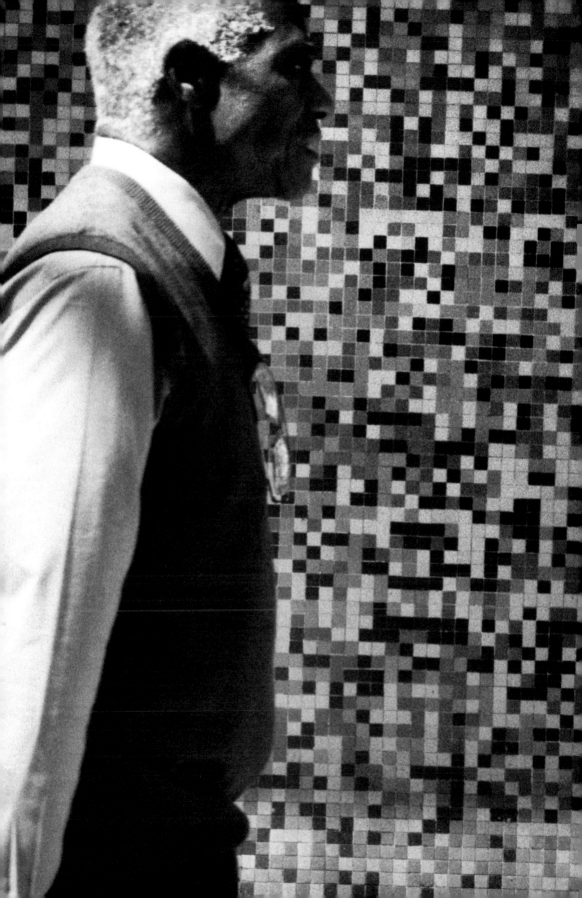

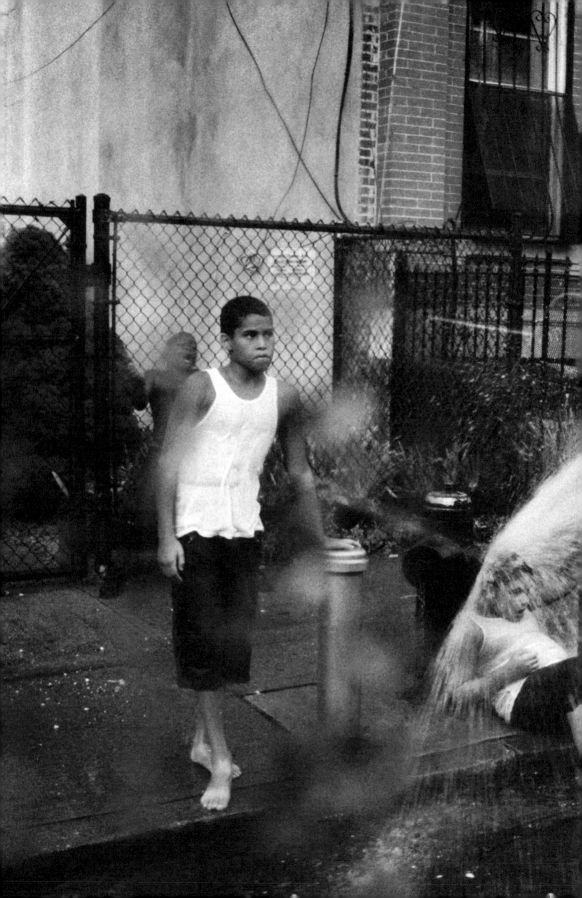

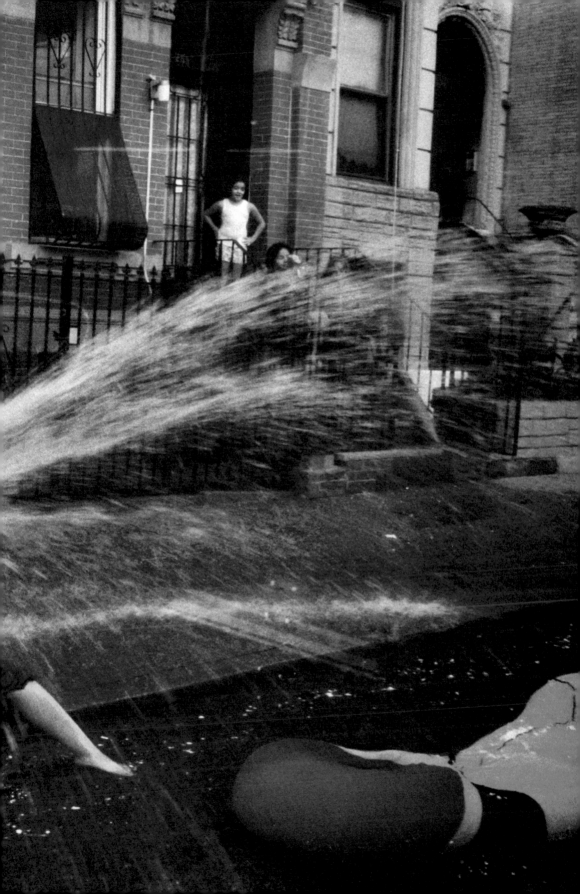

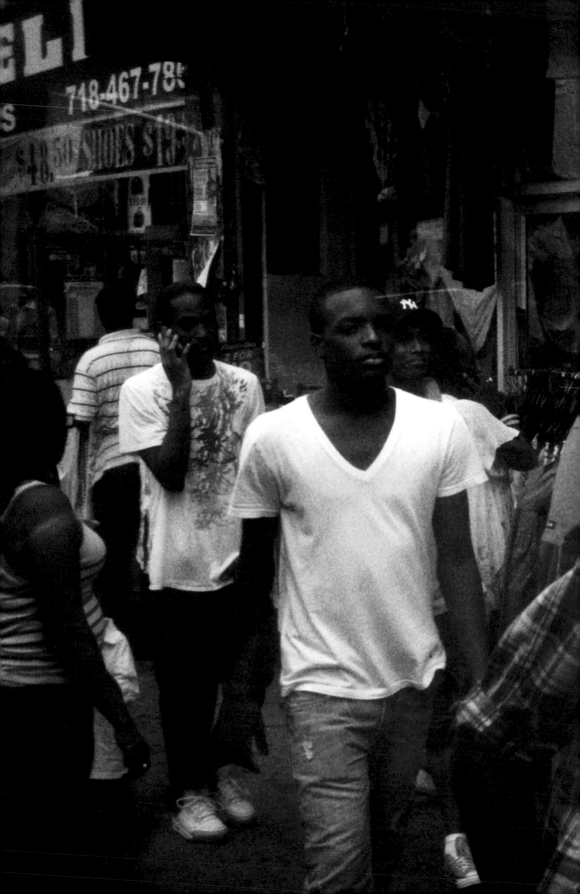

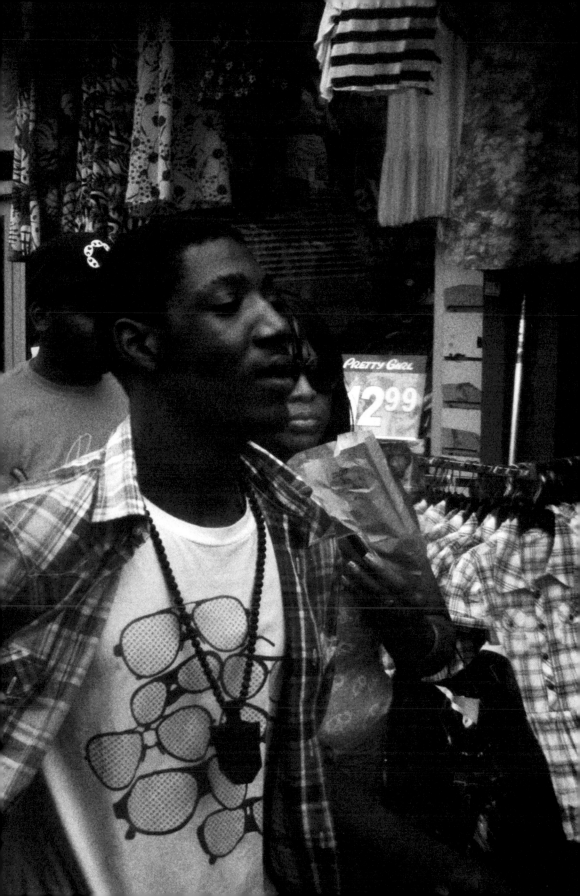

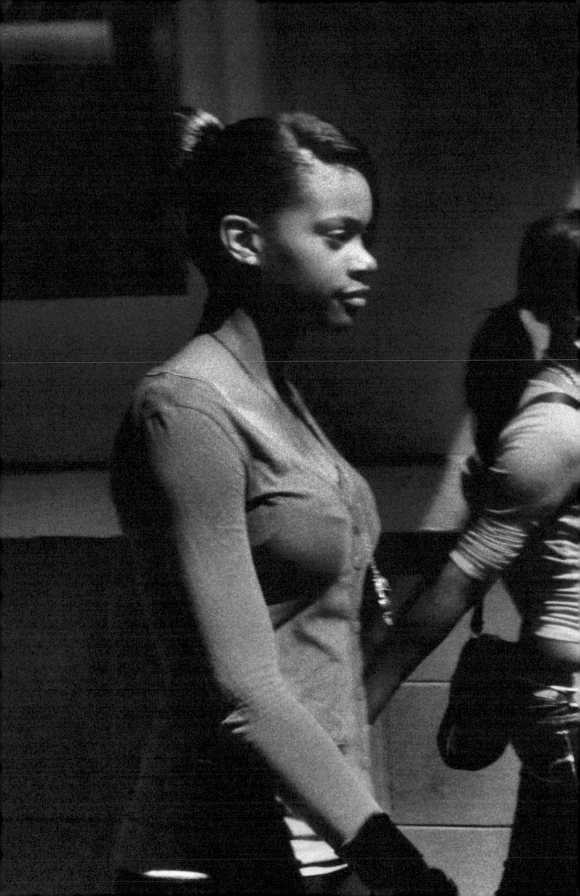

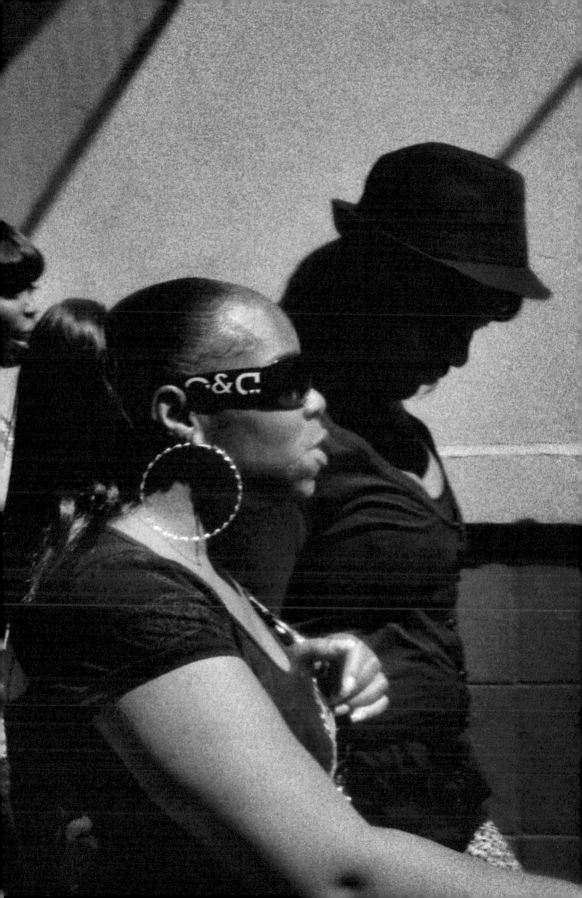

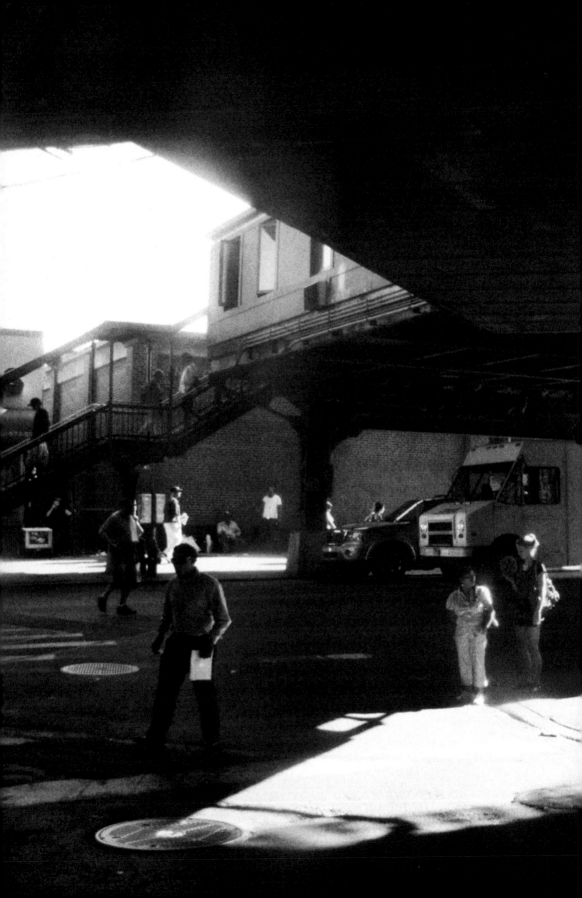

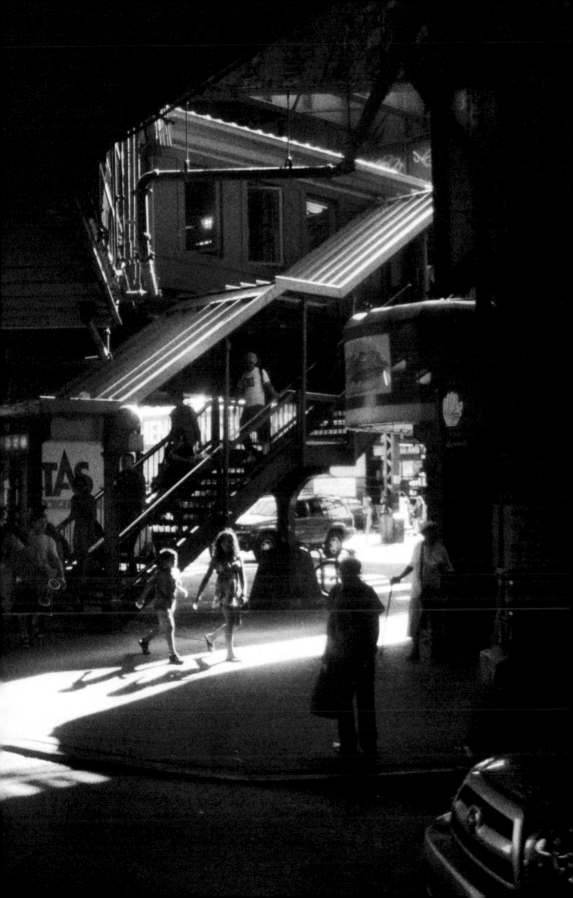

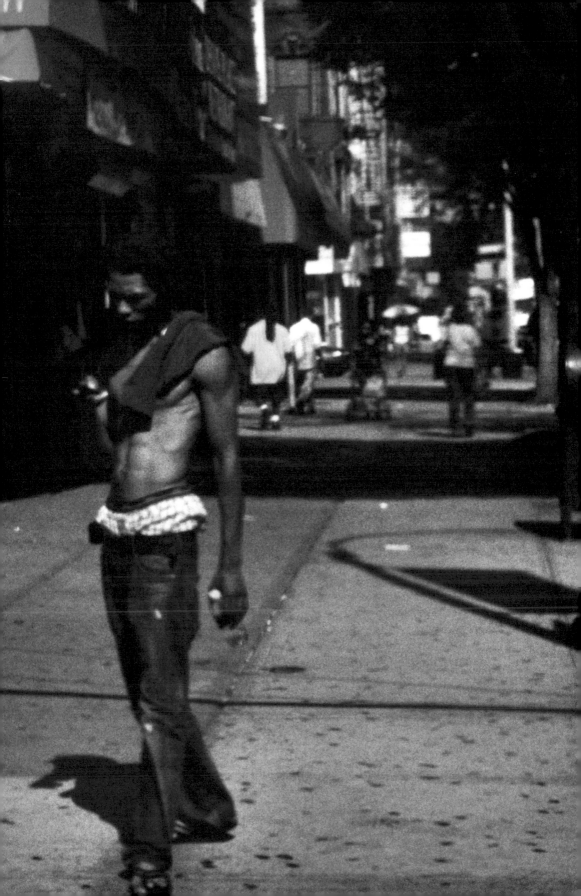

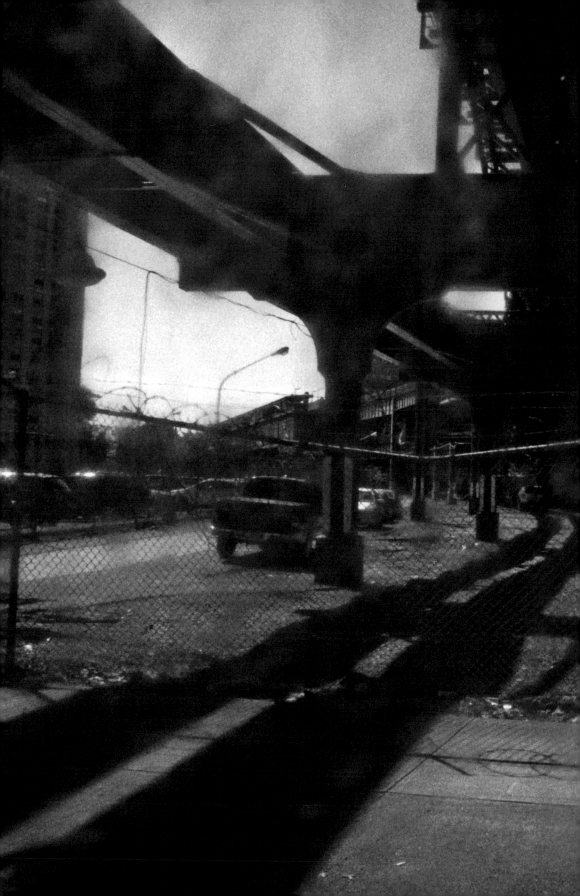

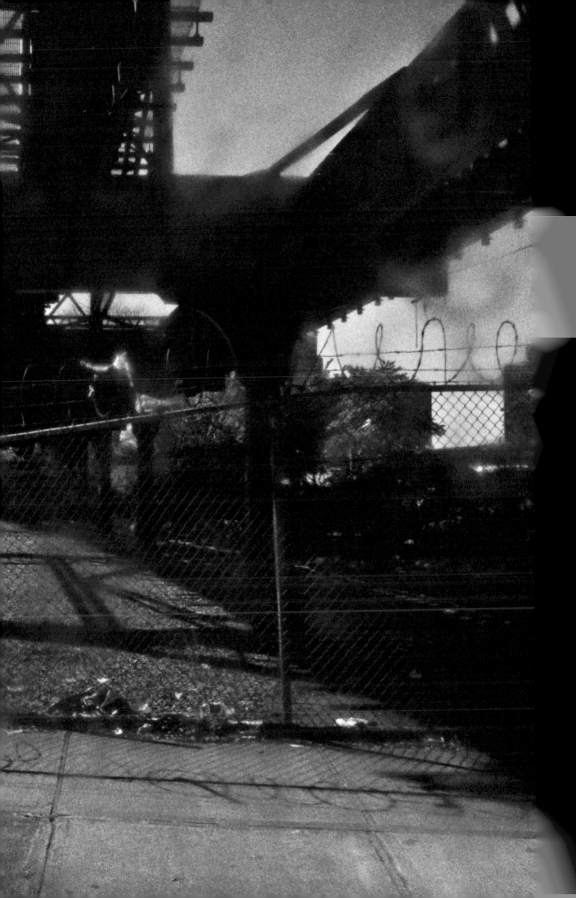

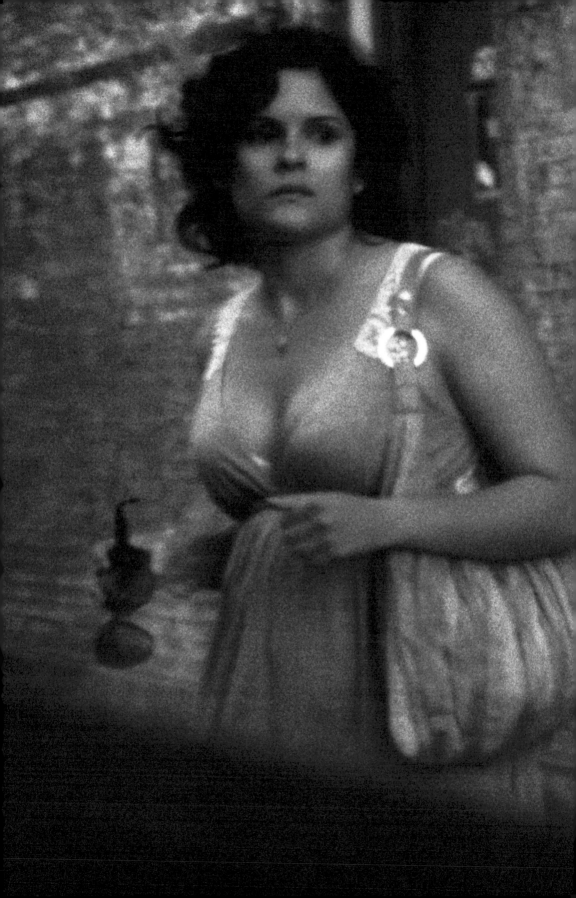

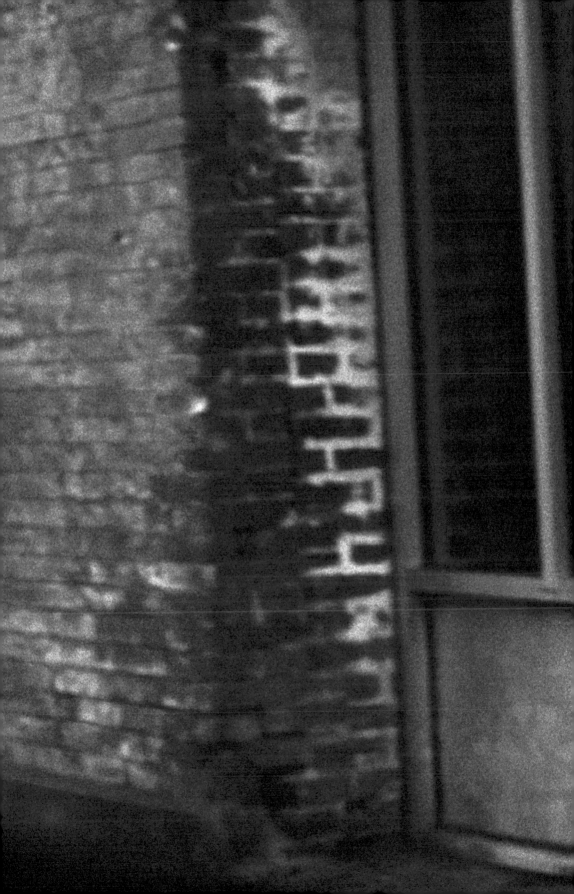

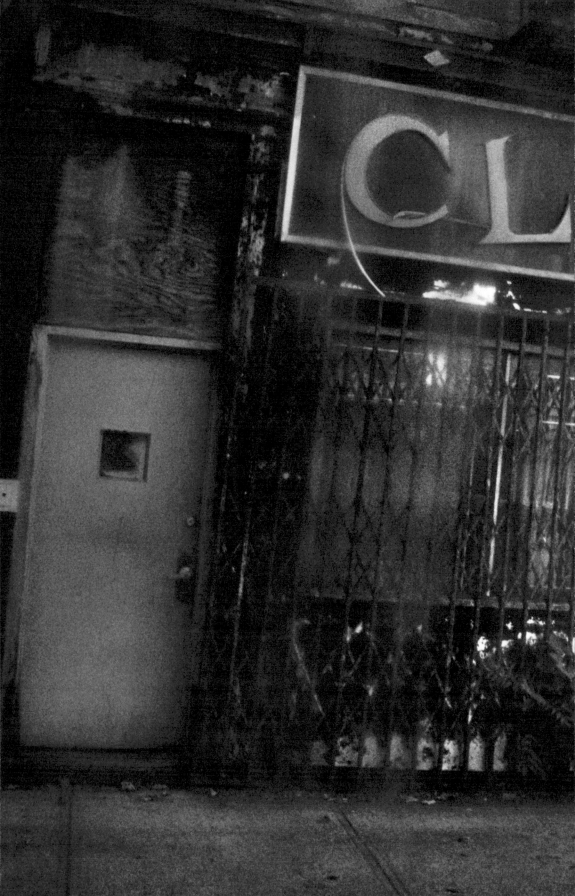

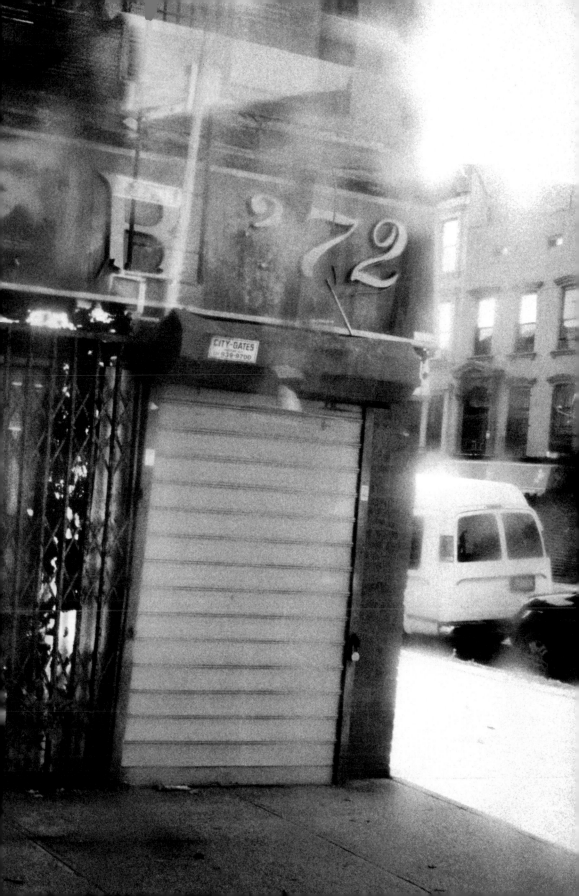

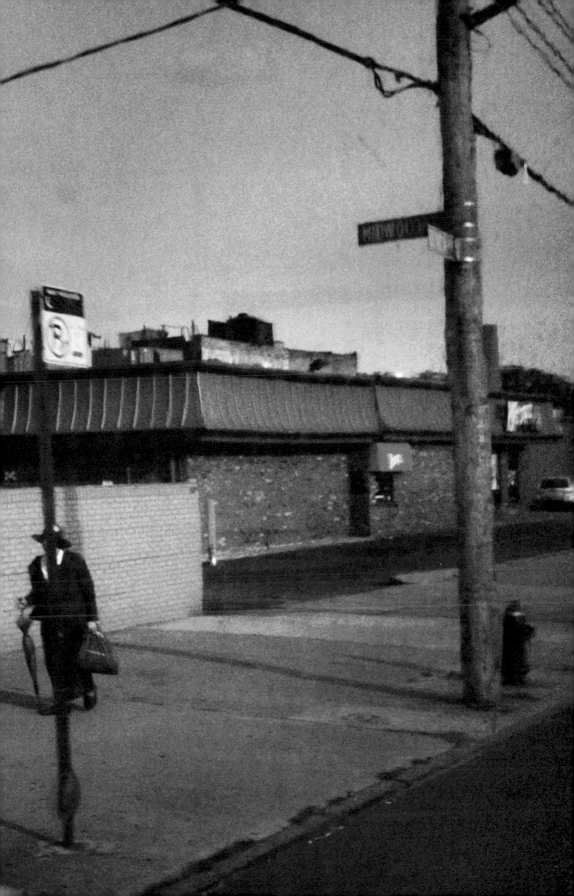

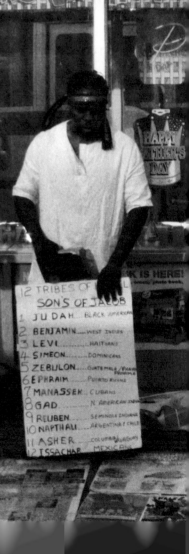

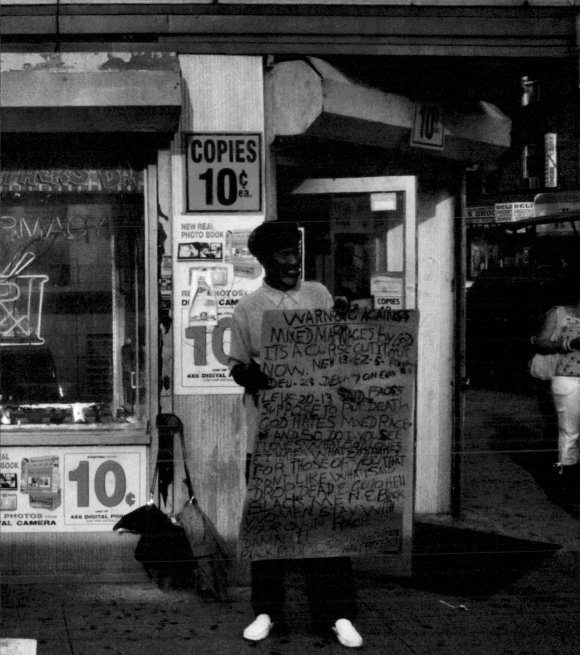

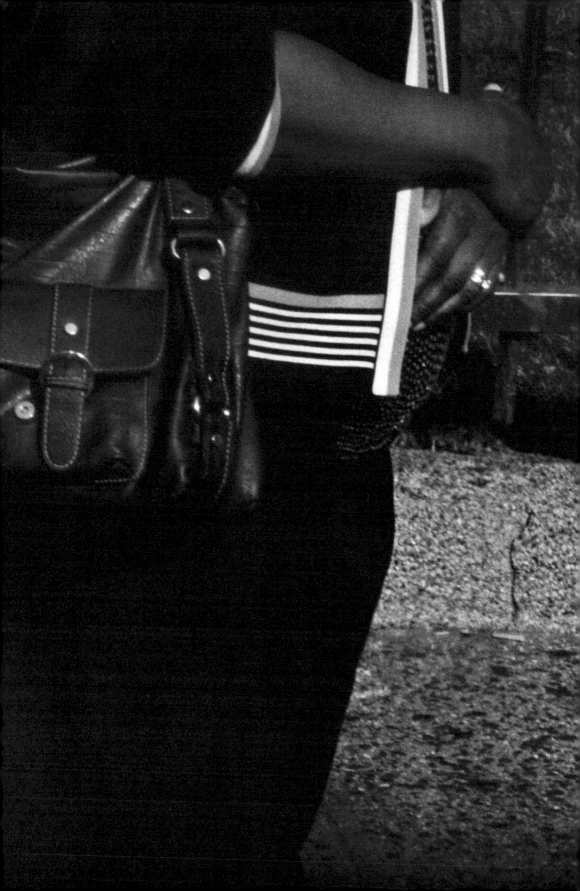

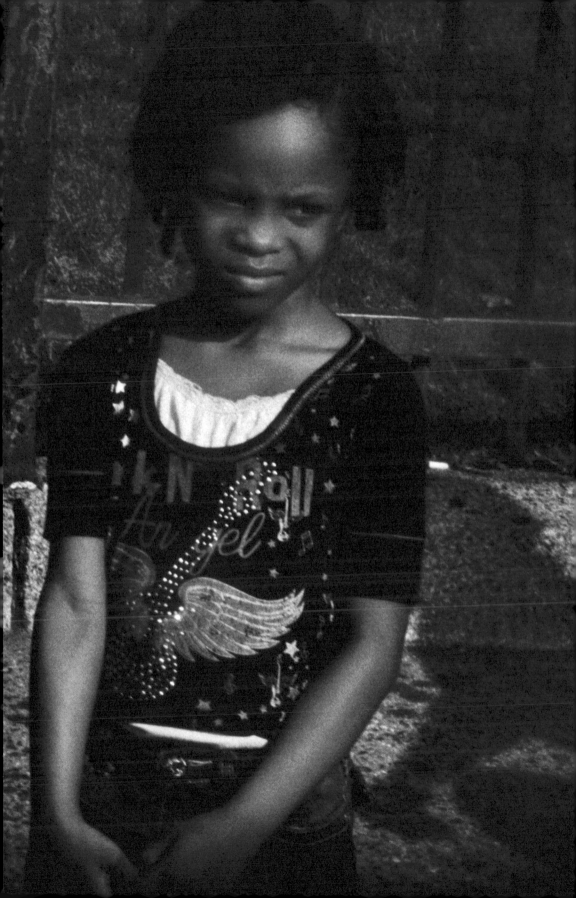

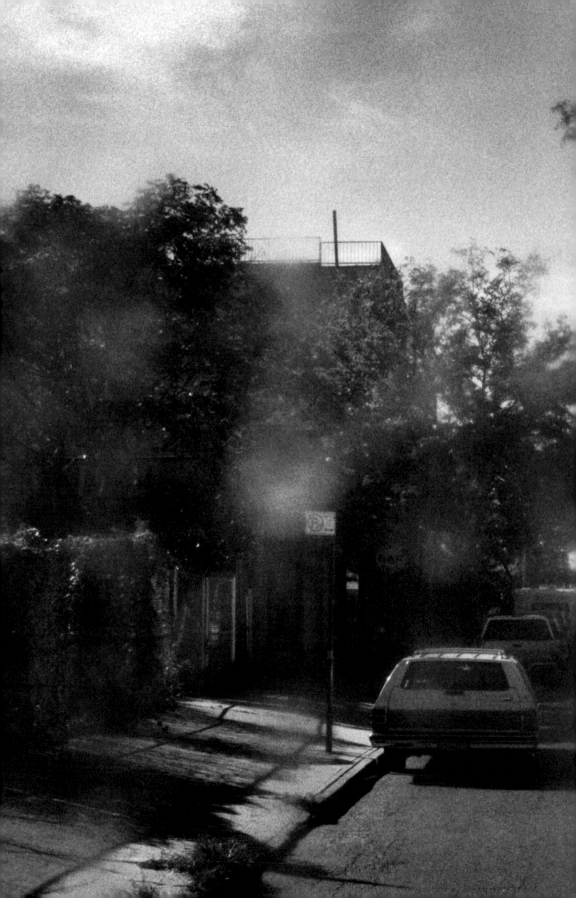

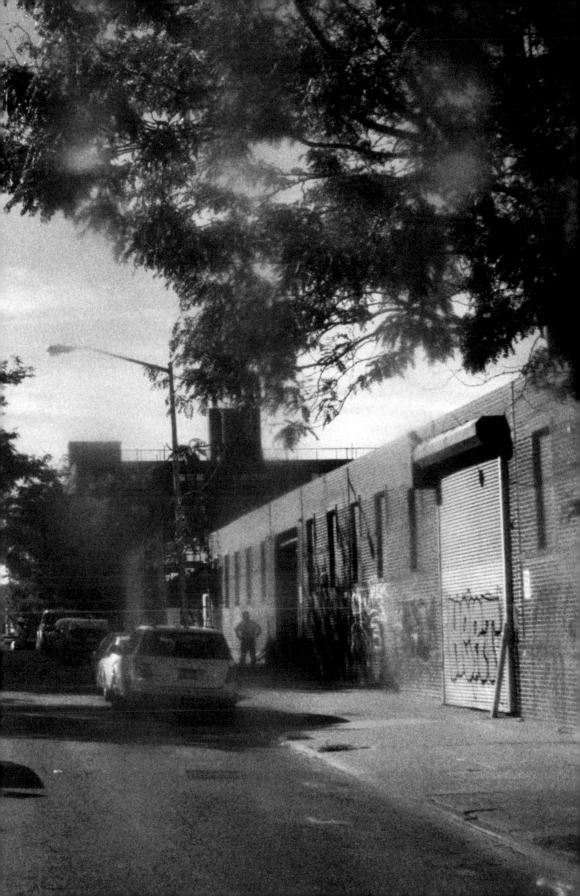

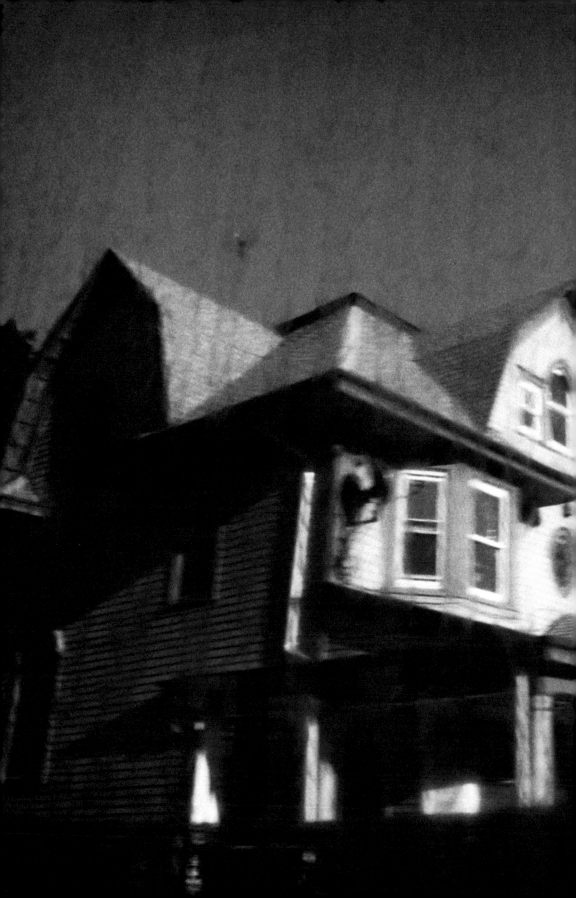

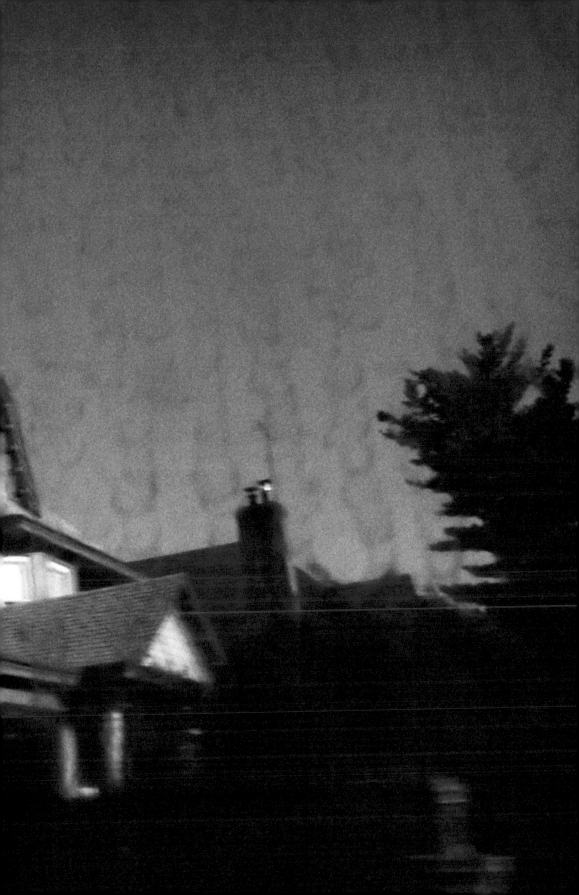

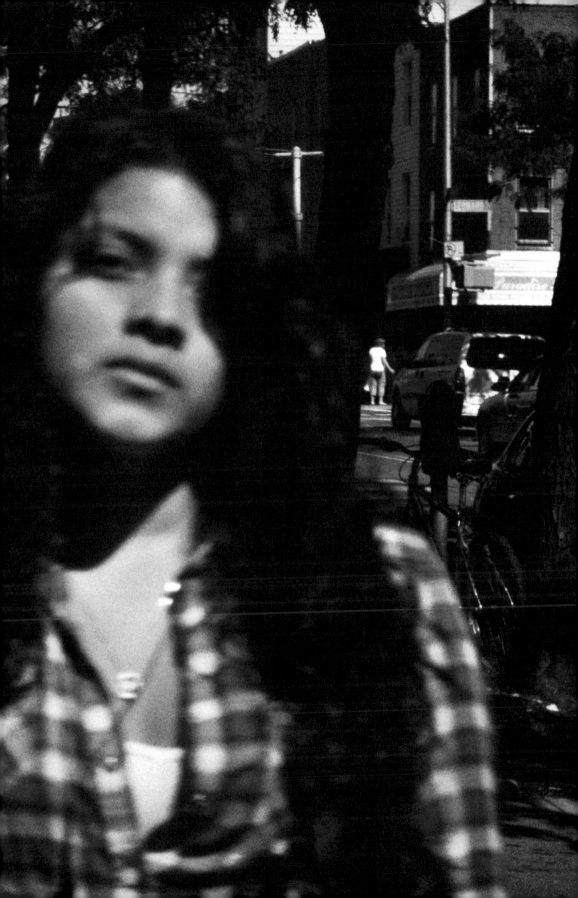

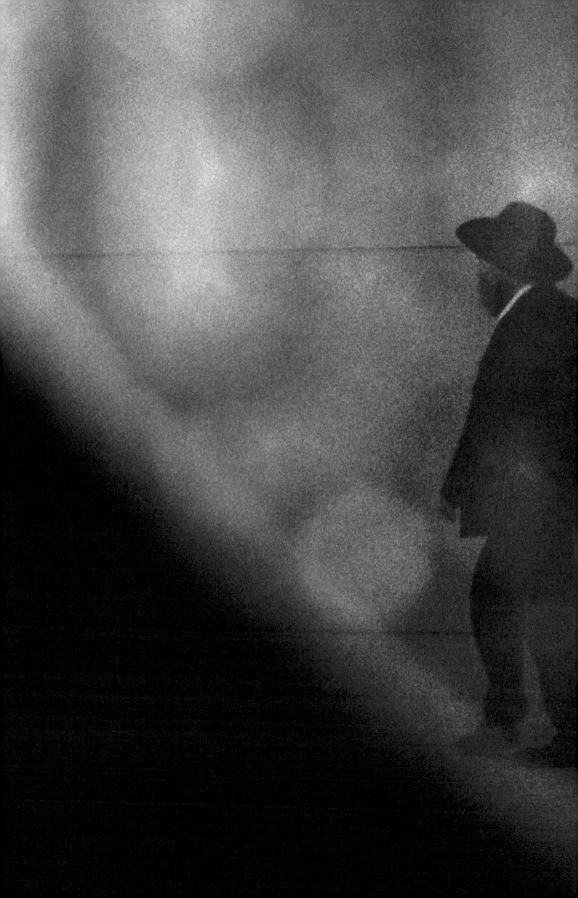

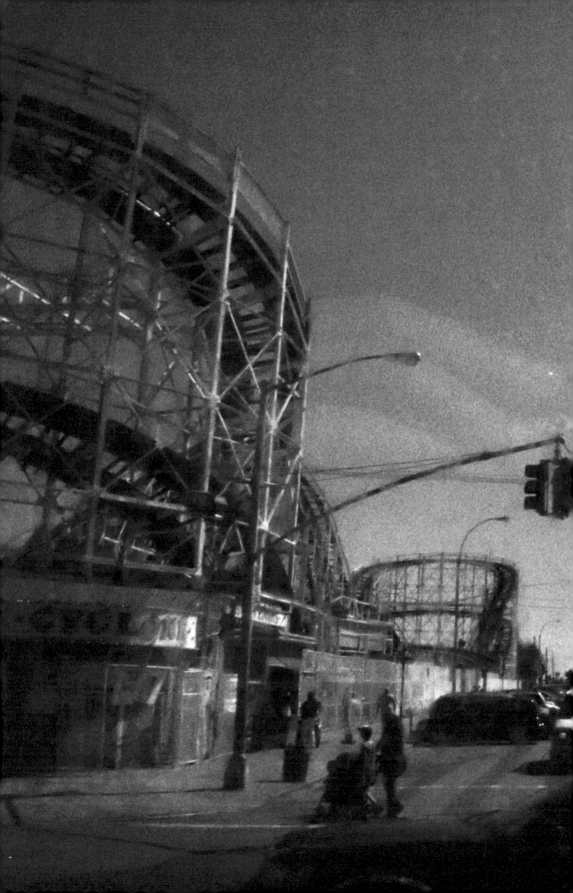

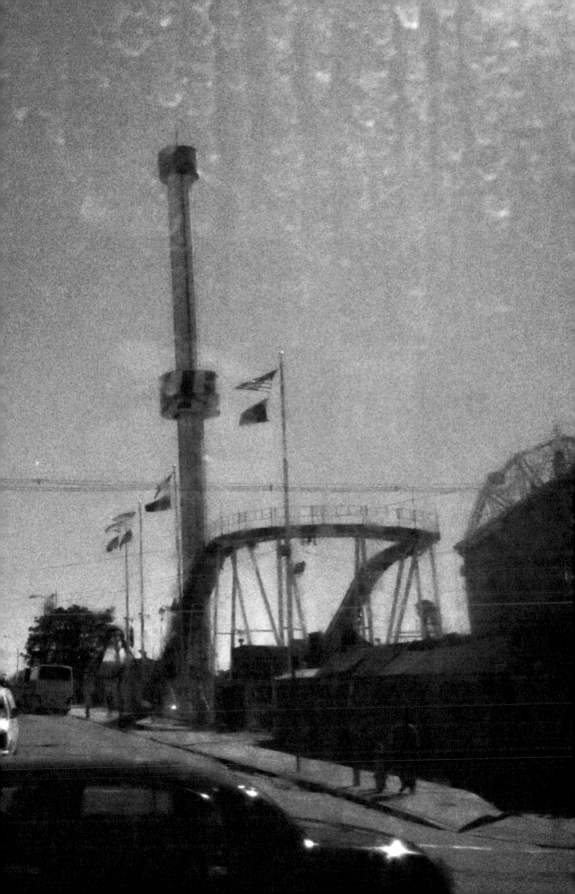

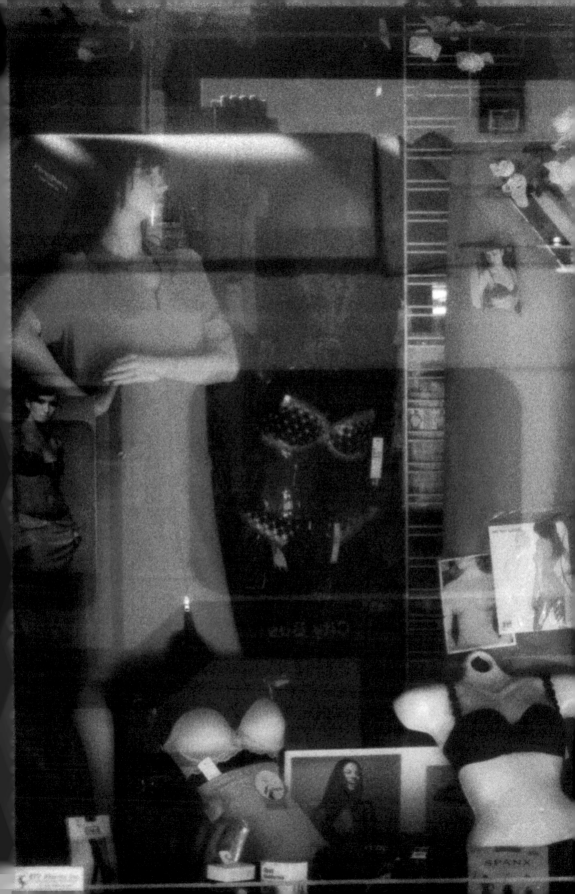

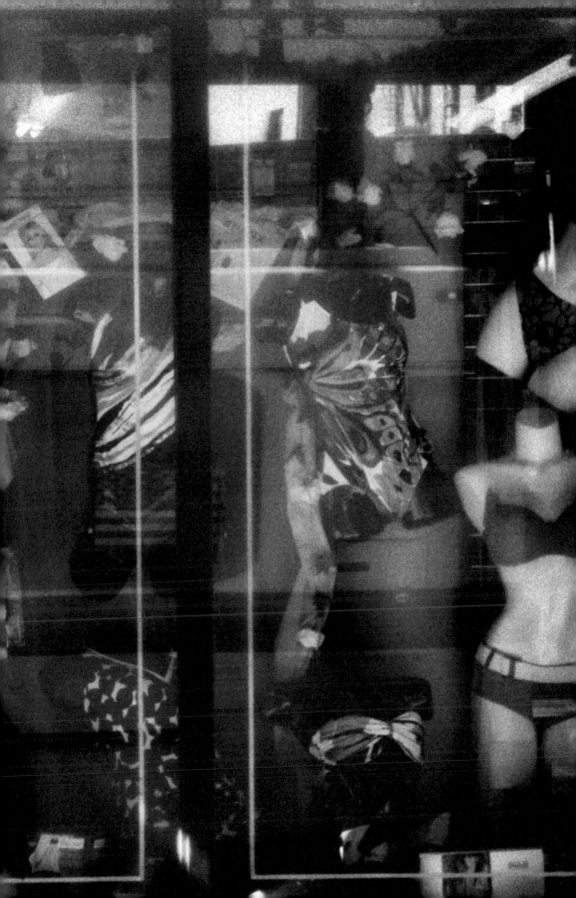

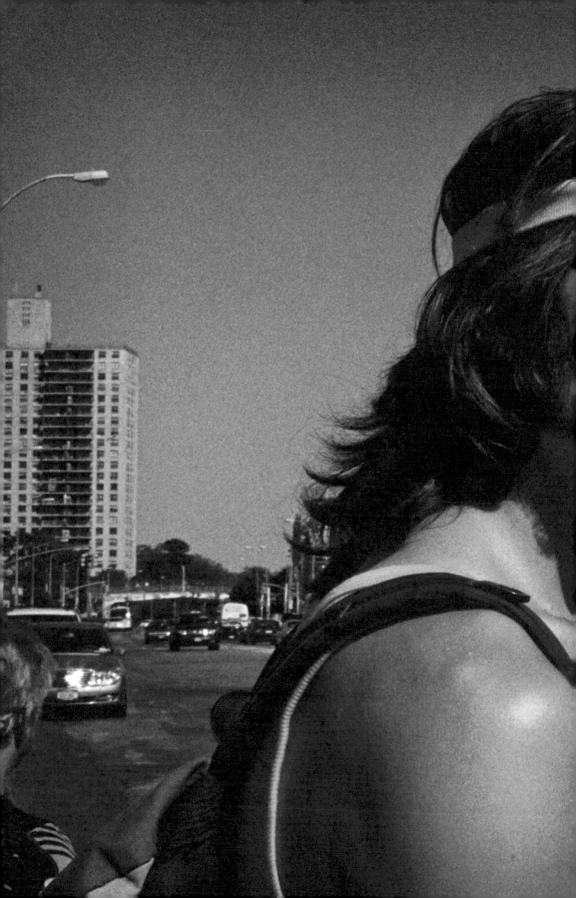

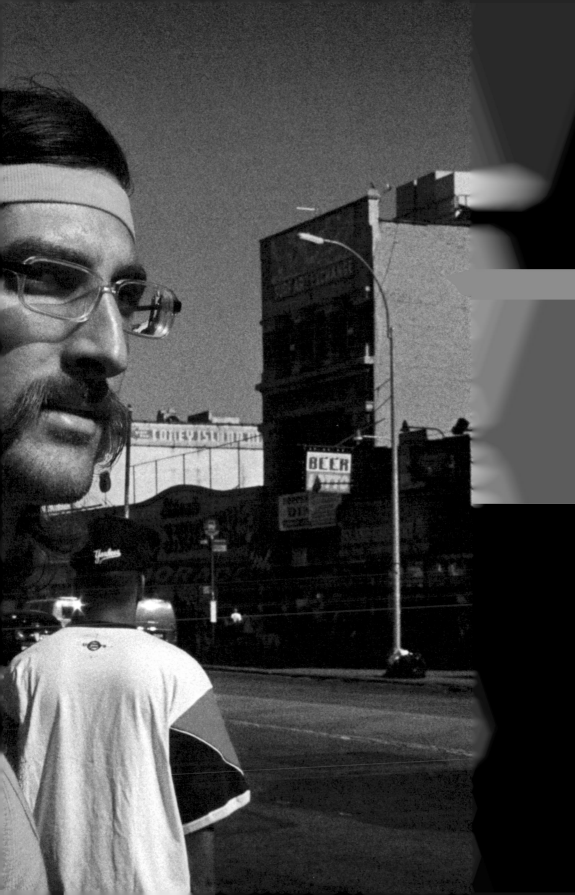

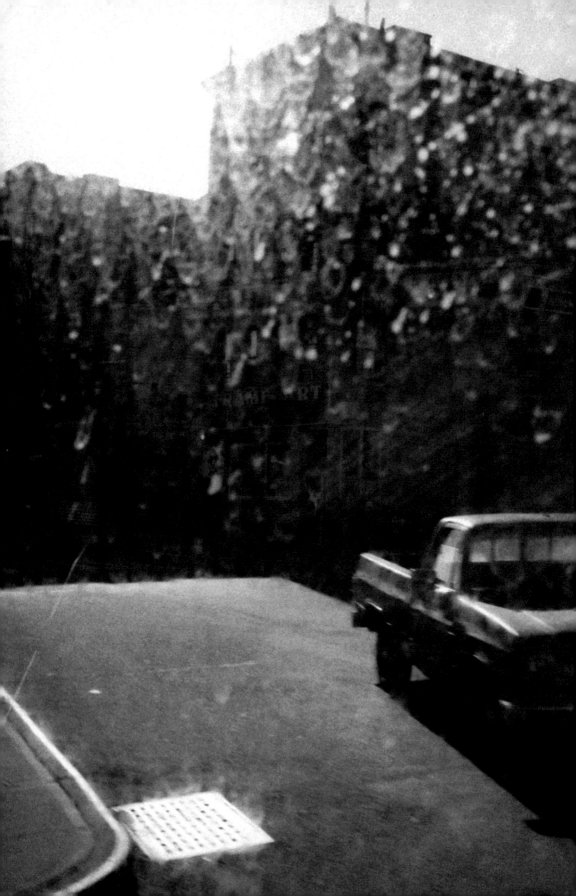

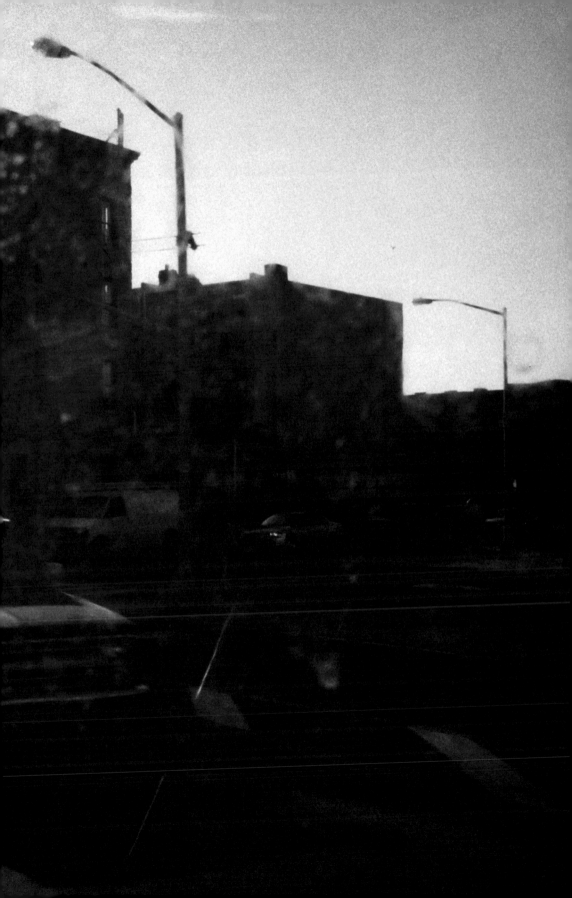

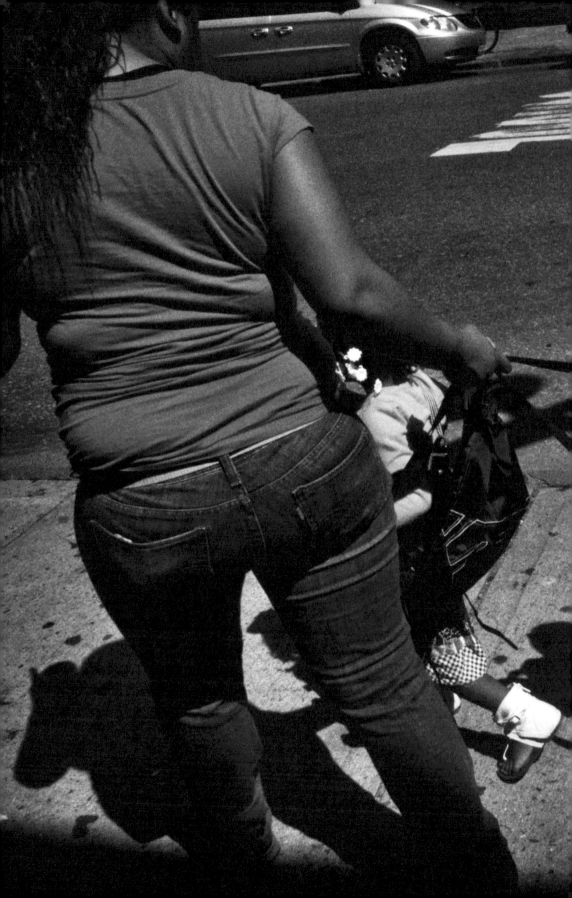

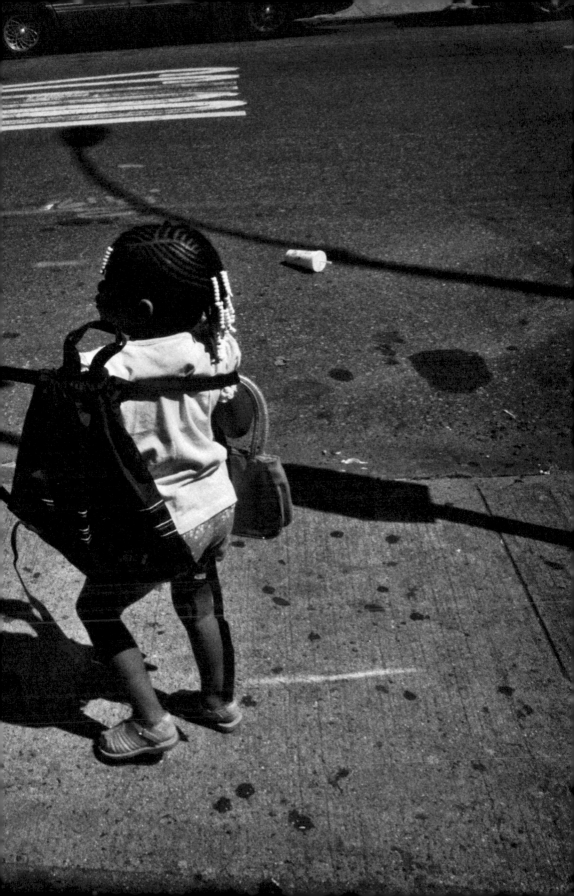

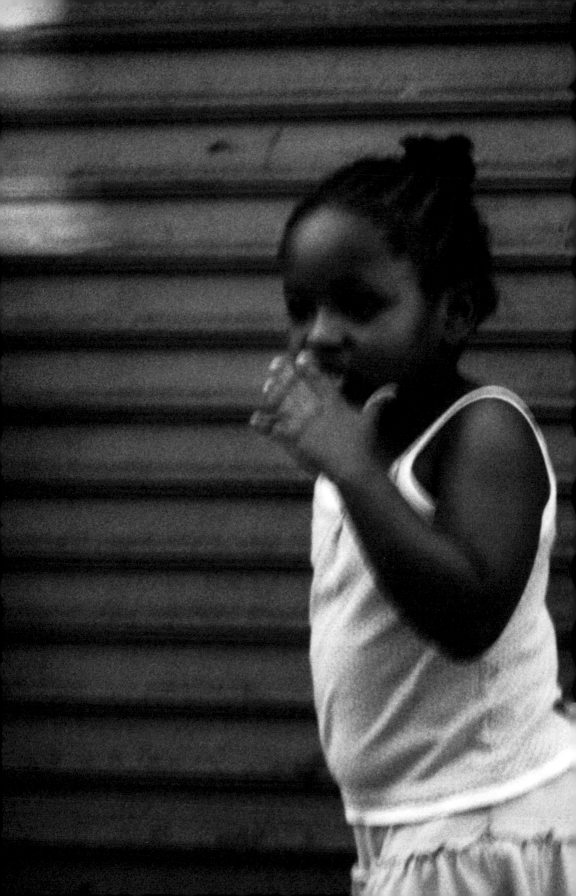

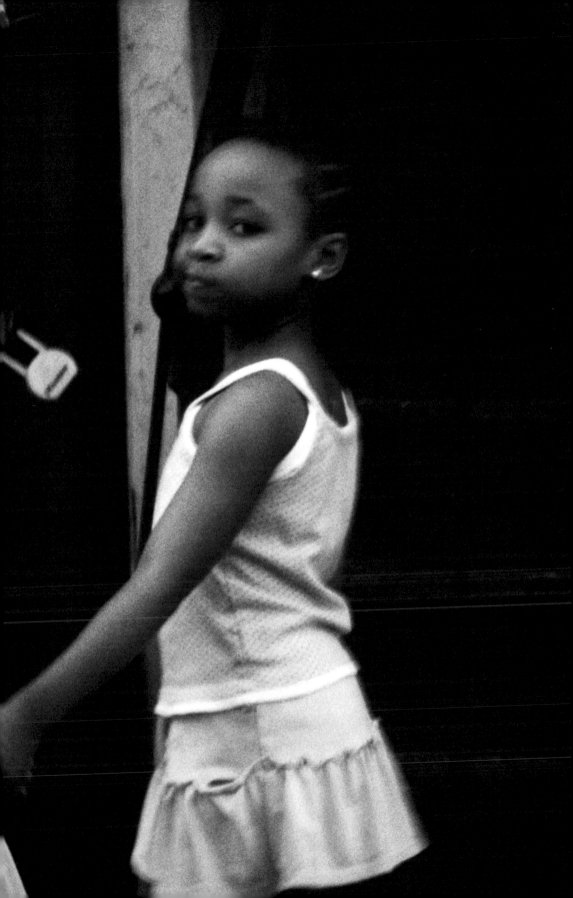

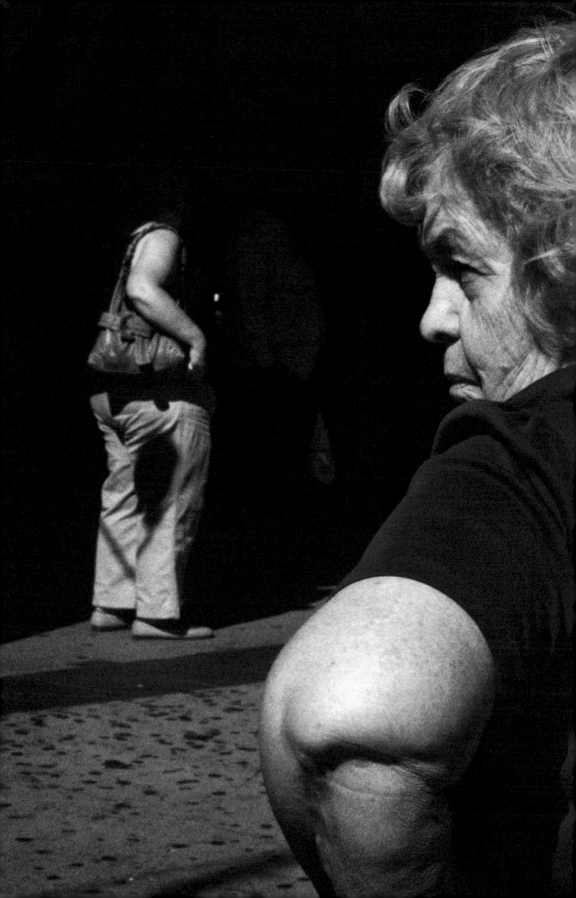

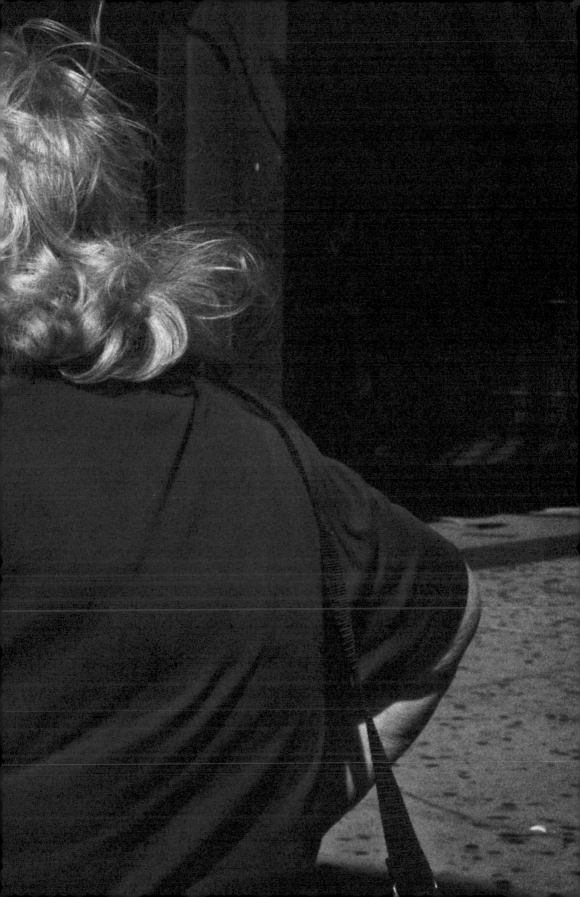

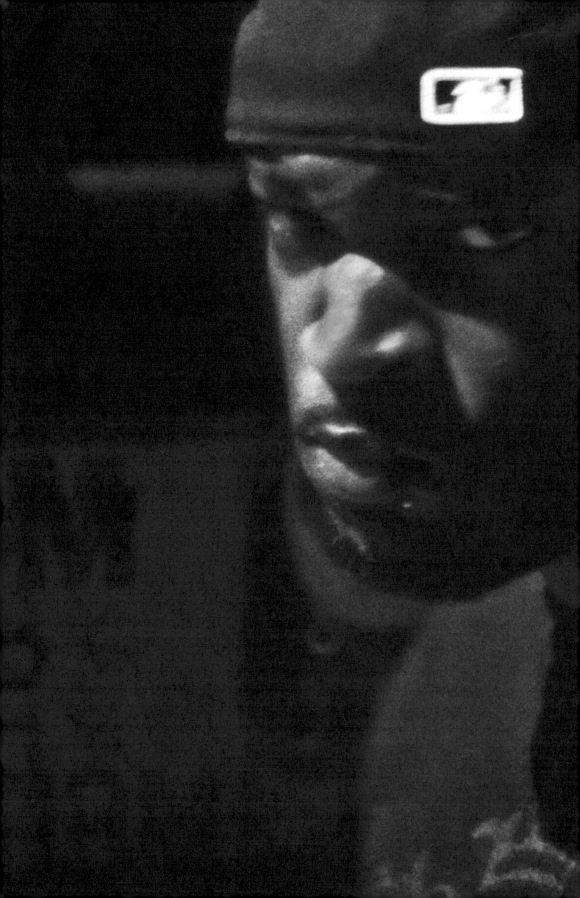

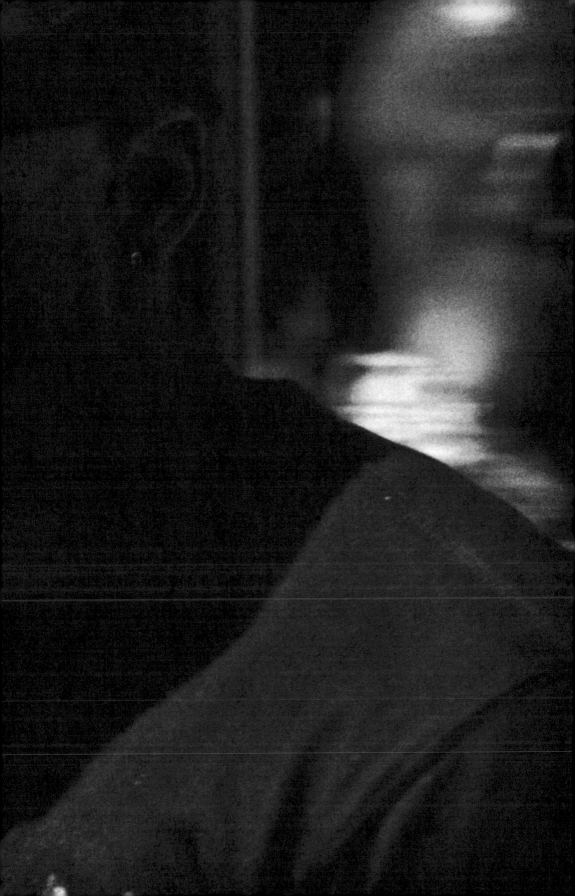

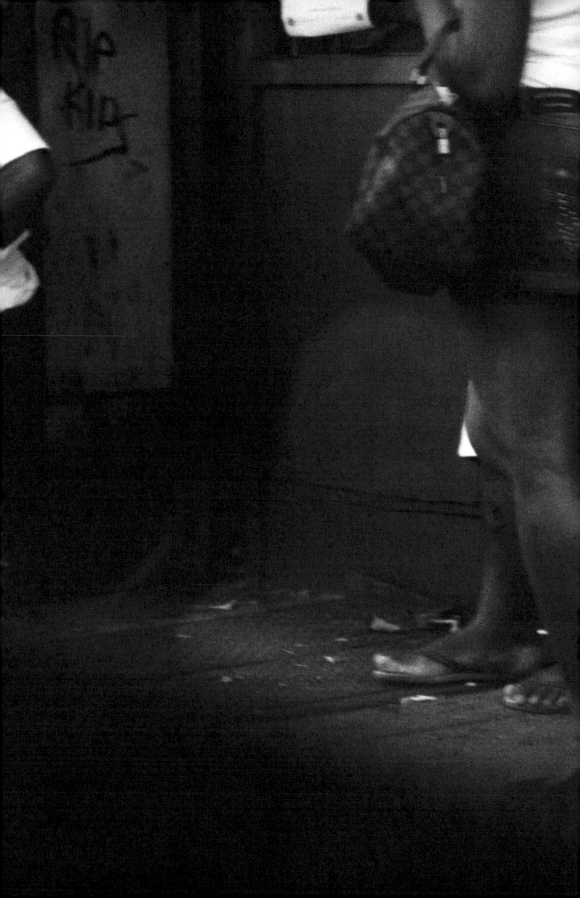

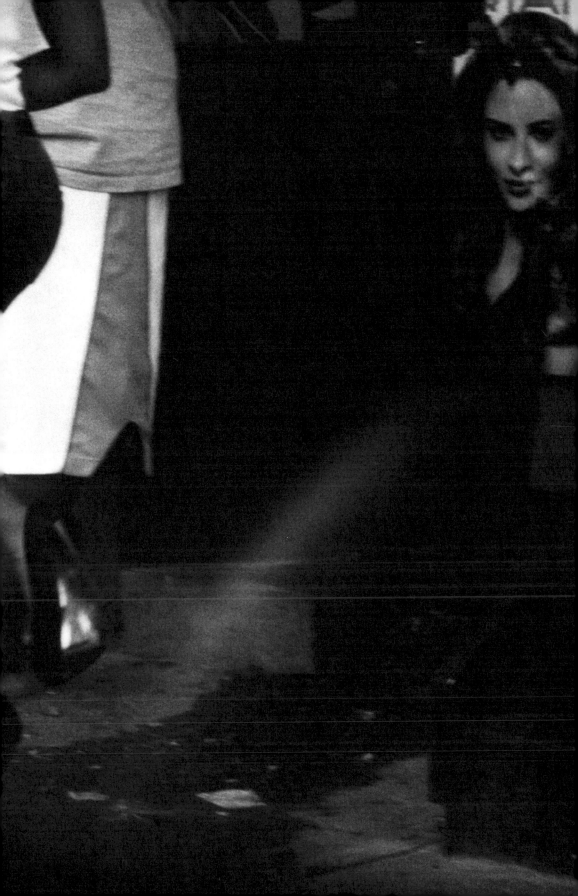

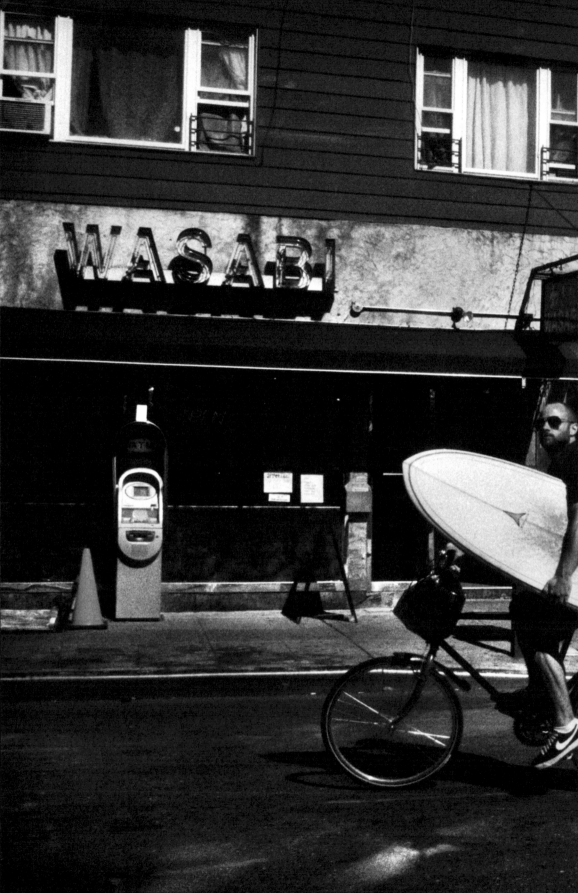

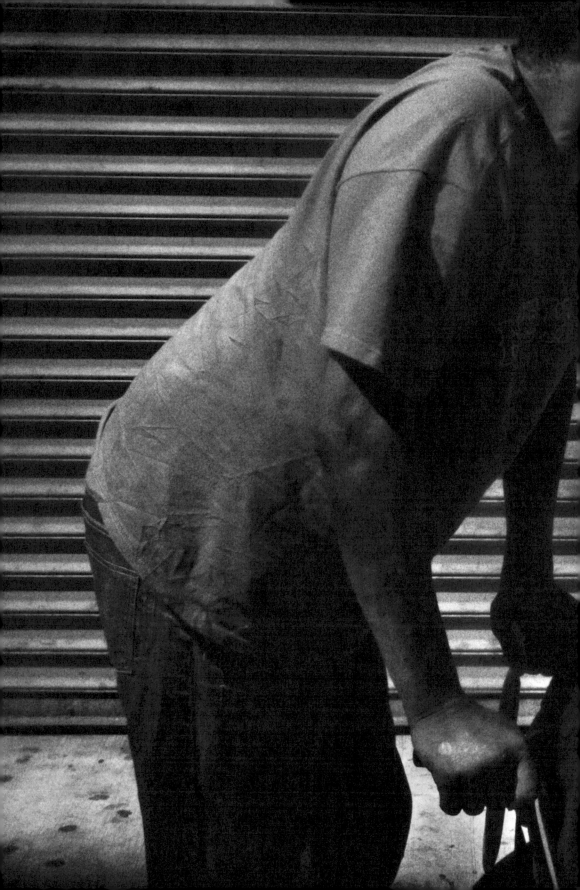

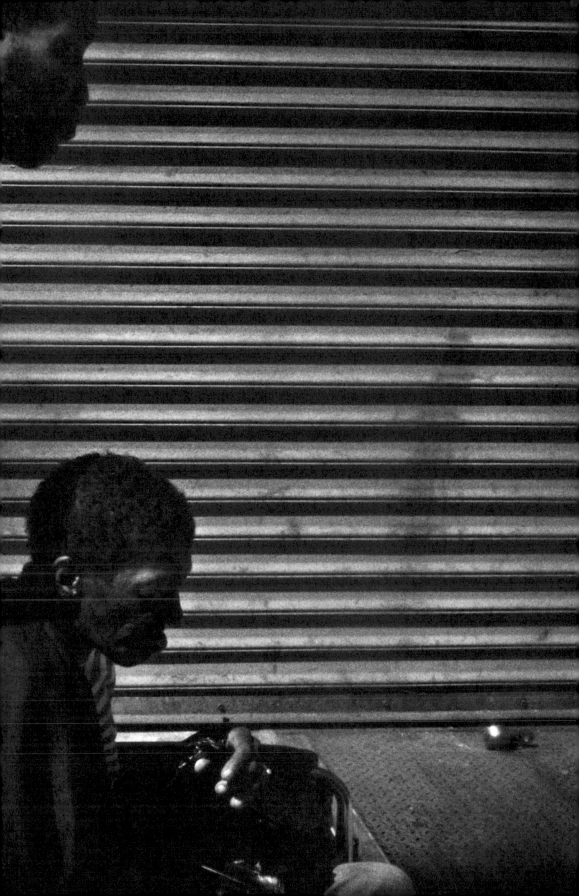

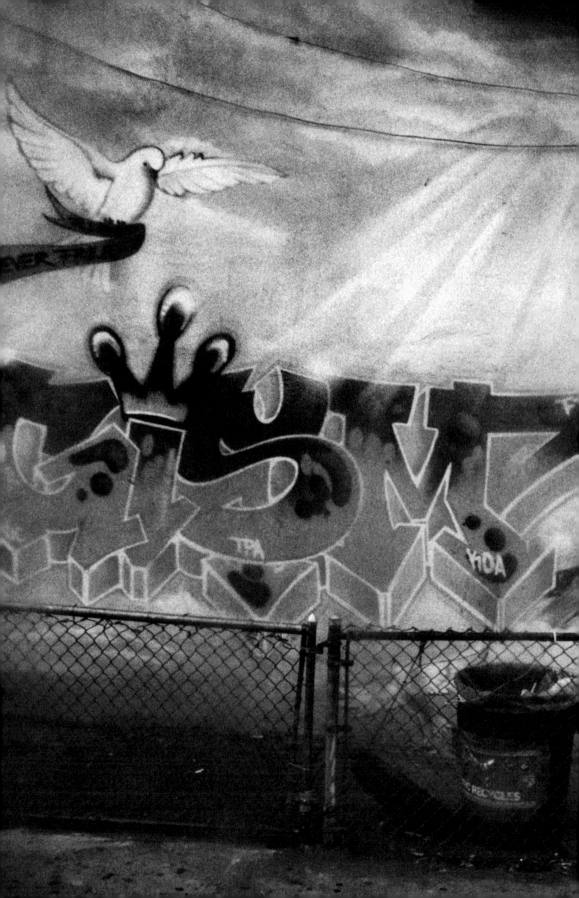

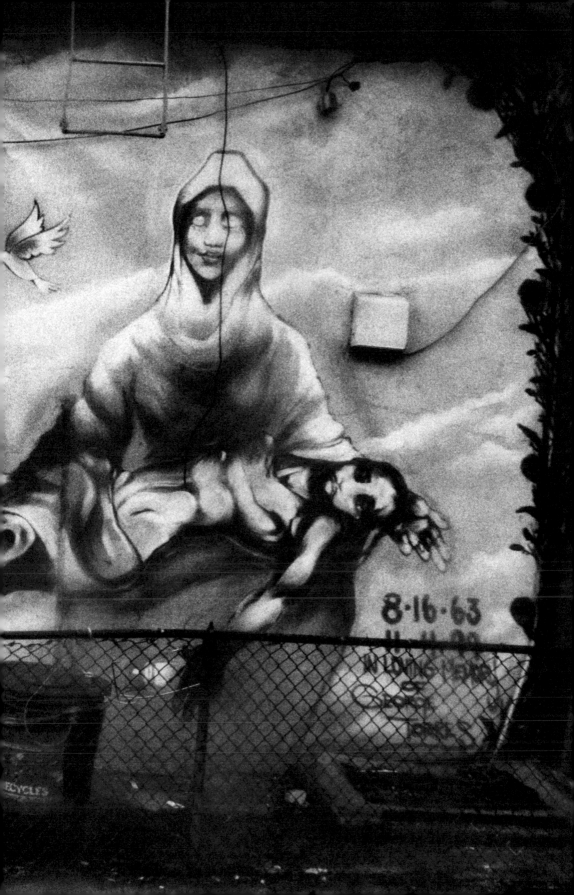

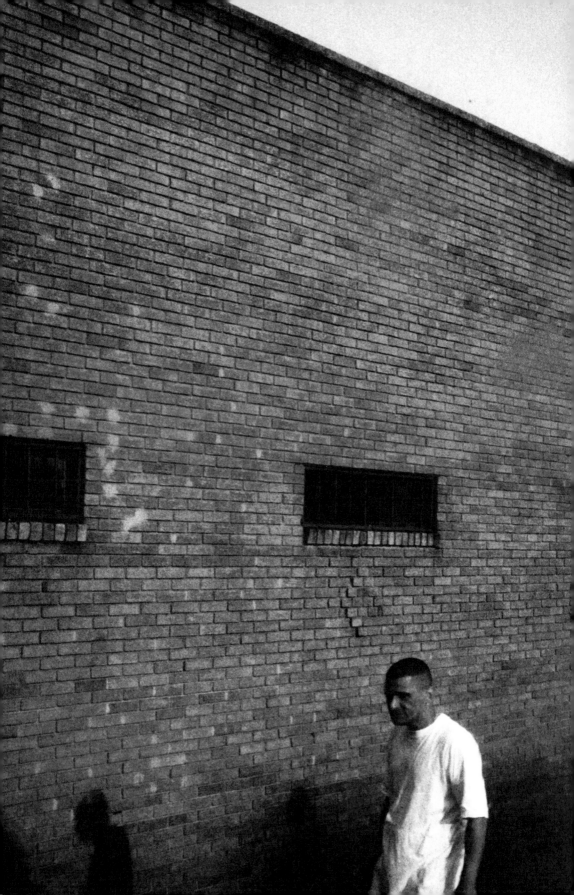

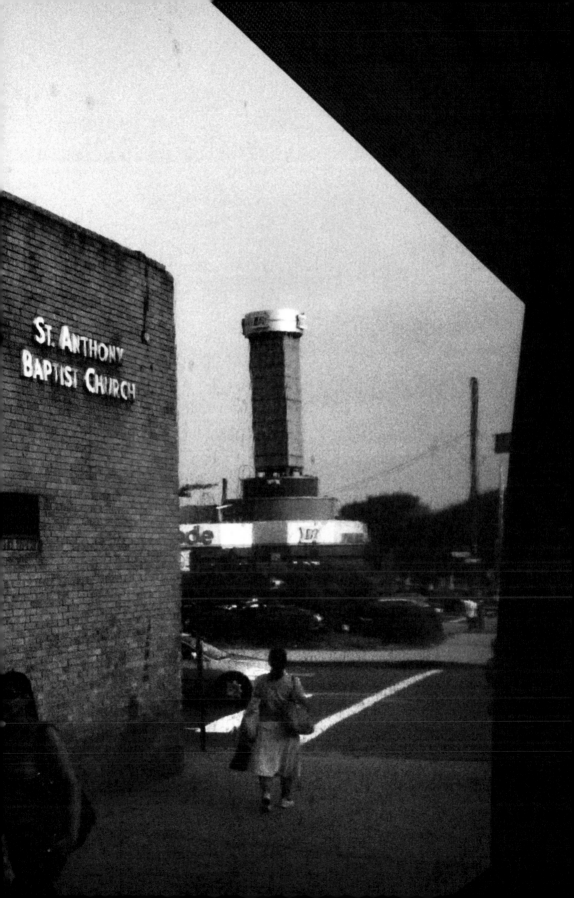

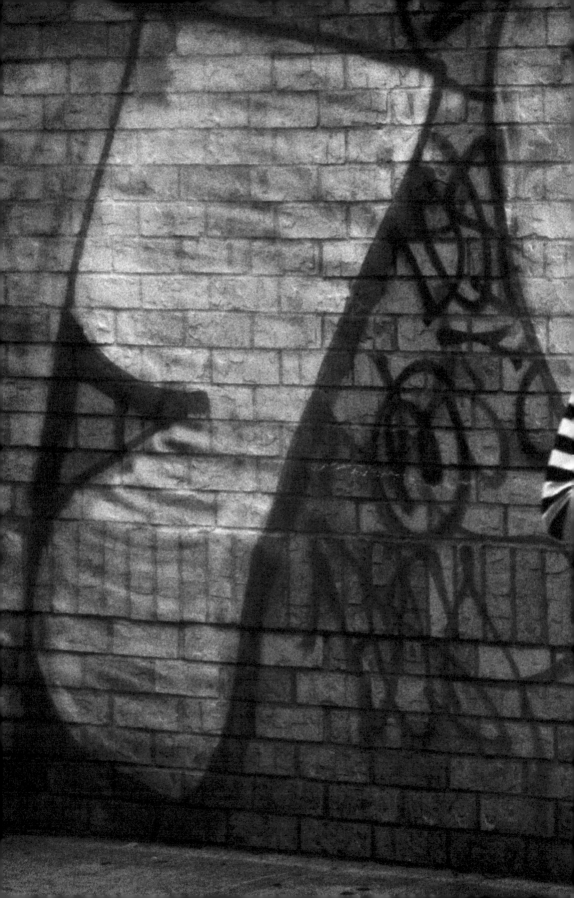

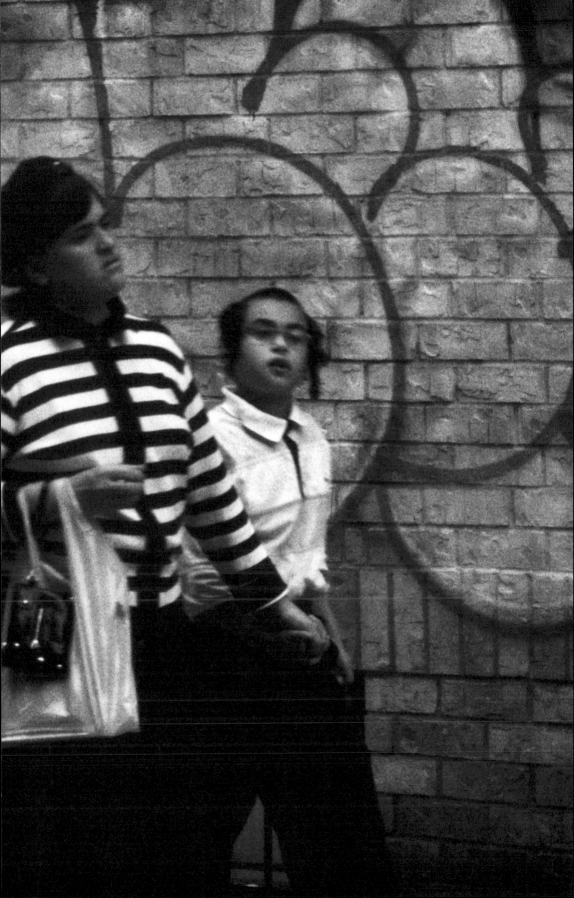

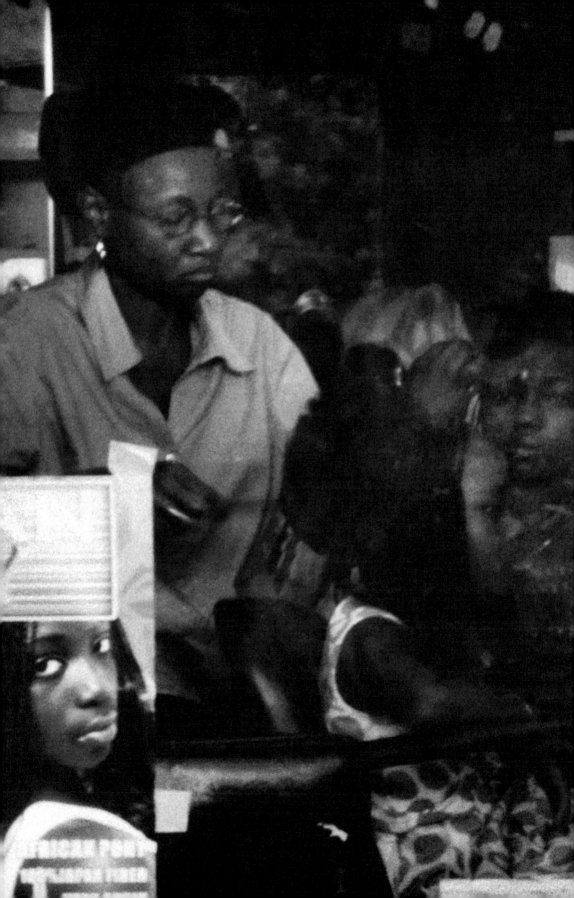

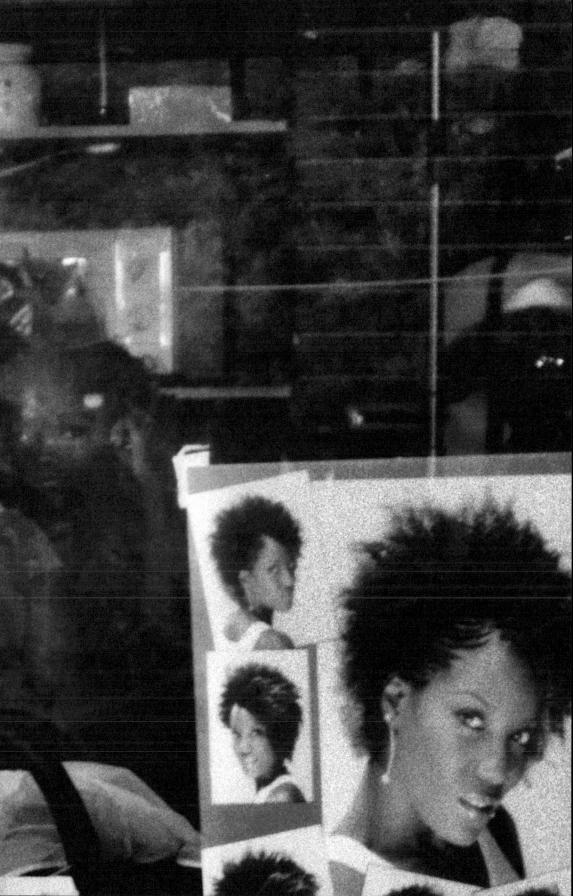

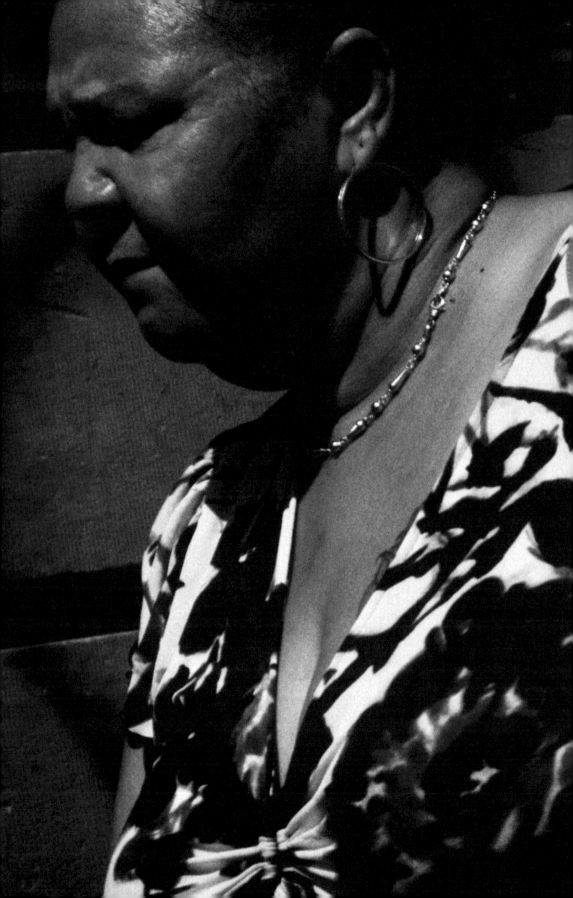

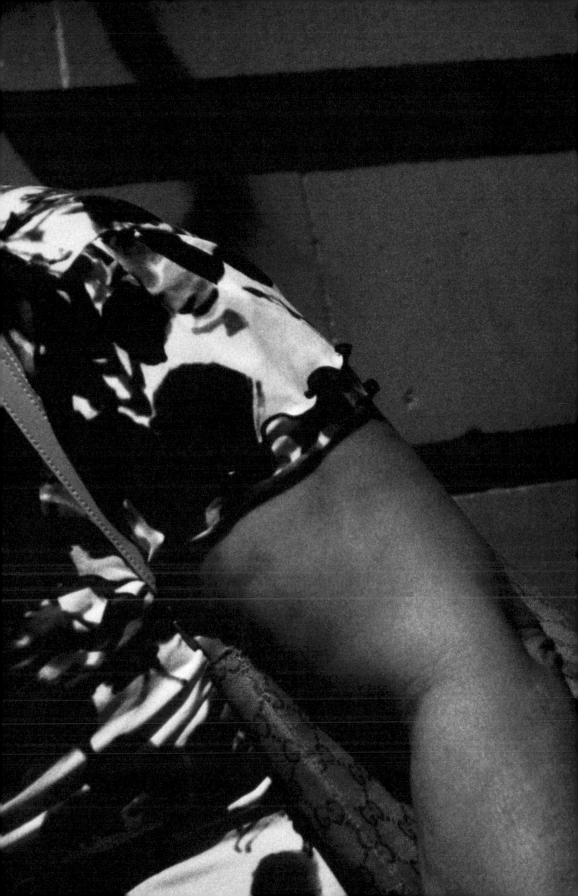

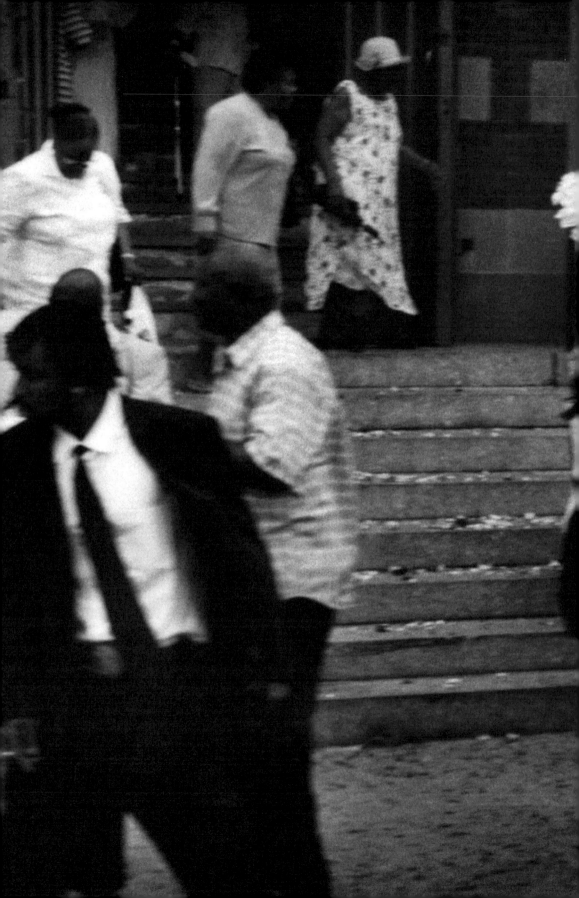

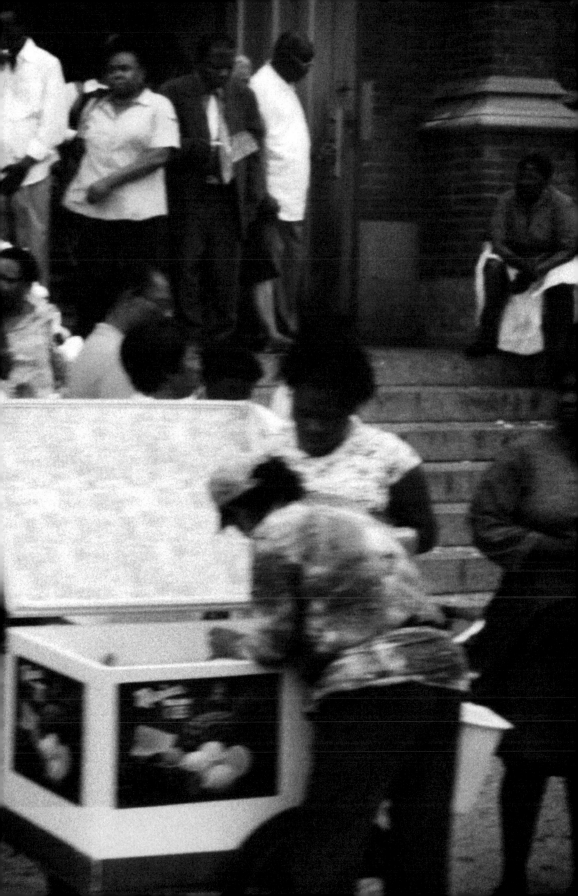

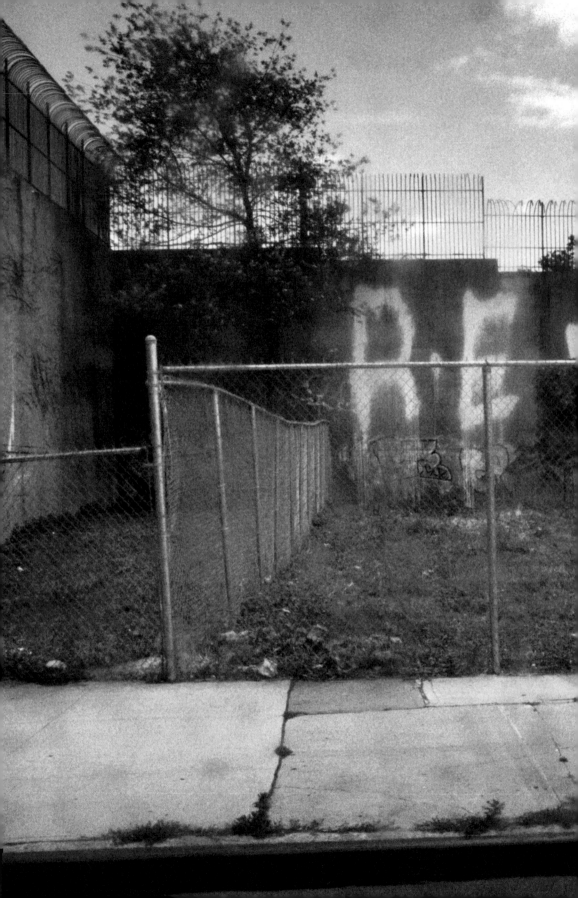

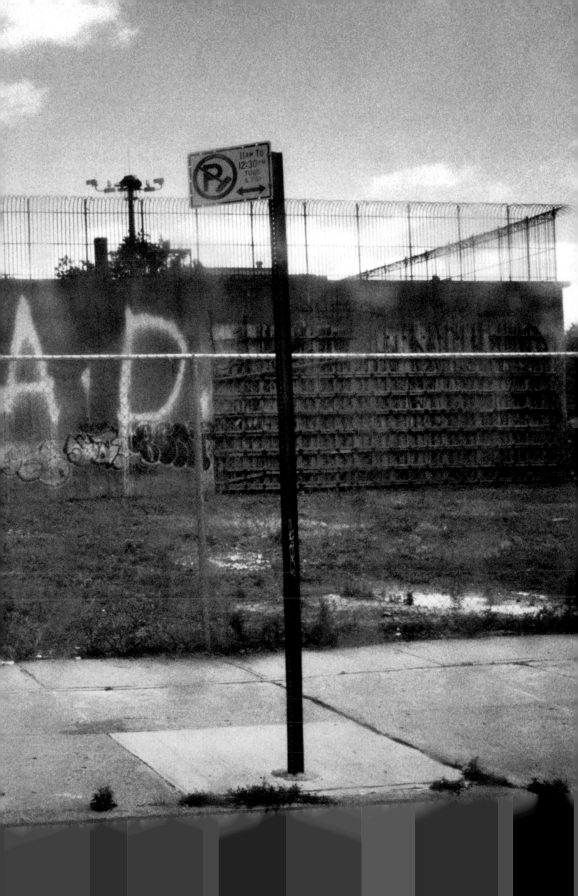

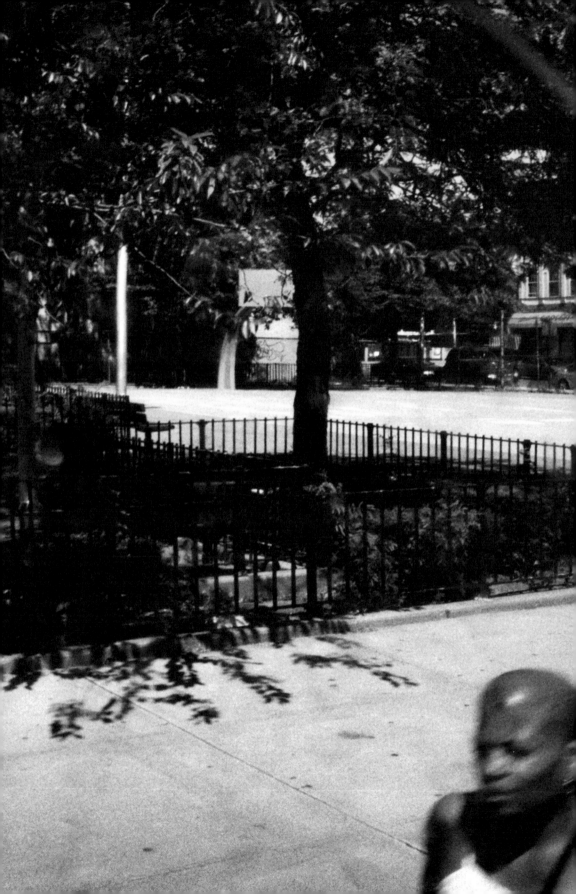

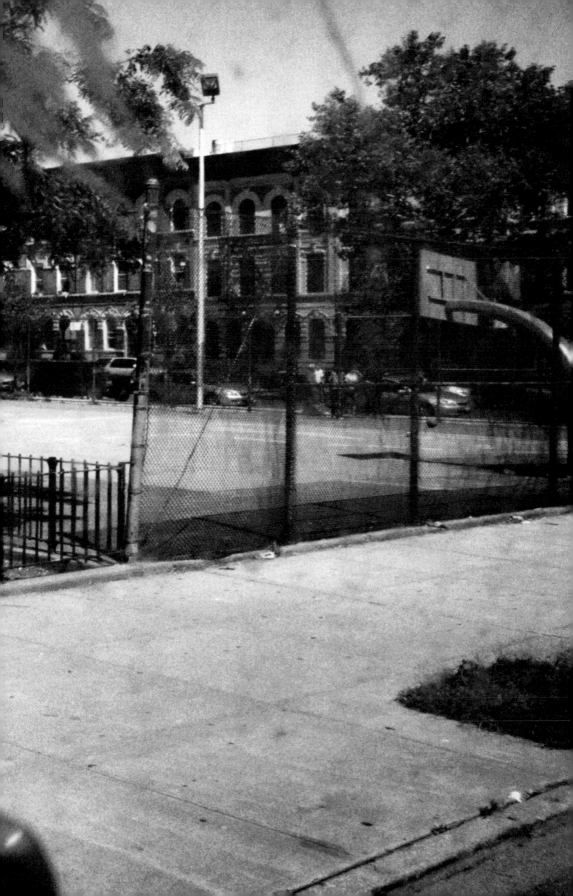

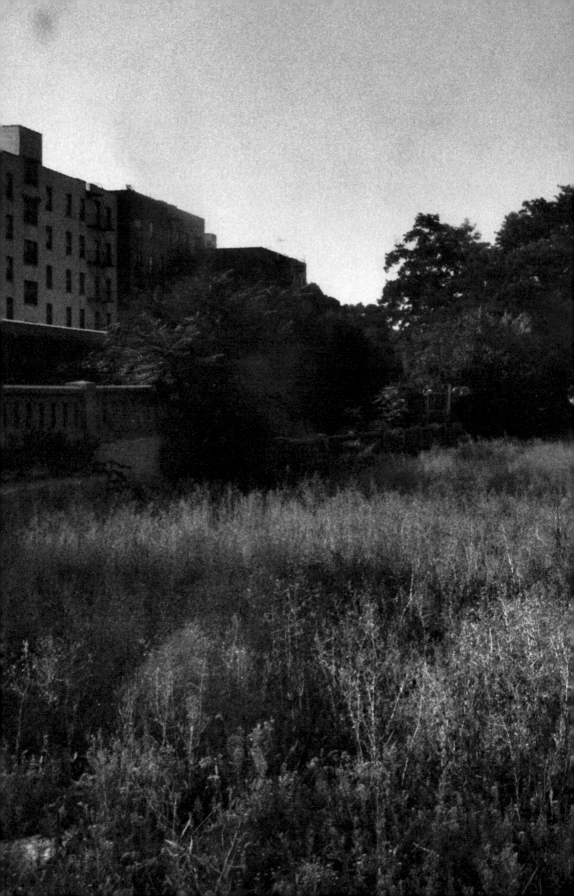

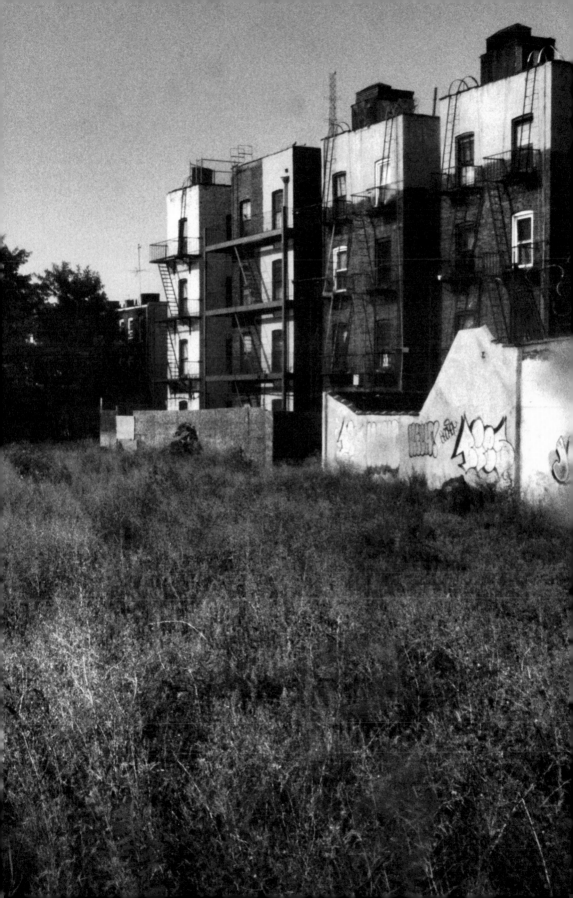

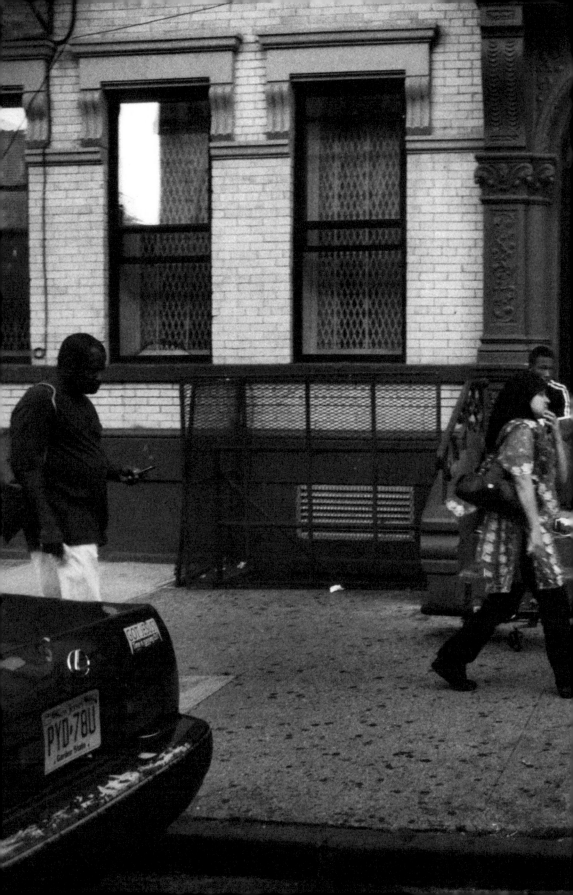

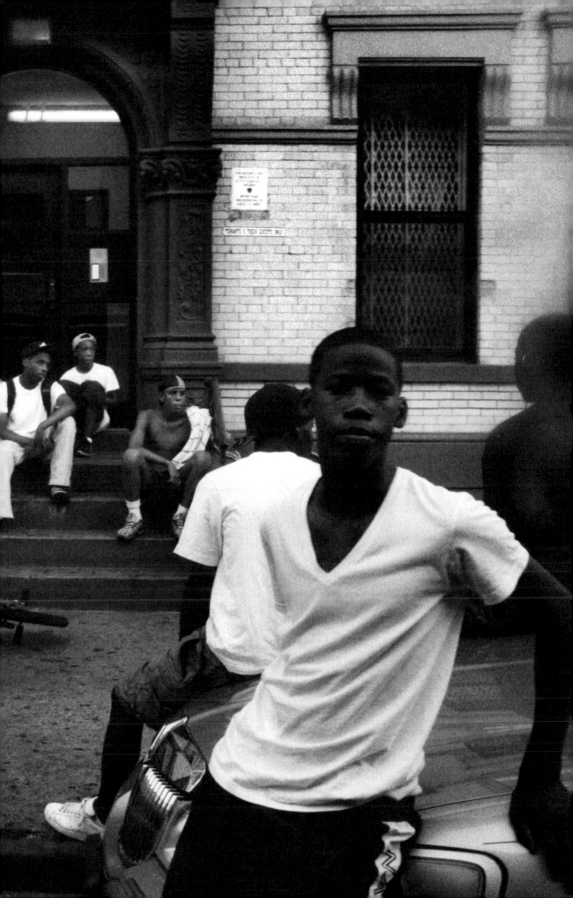

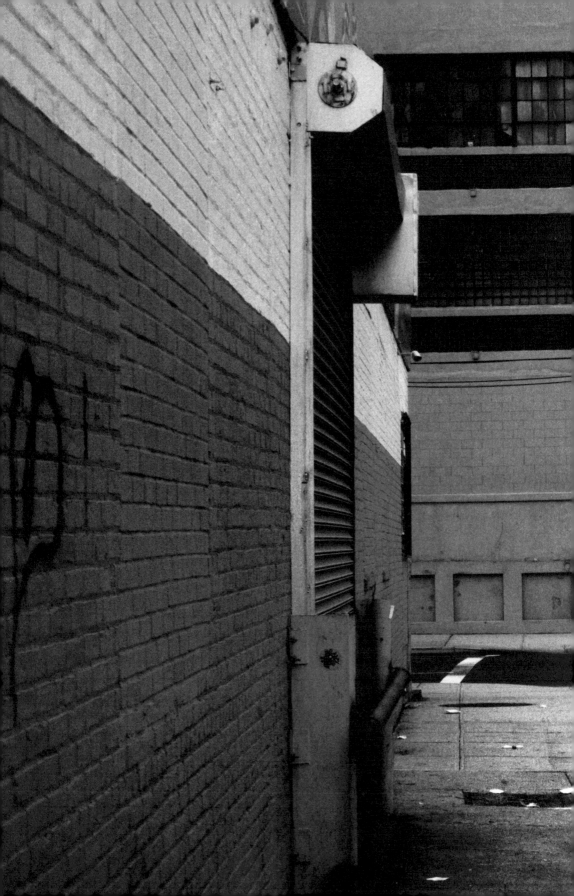

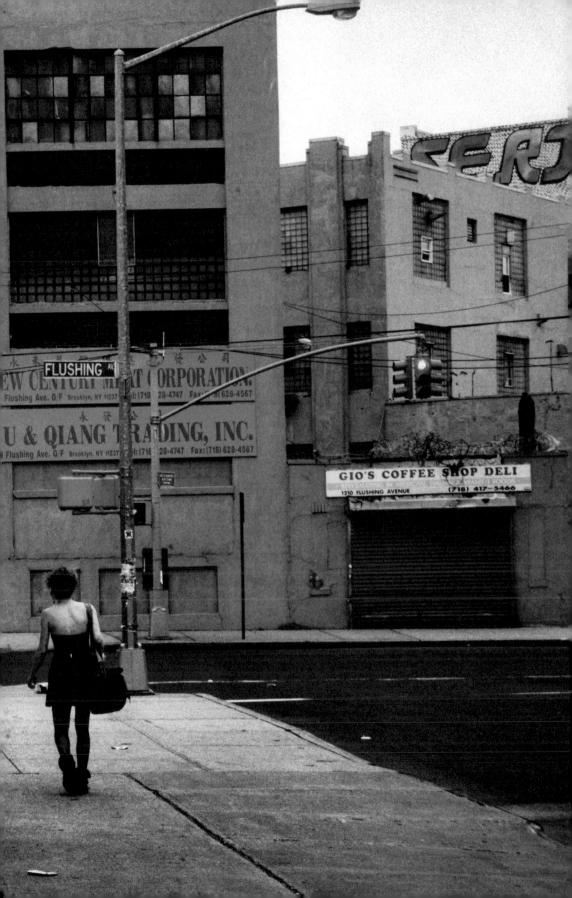

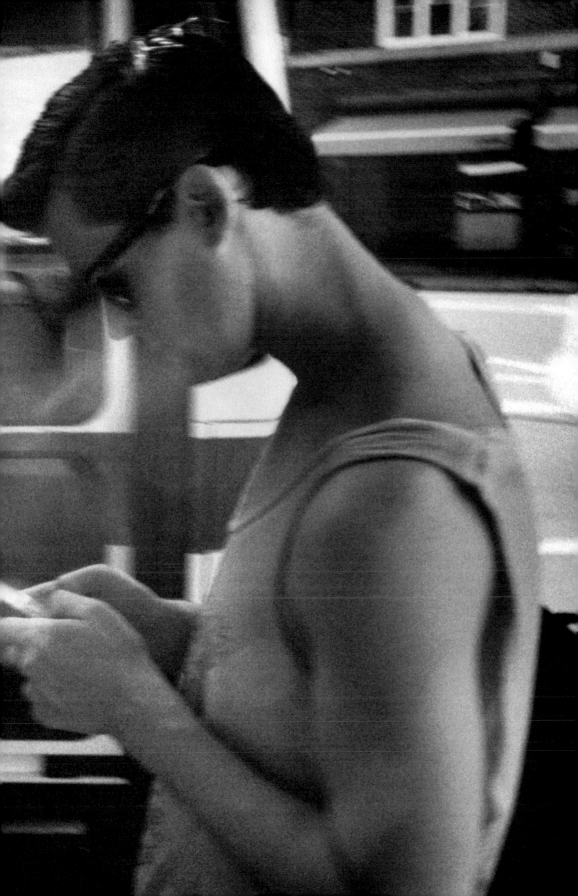

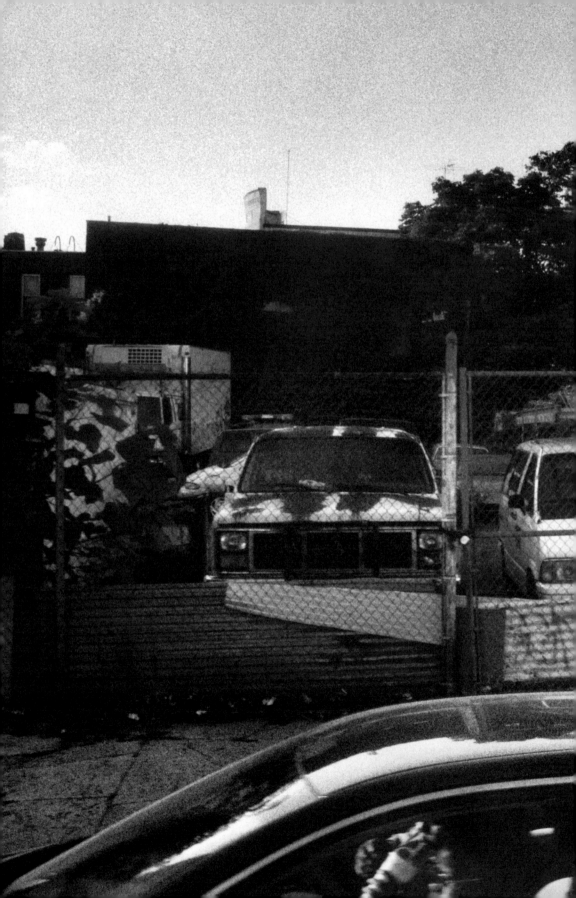

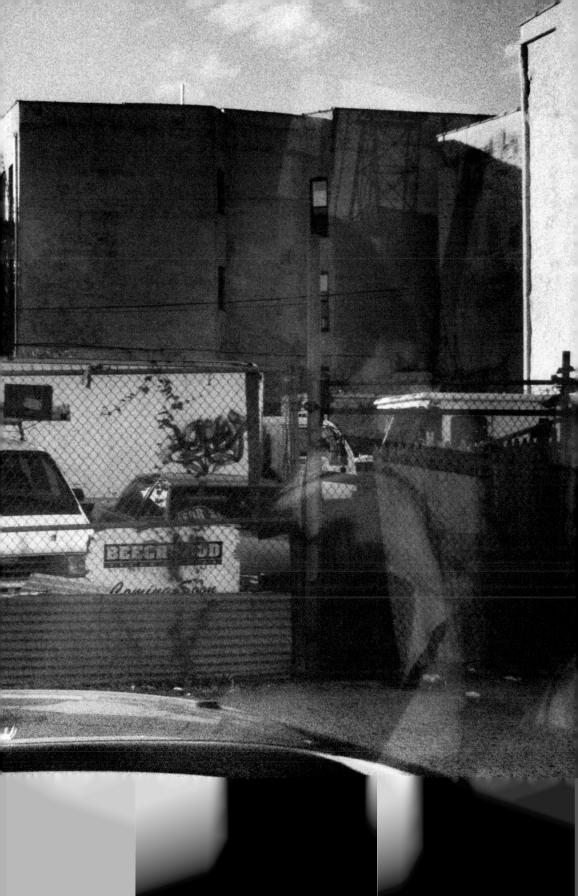

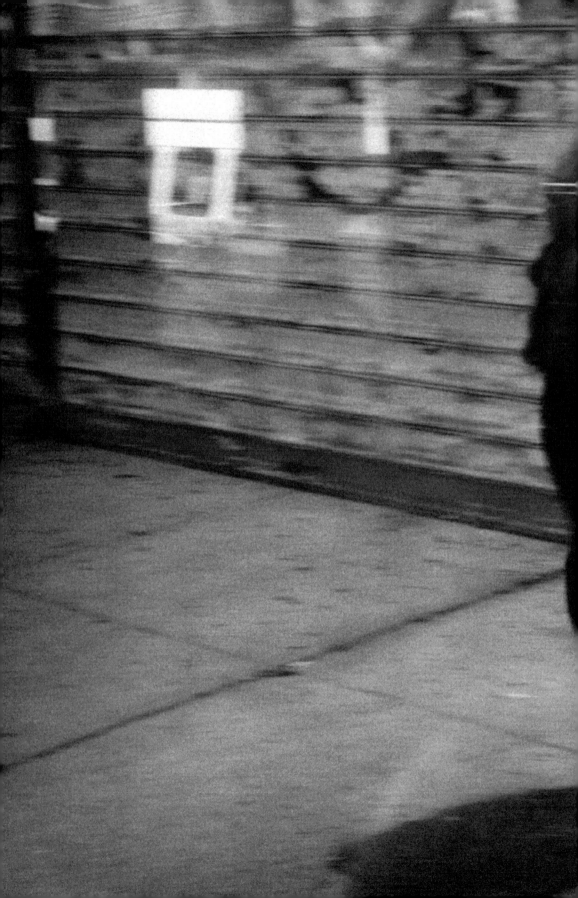

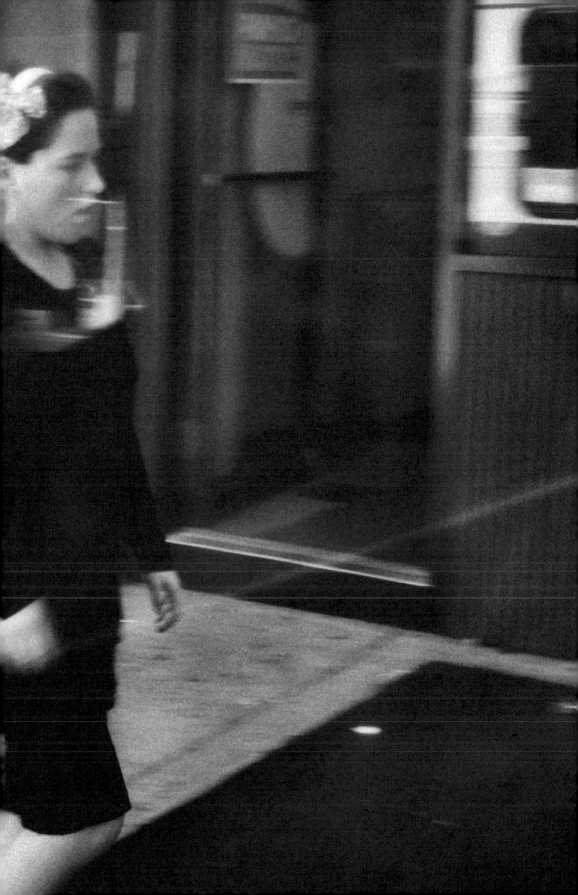

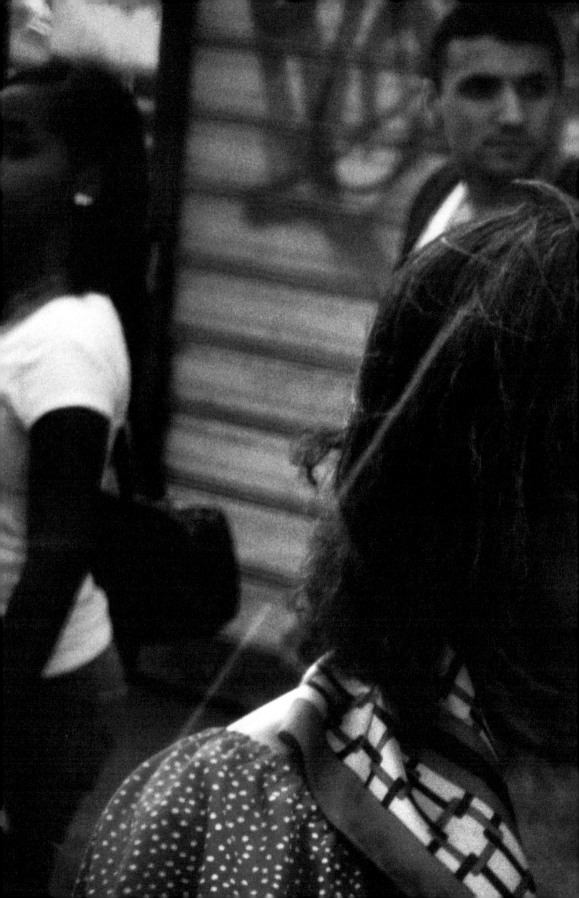

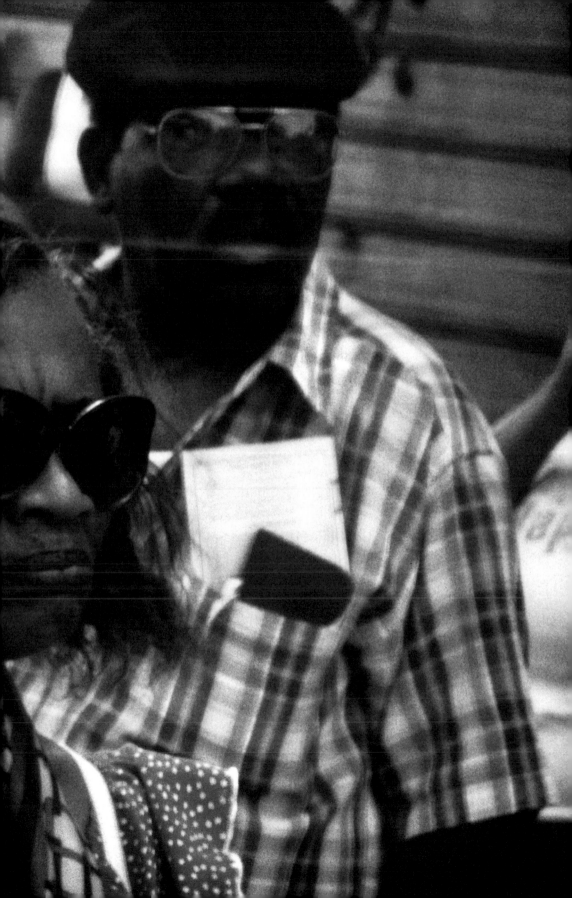

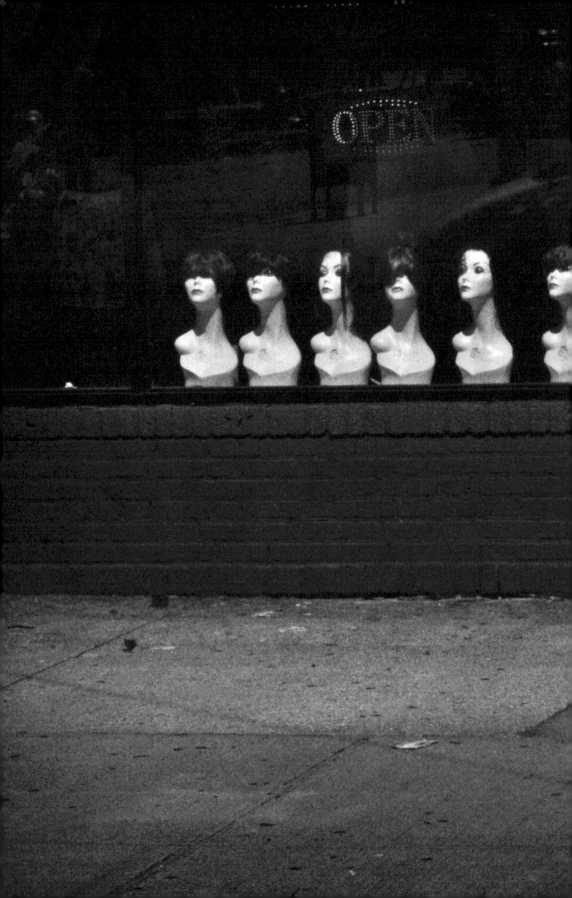

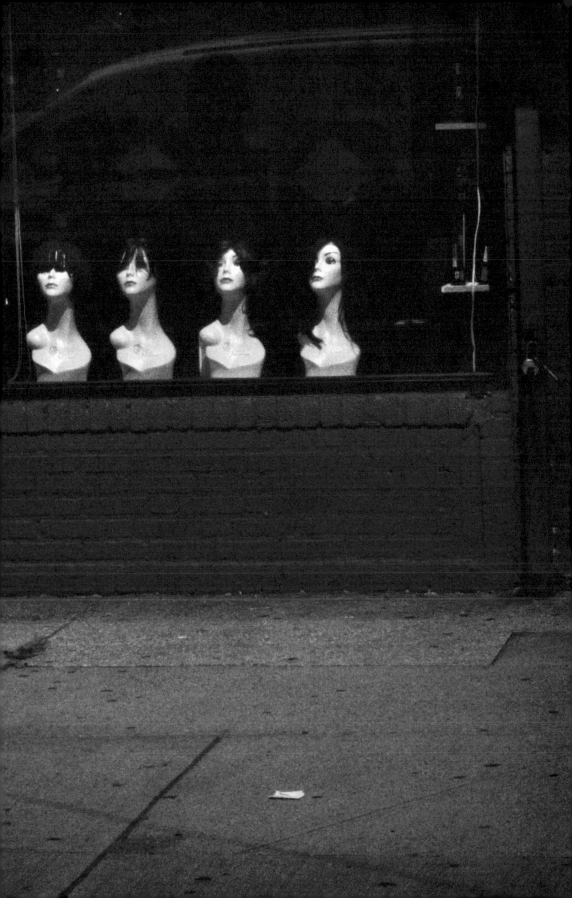

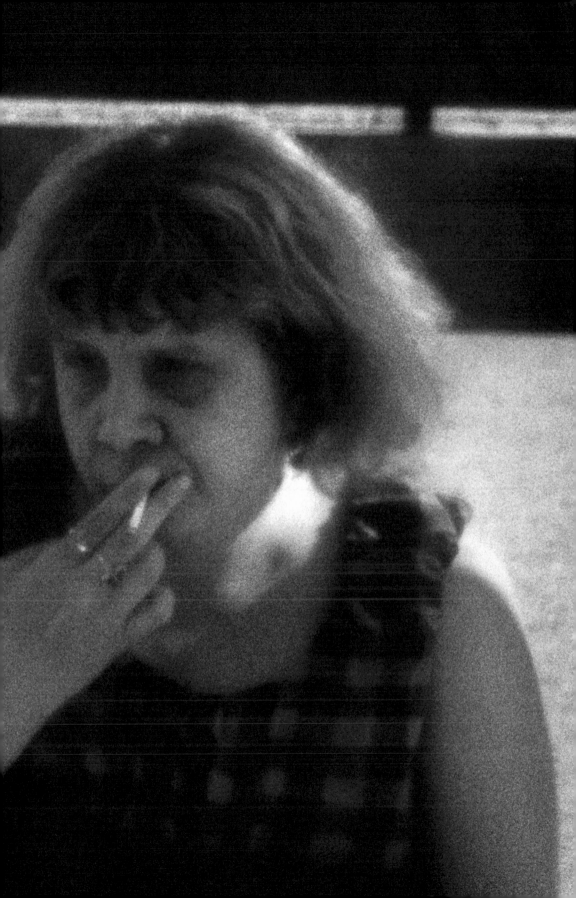

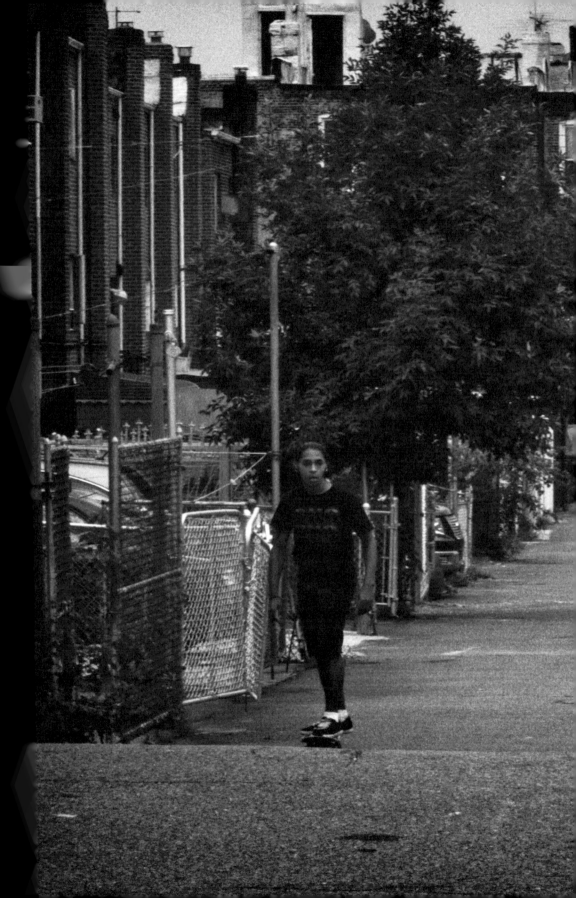

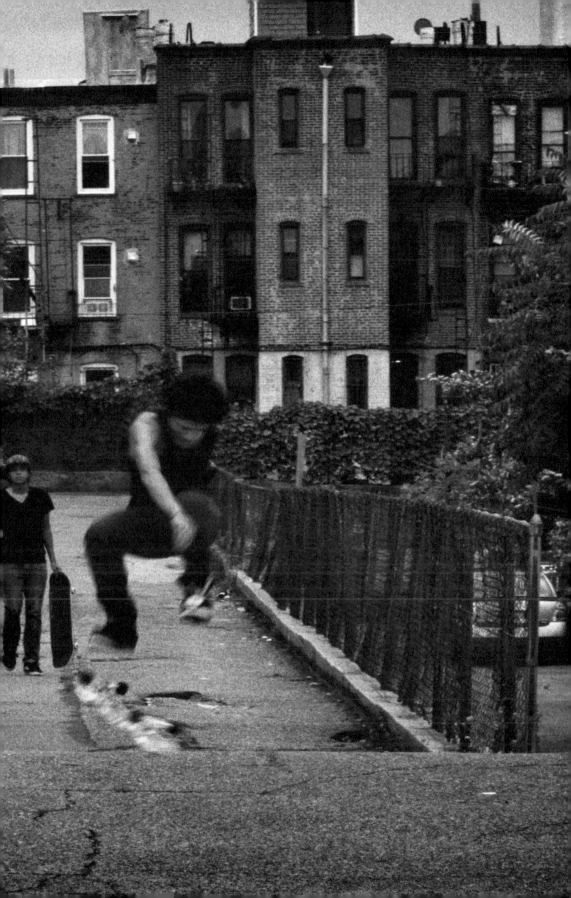

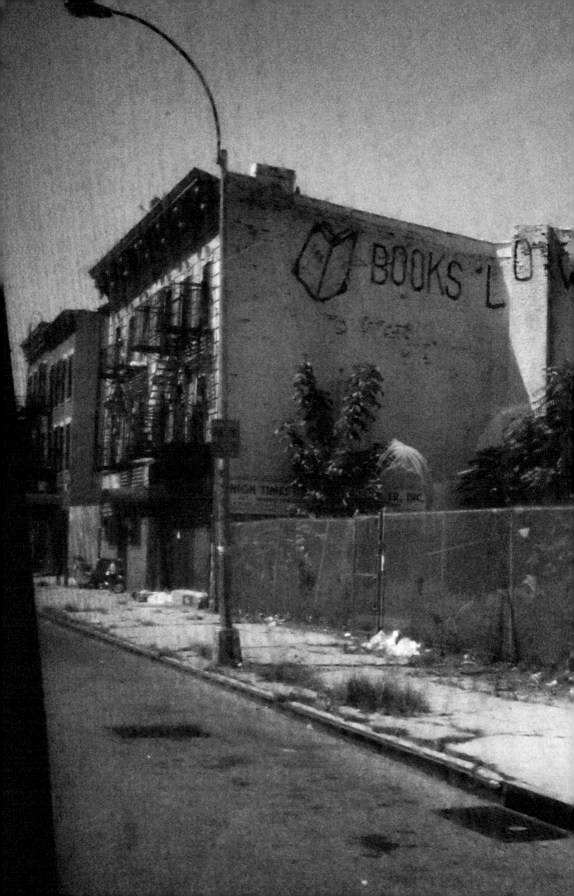

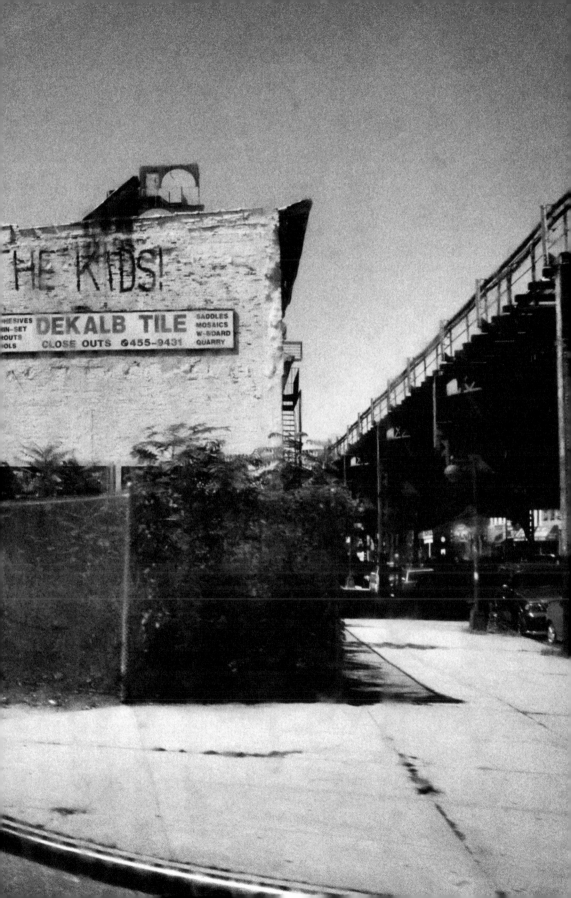

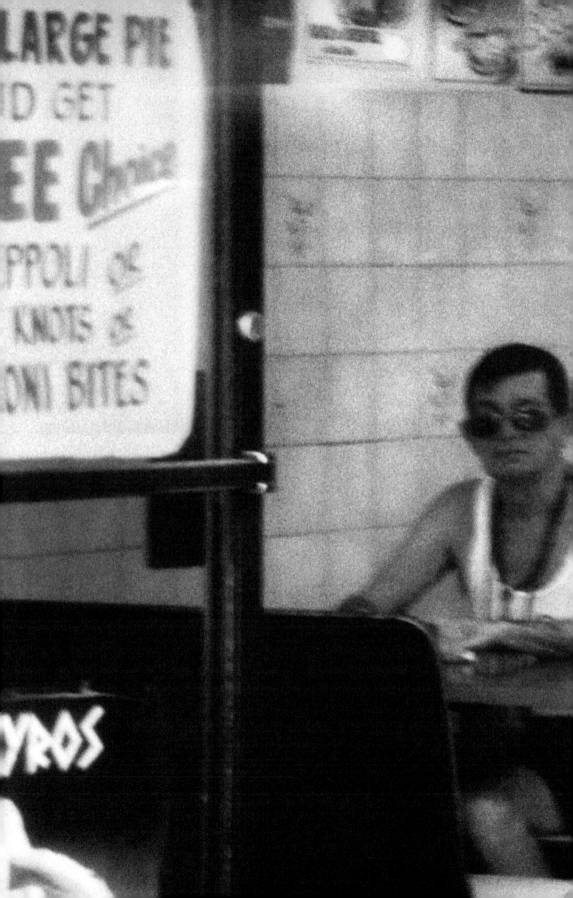

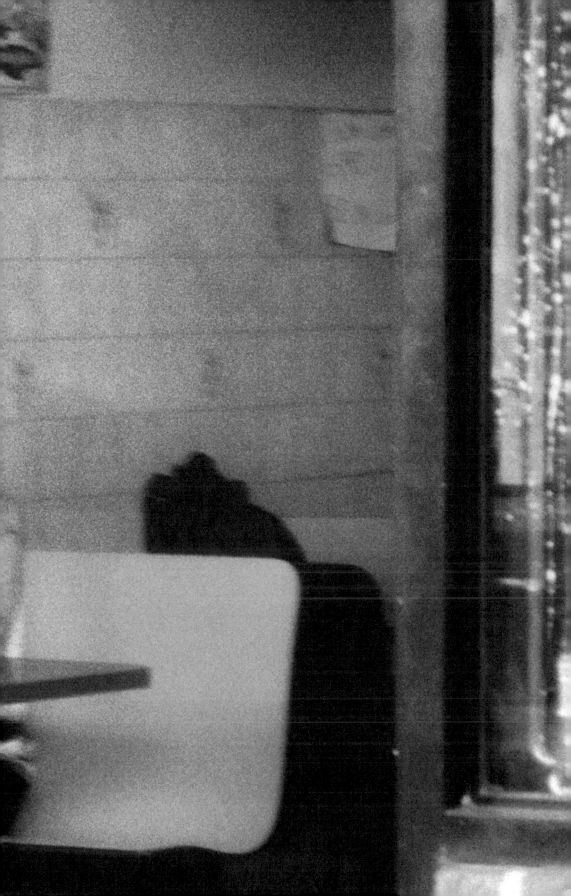

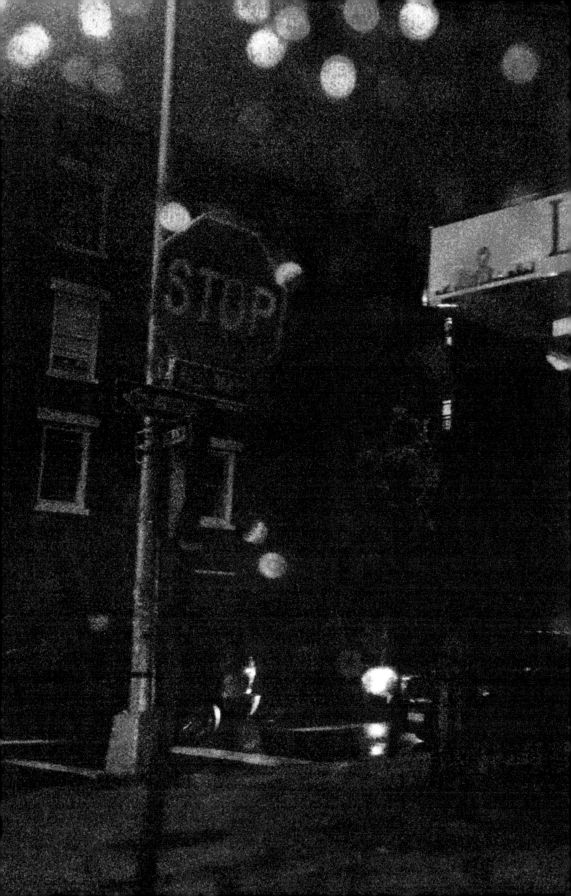

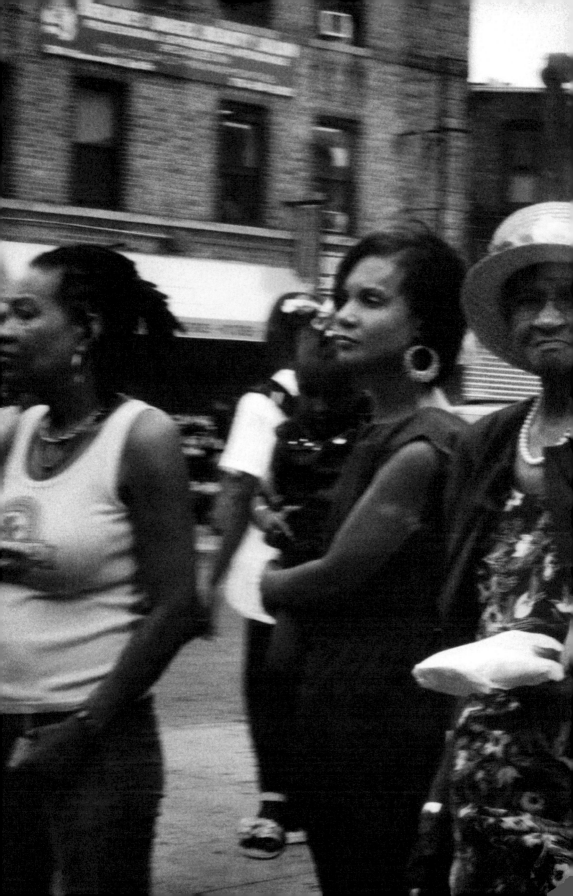

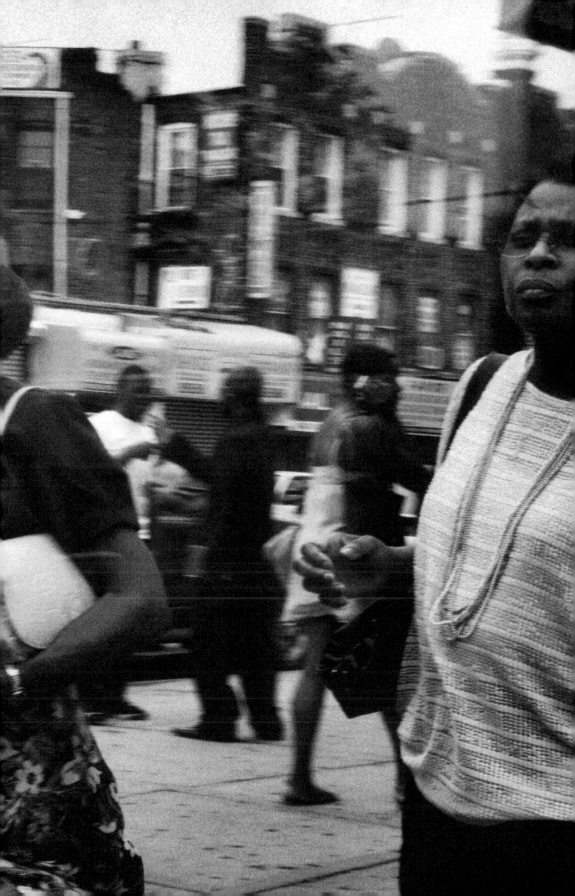

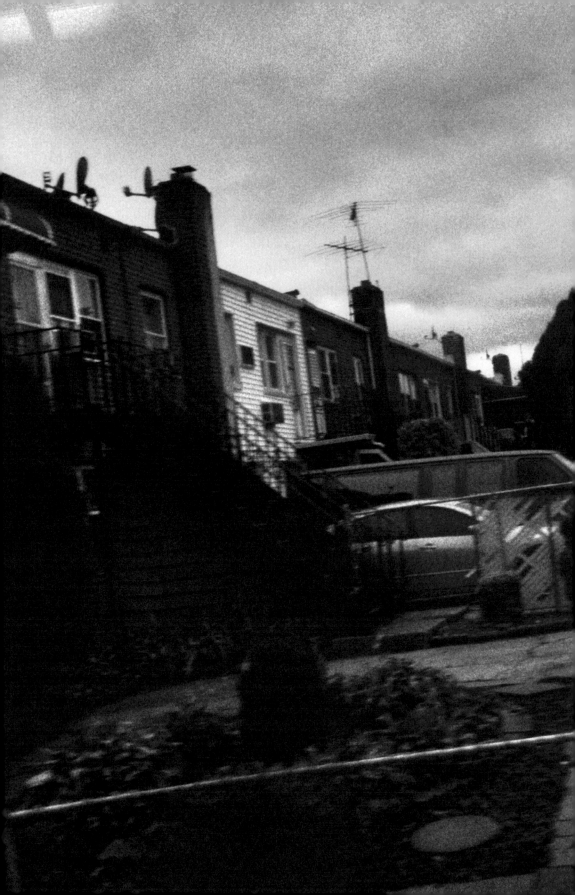

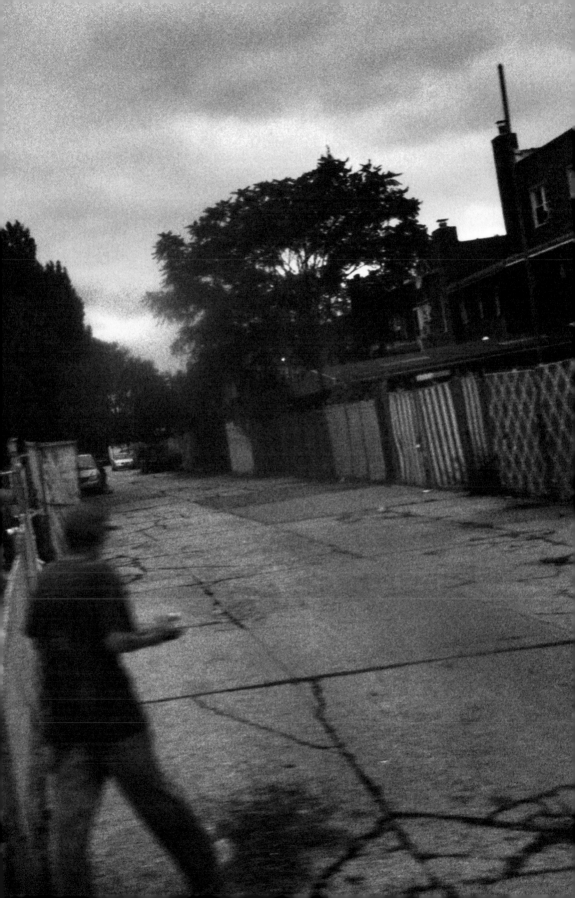

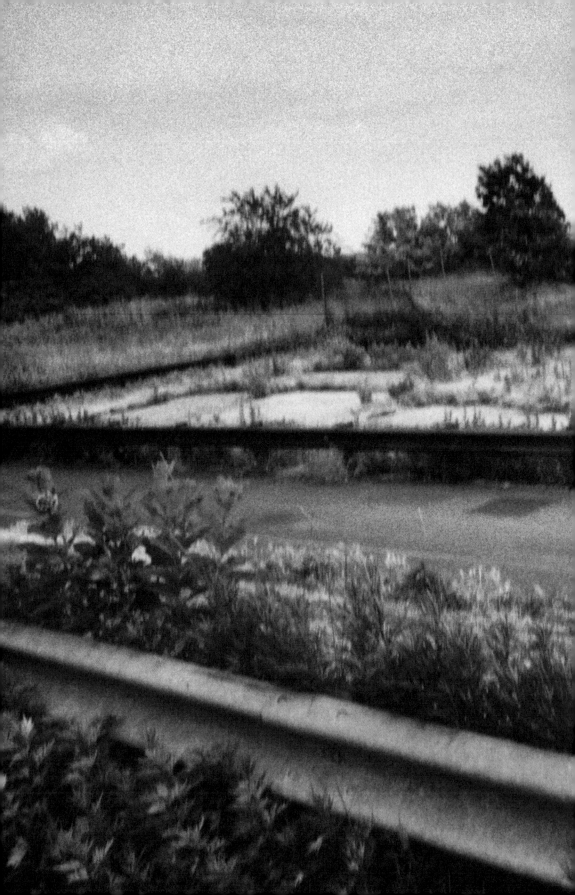

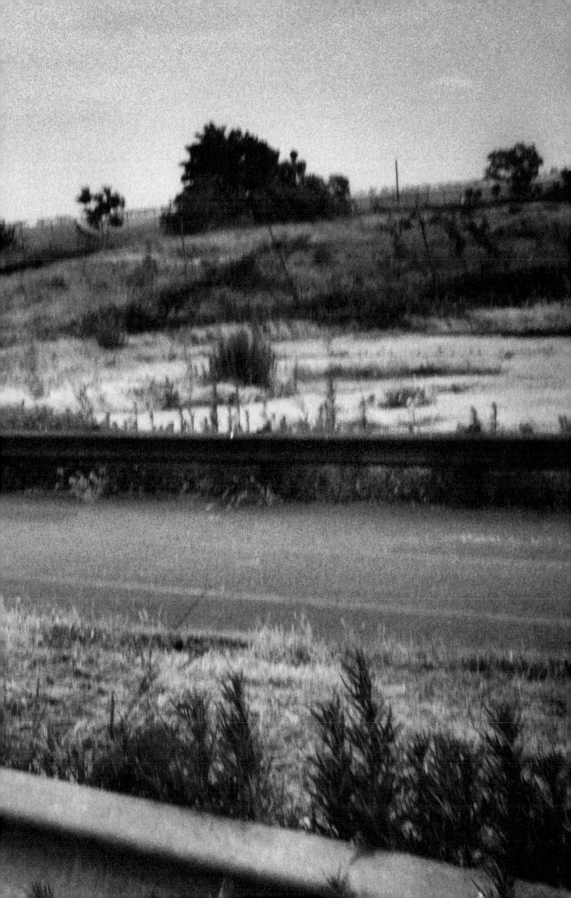

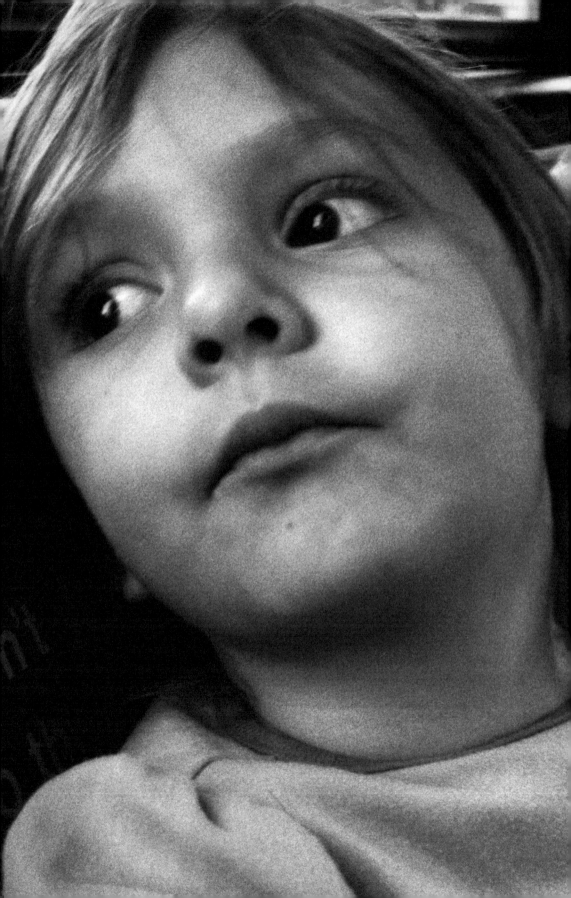

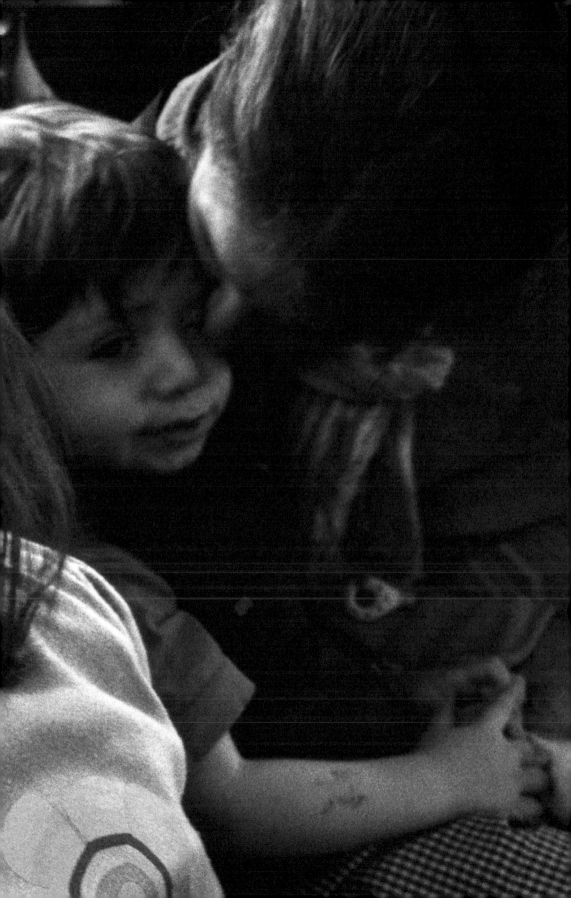

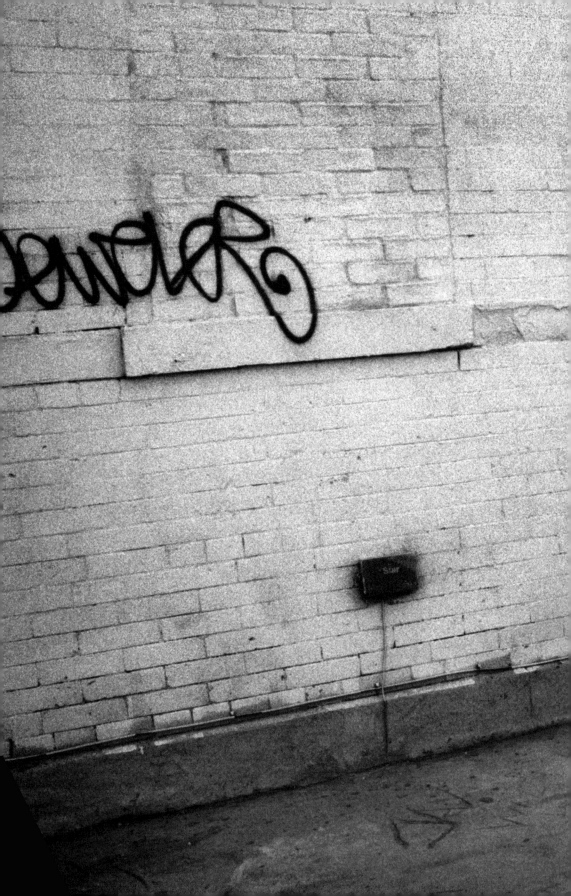

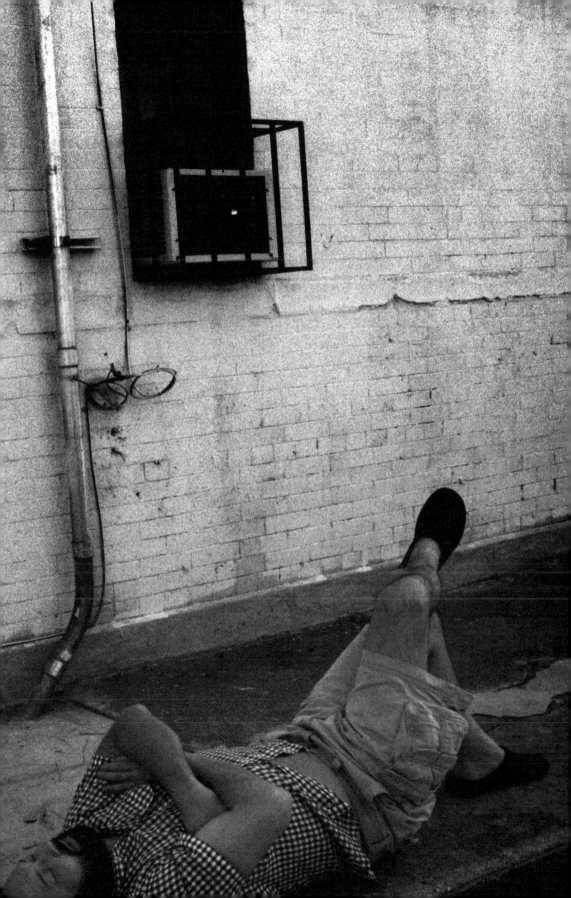

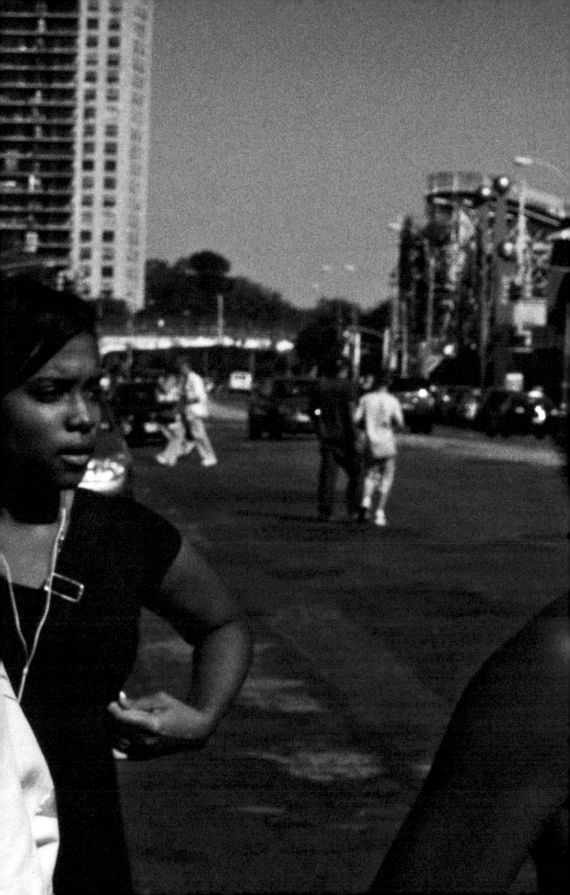

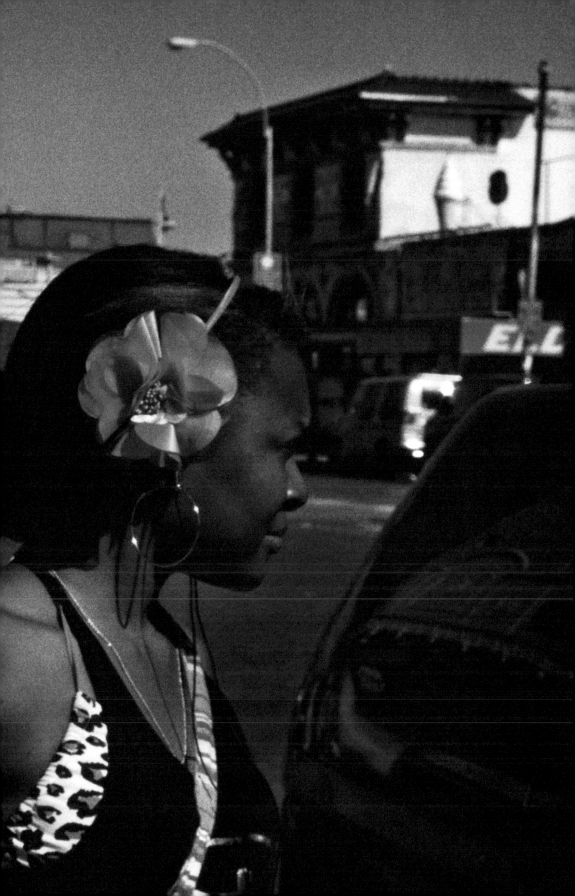

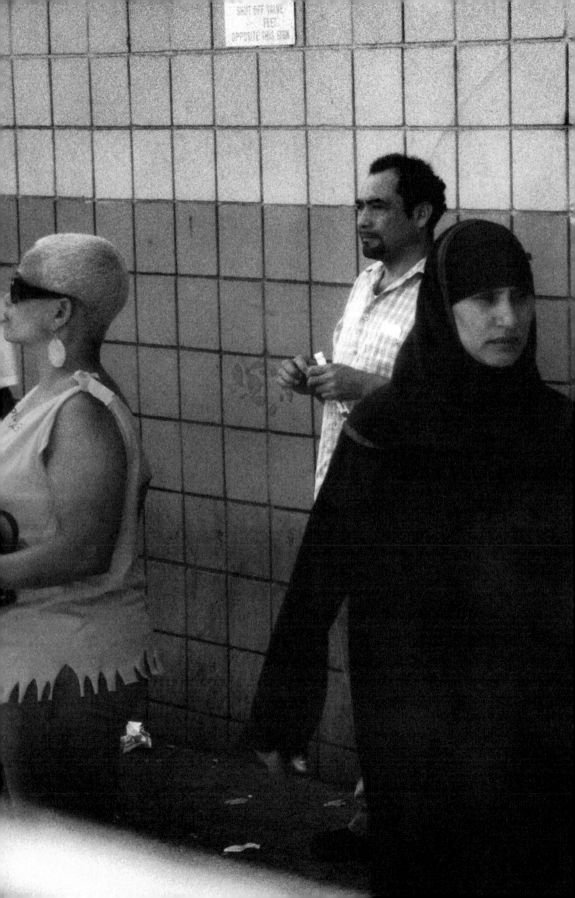

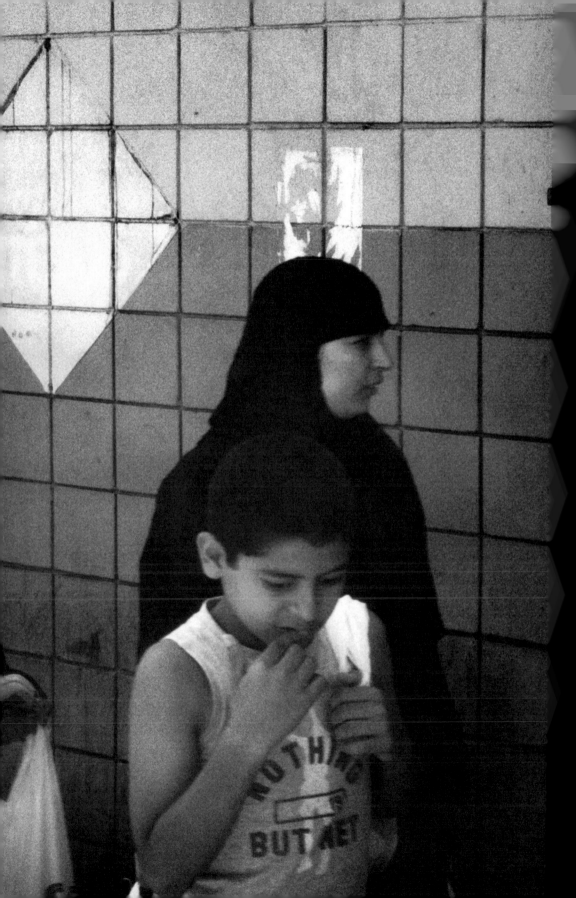

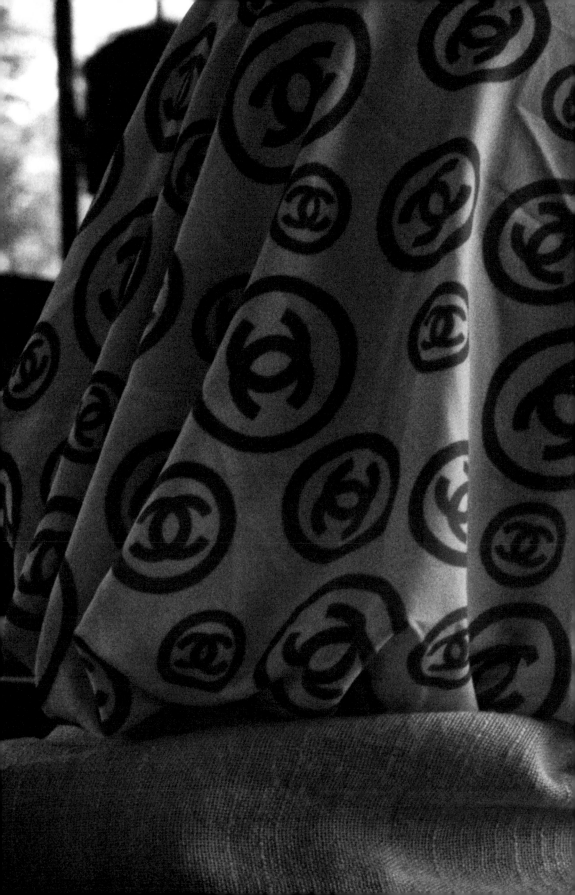

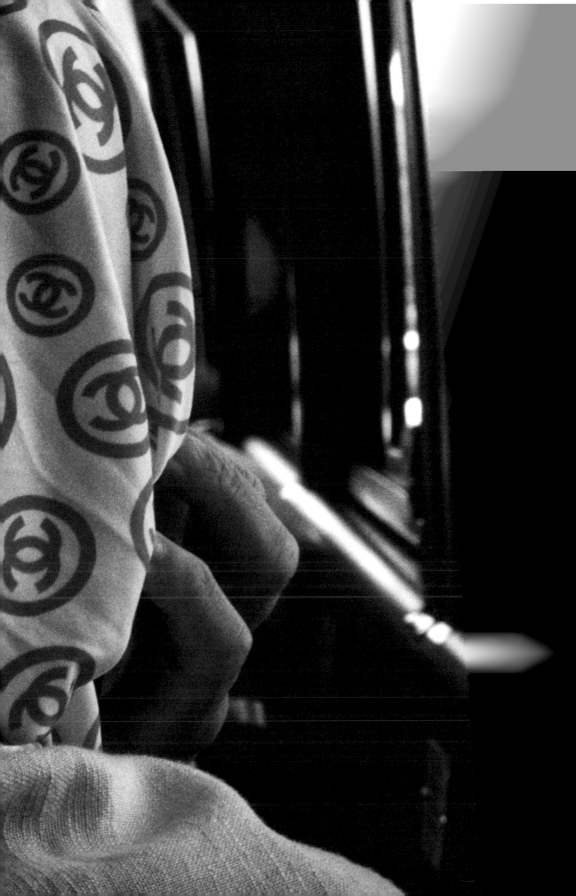

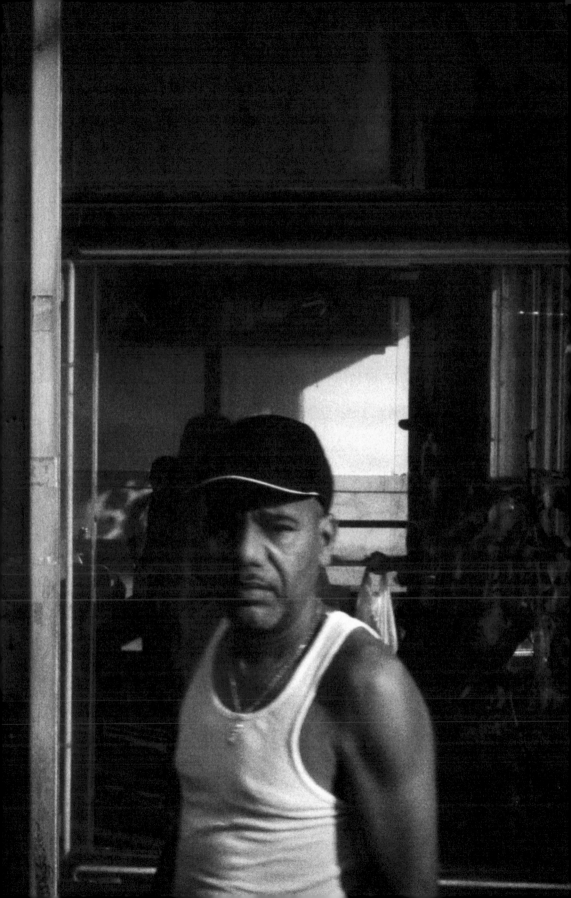

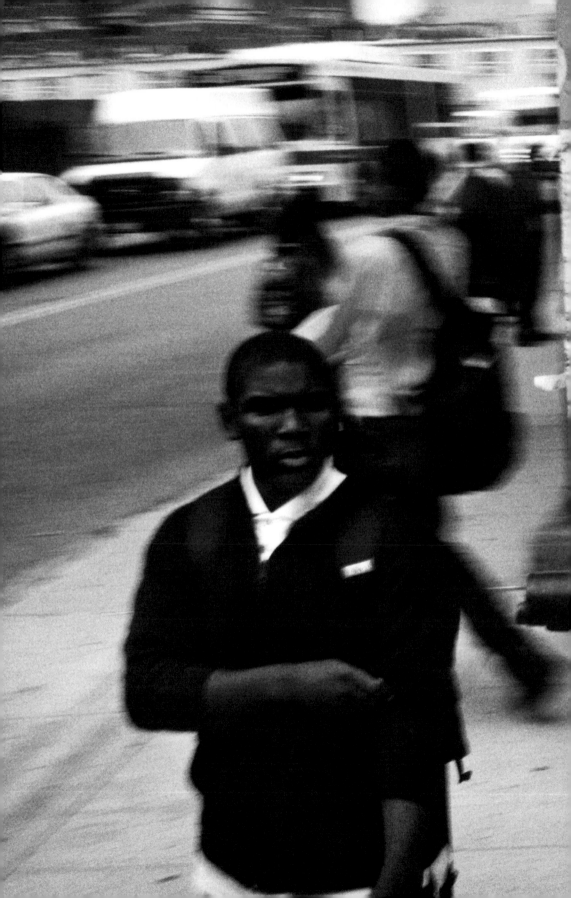

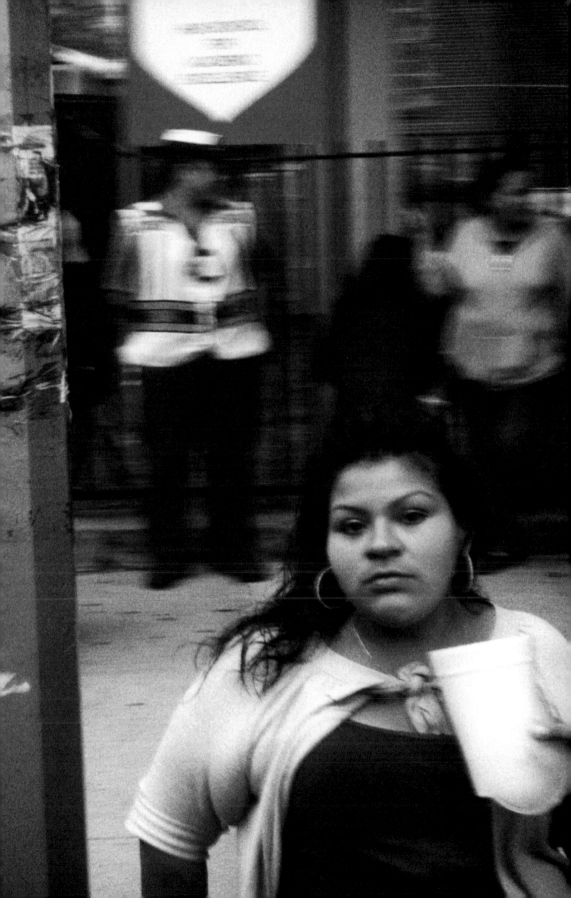

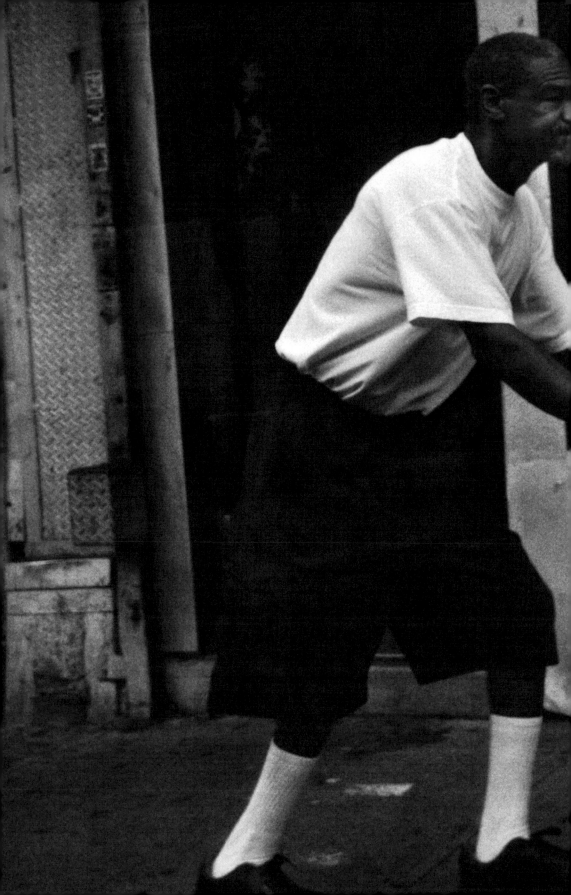

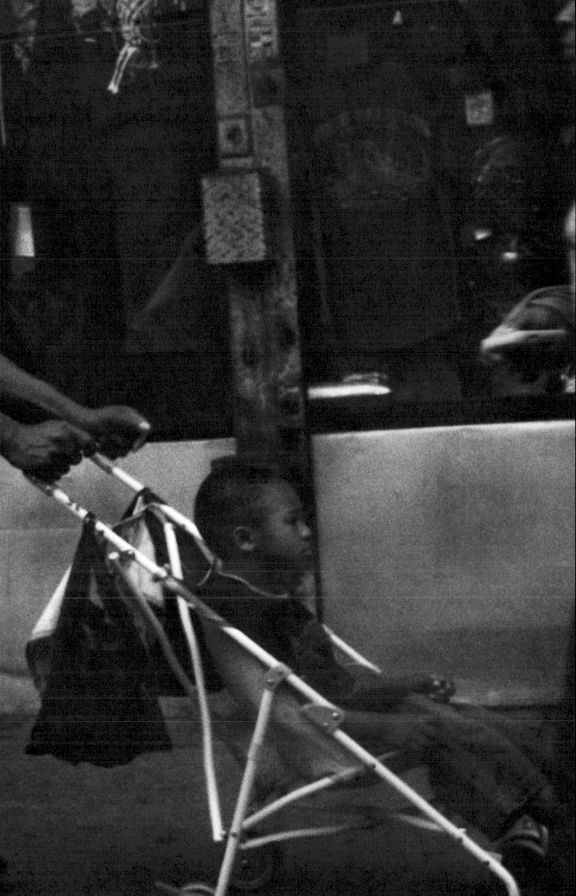

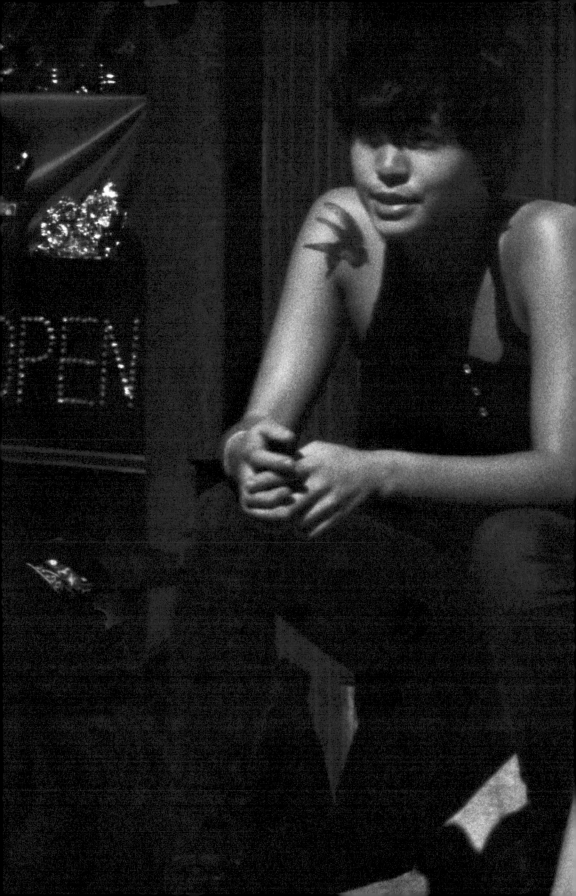

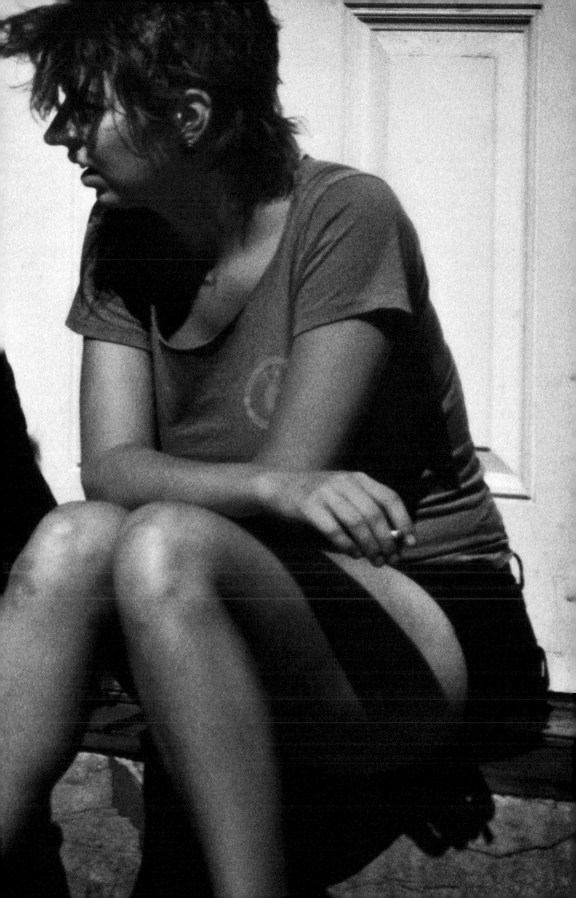

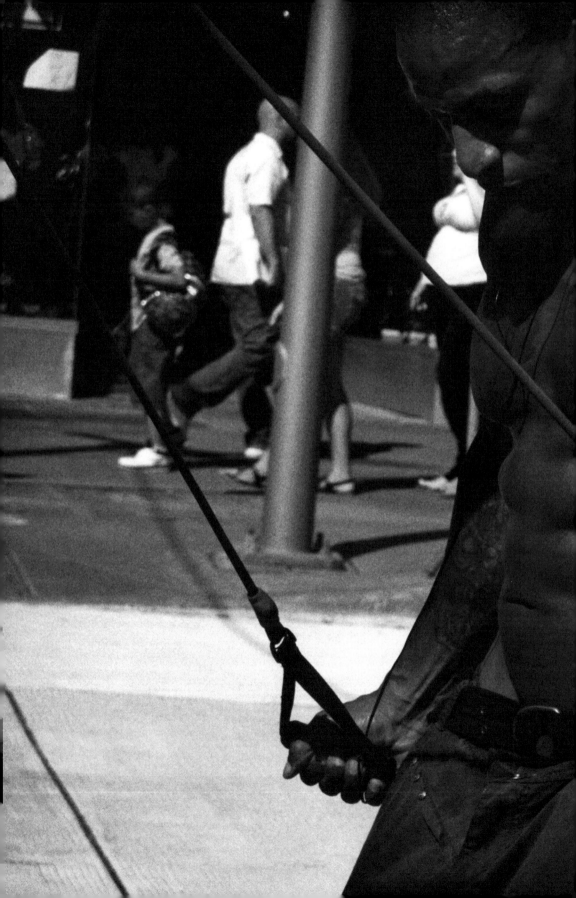

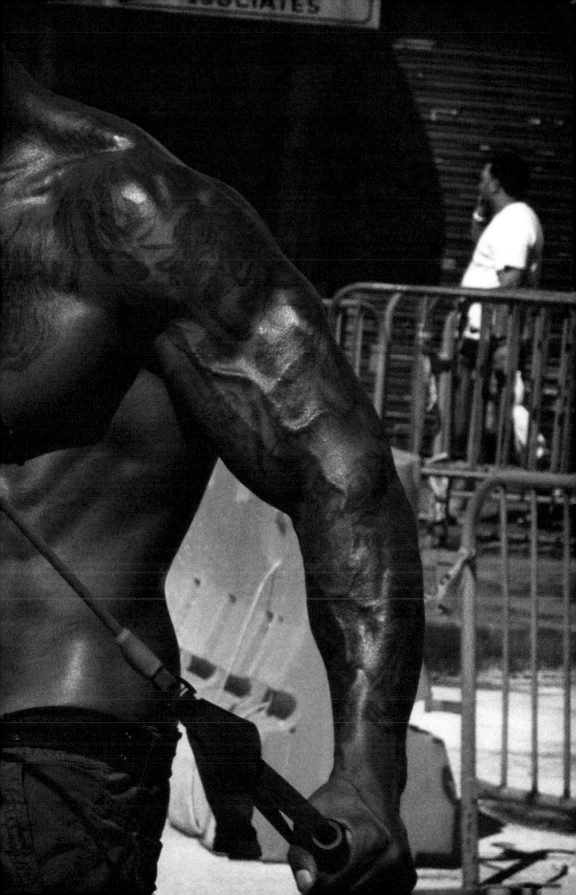

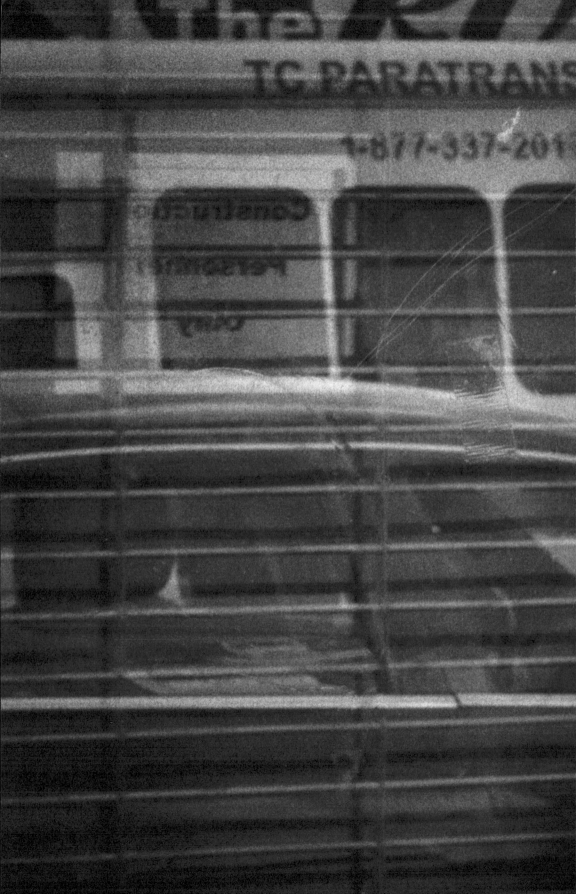

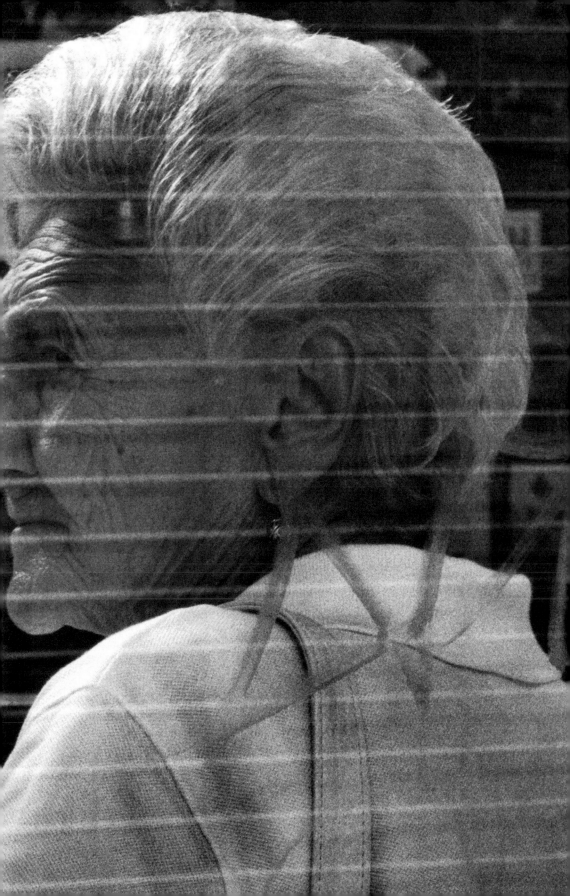

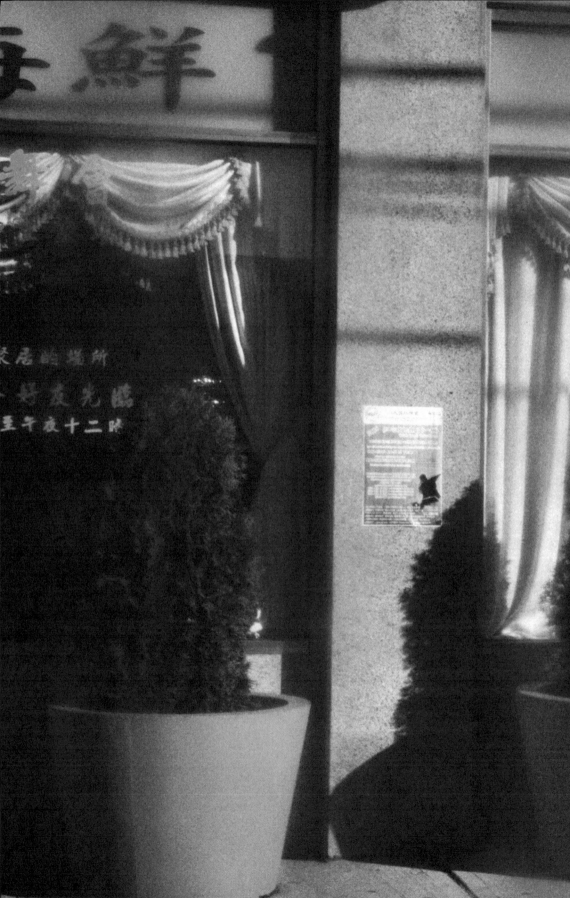

生猛龍蝦

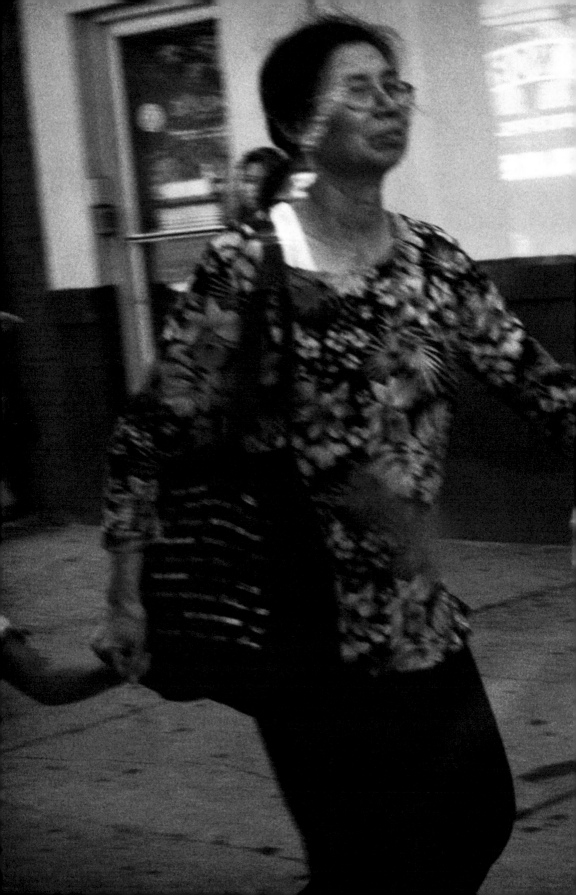

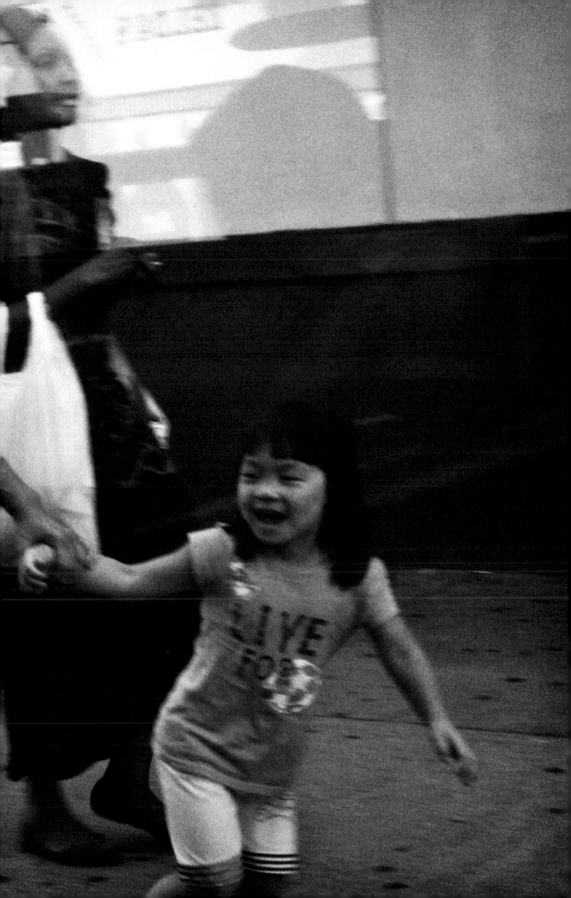

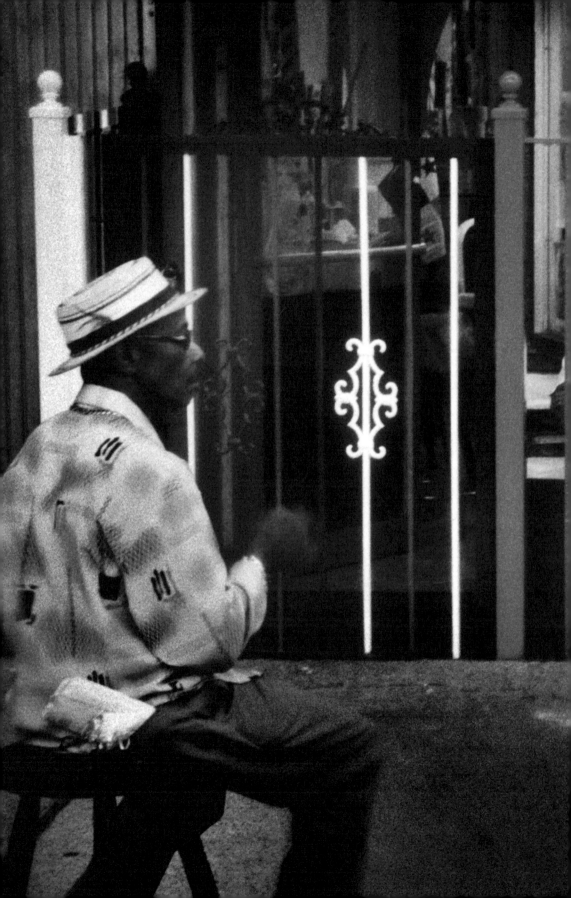

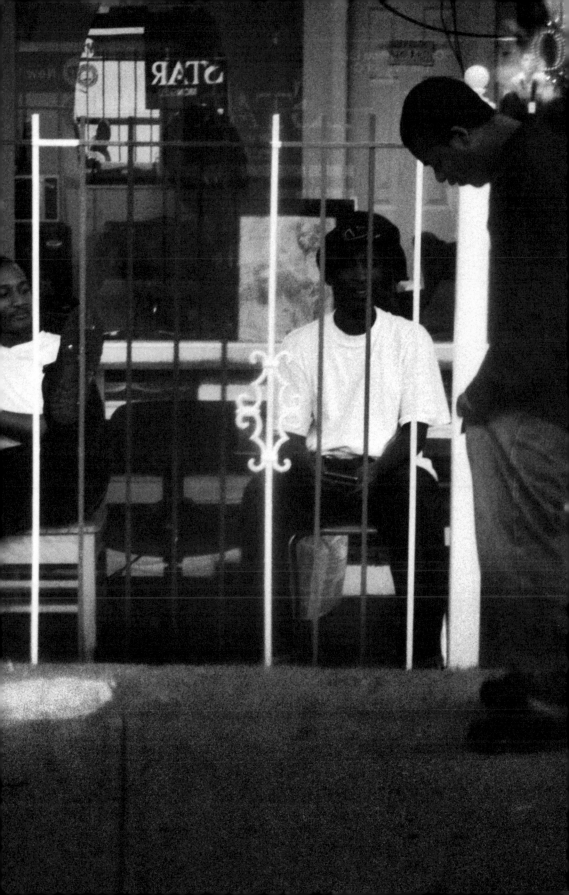

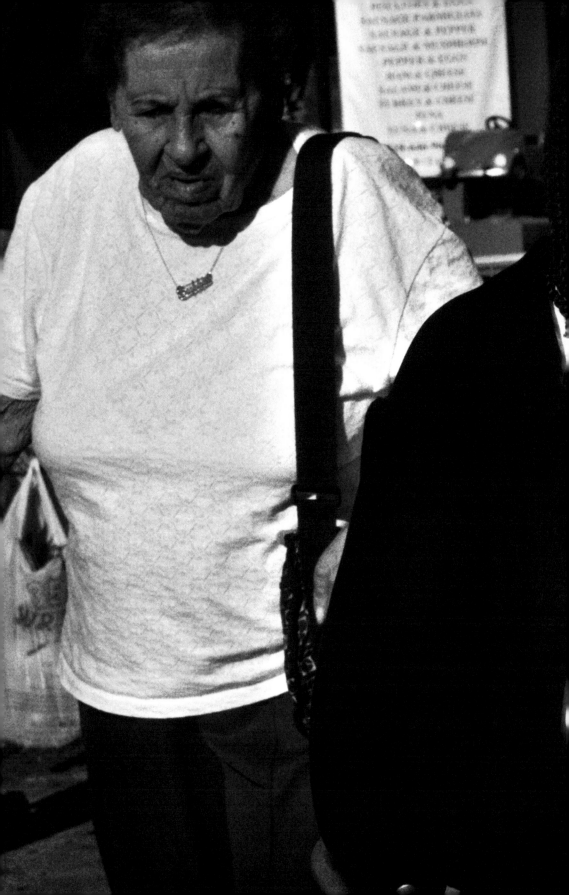

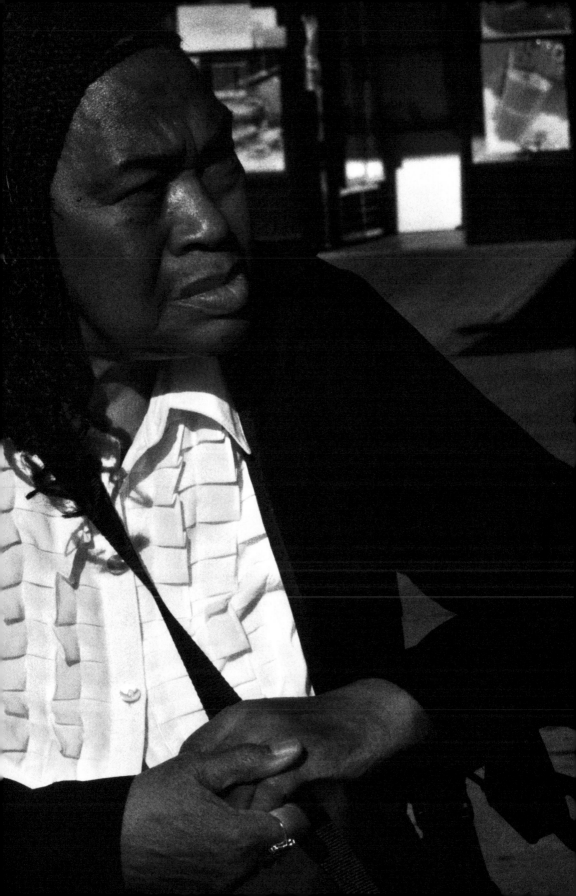

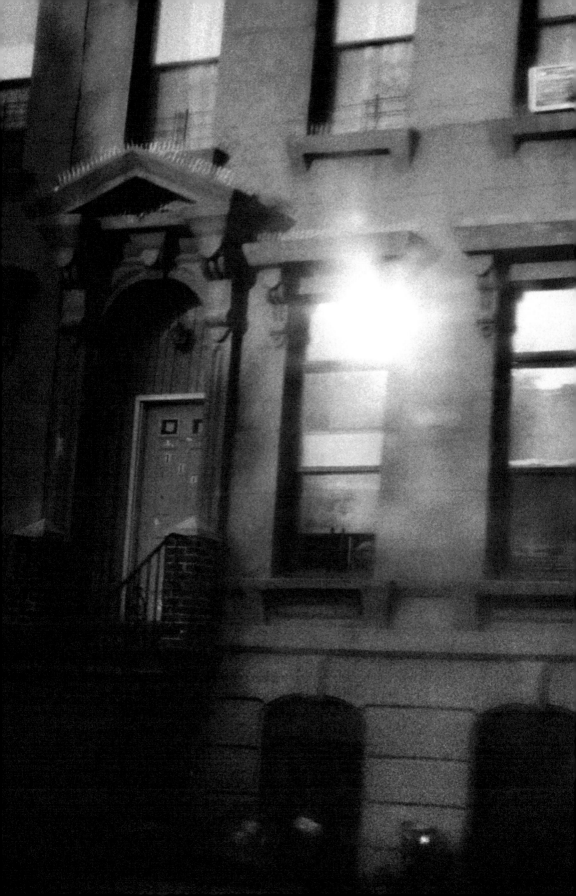

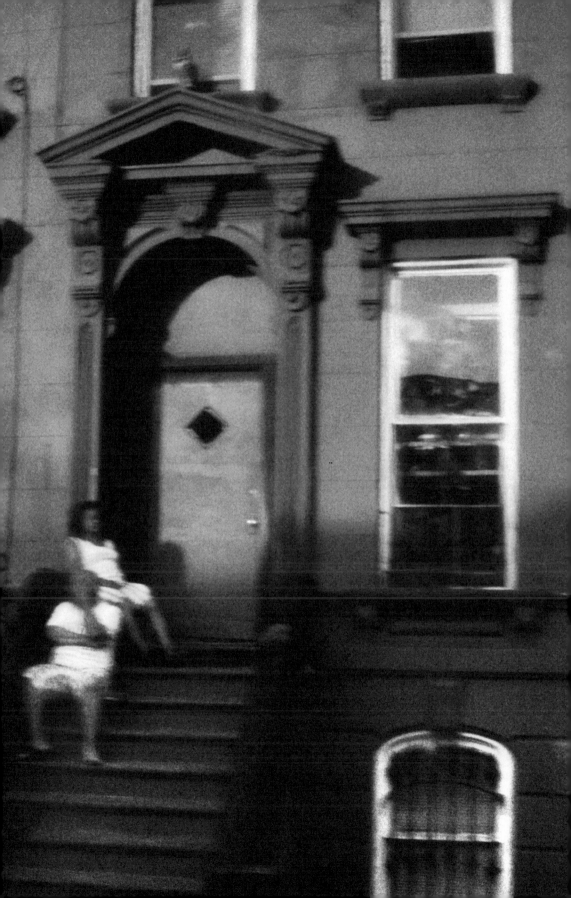

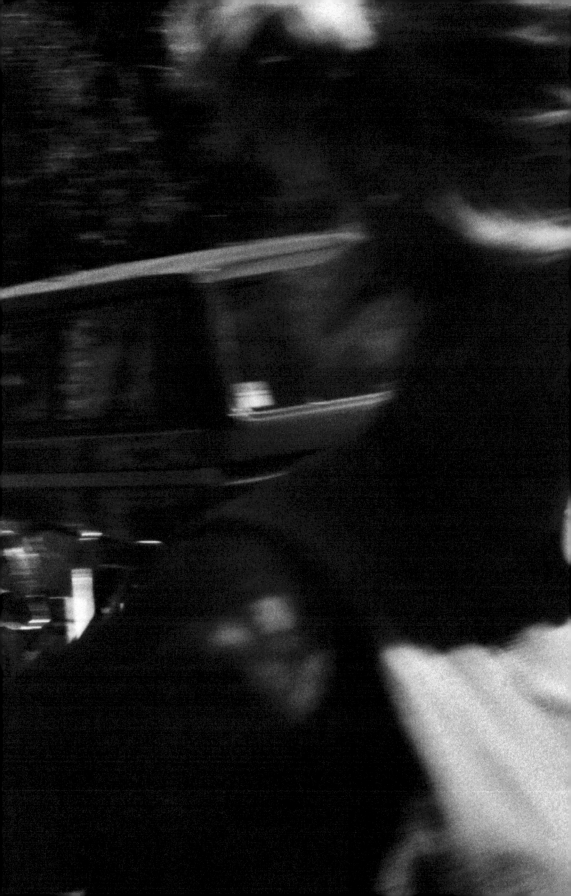

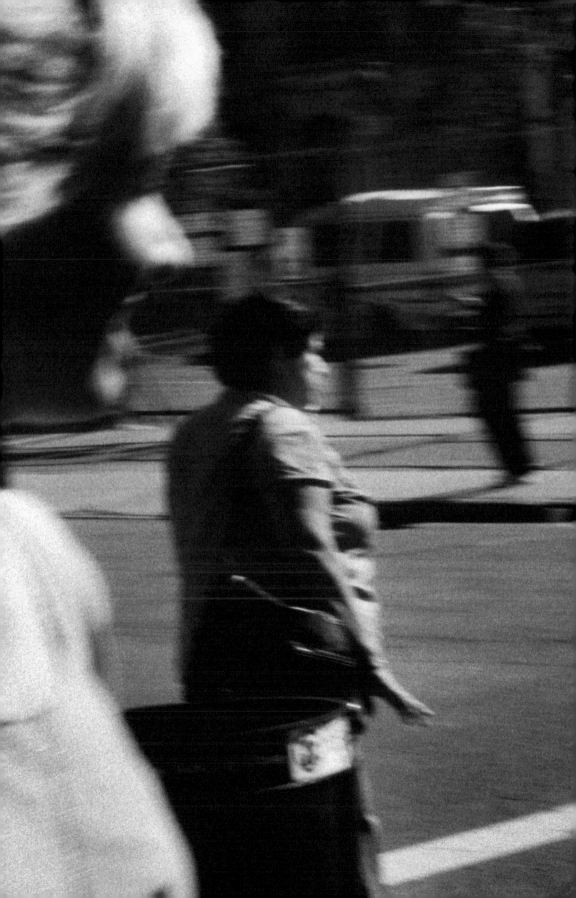

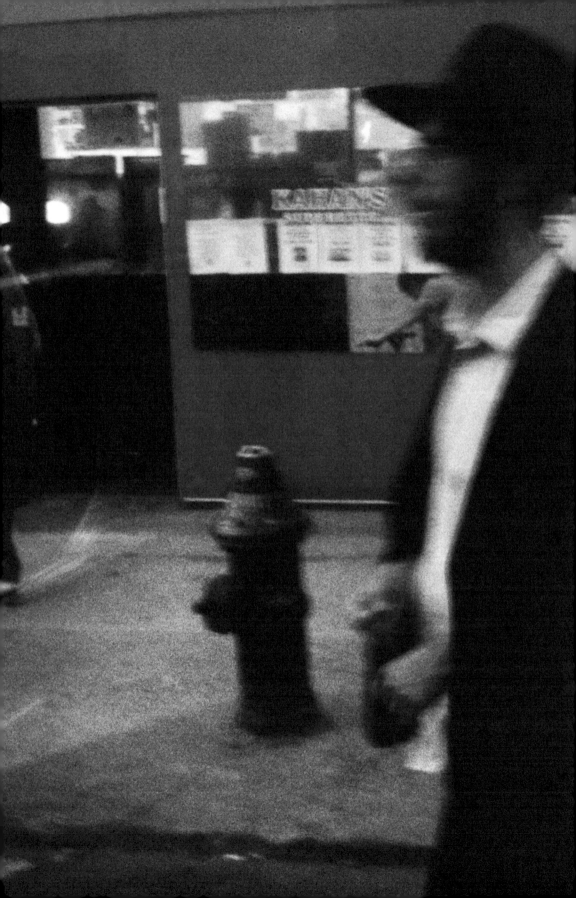

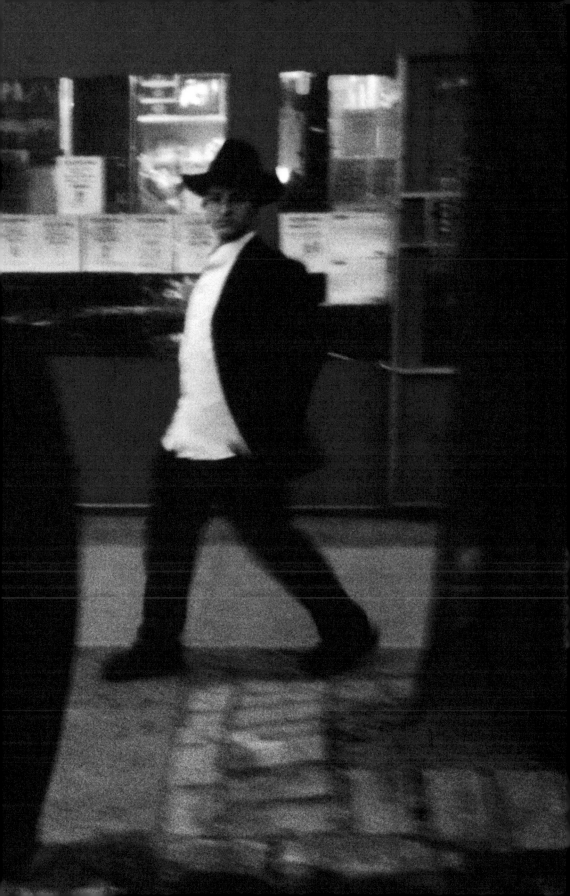

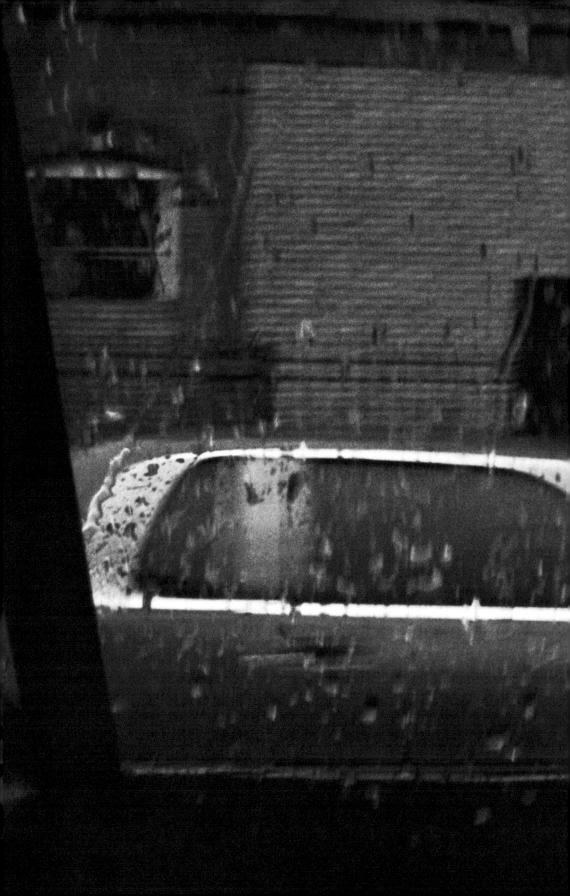

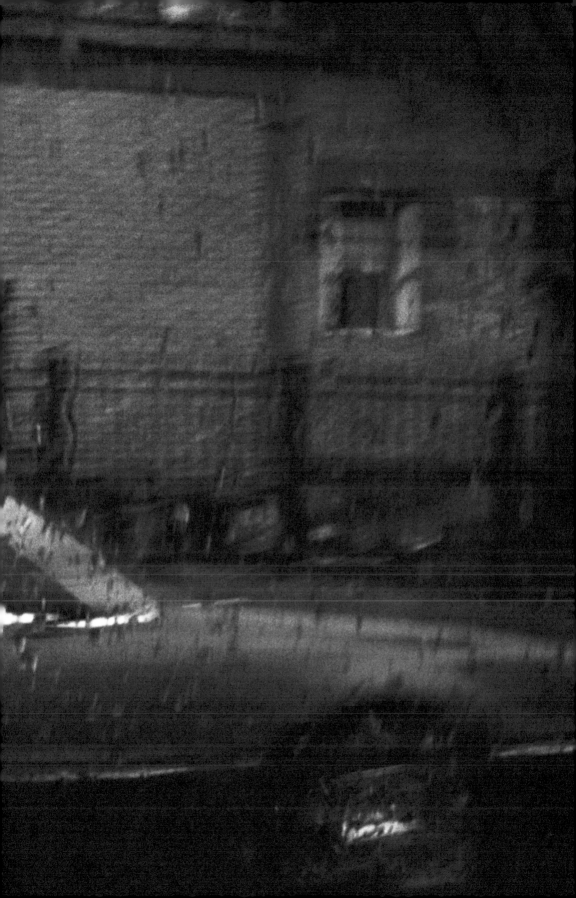

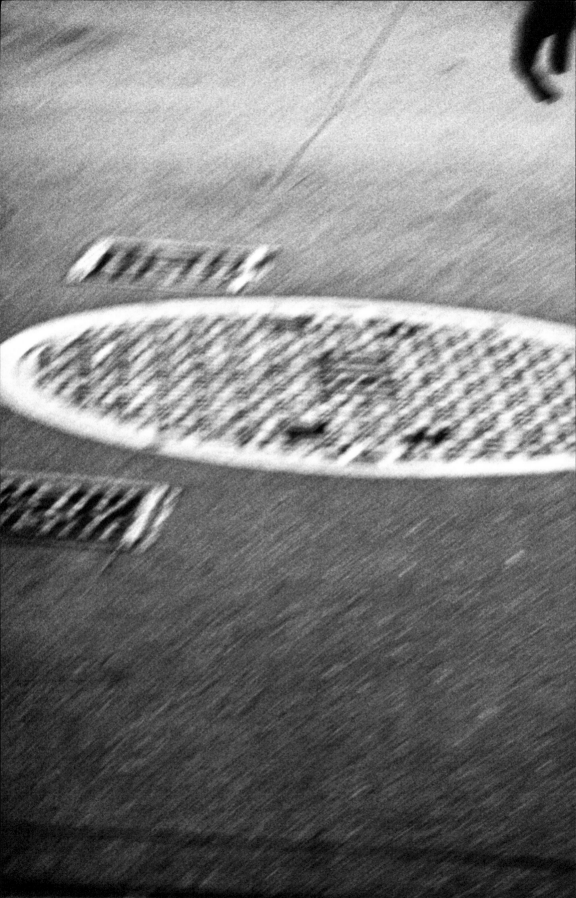

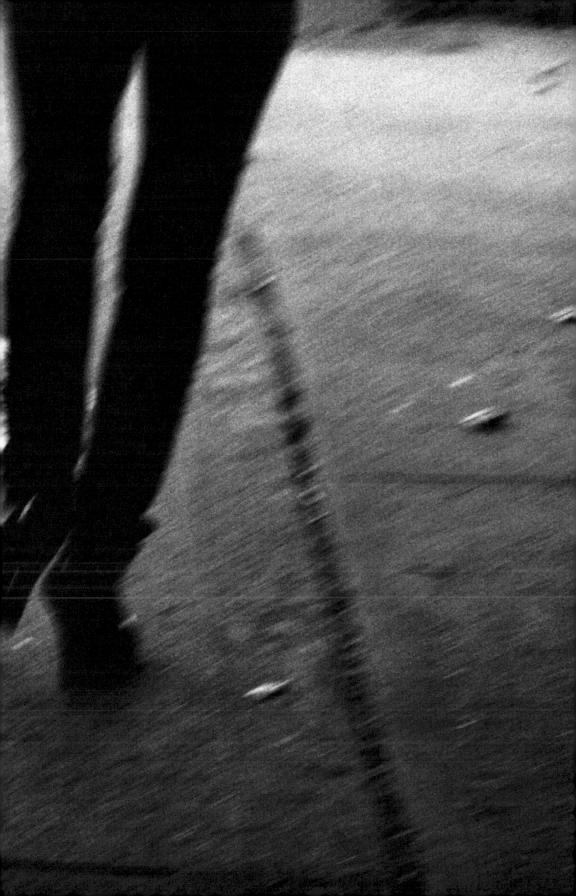

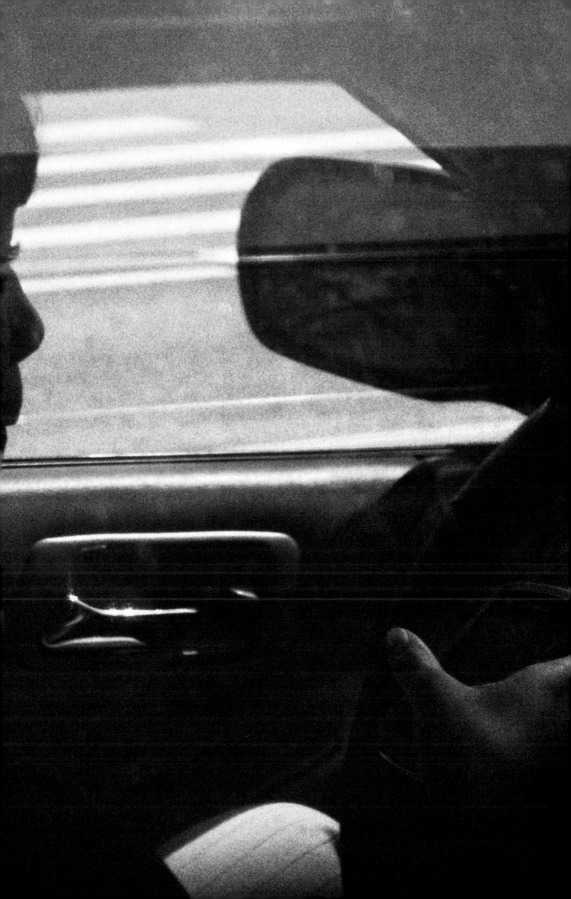

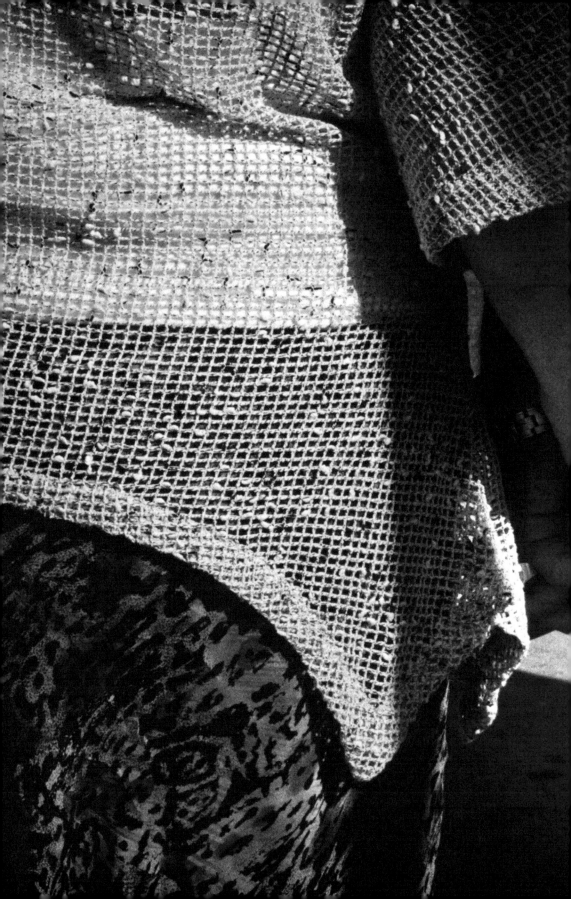

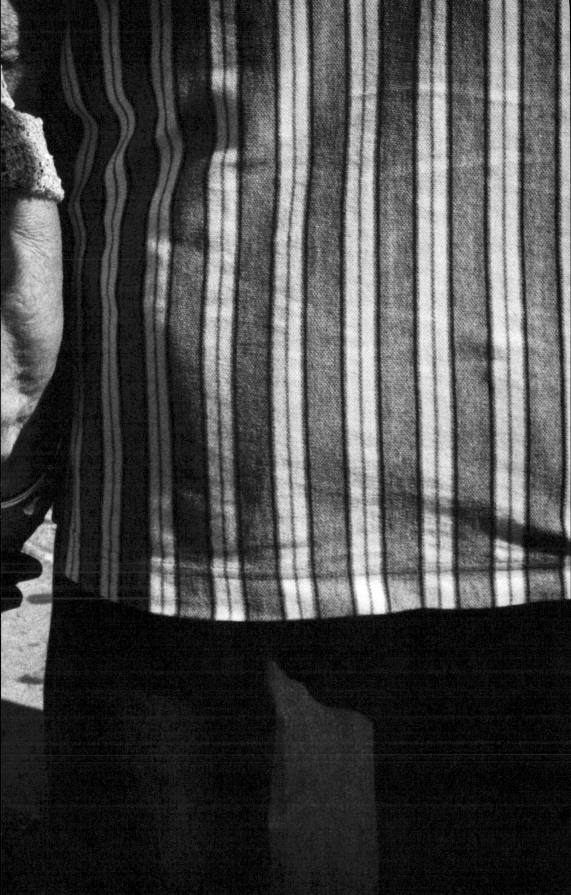

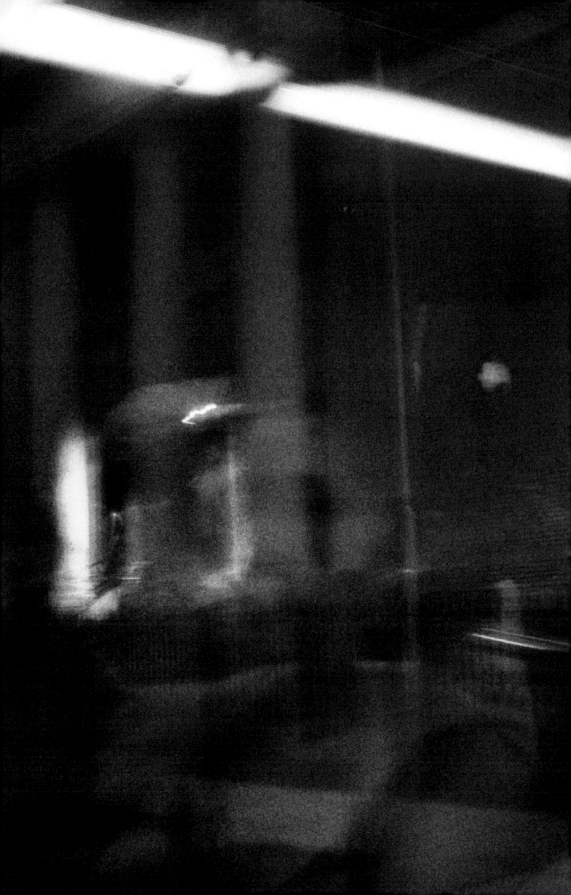

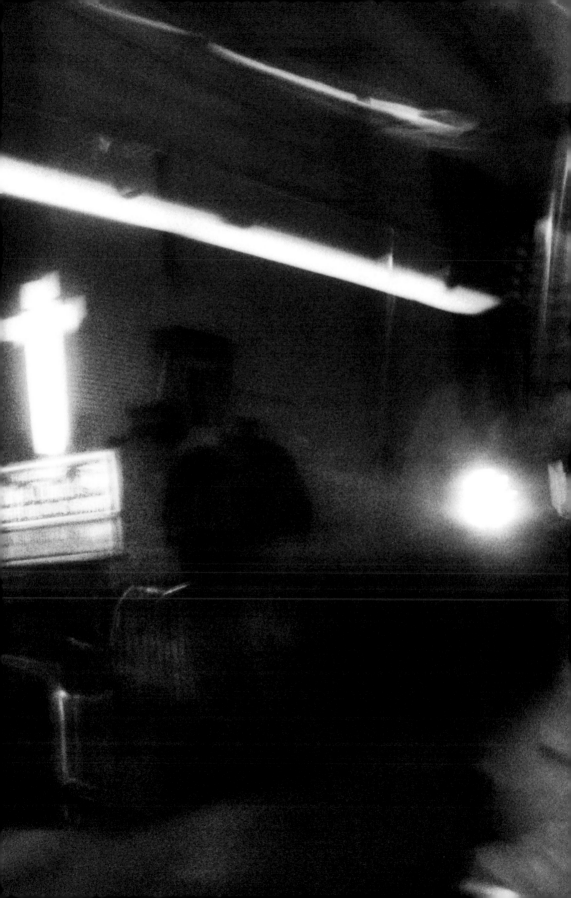

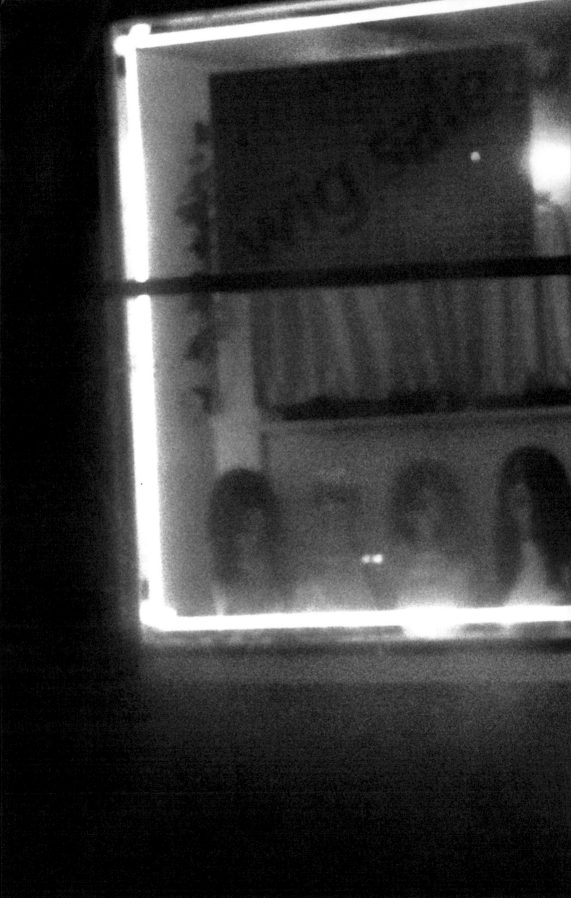

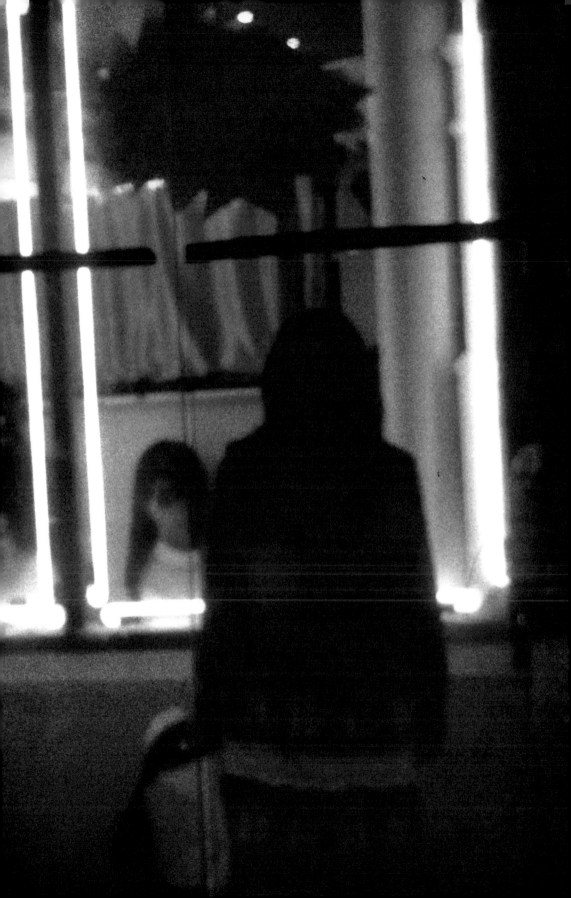

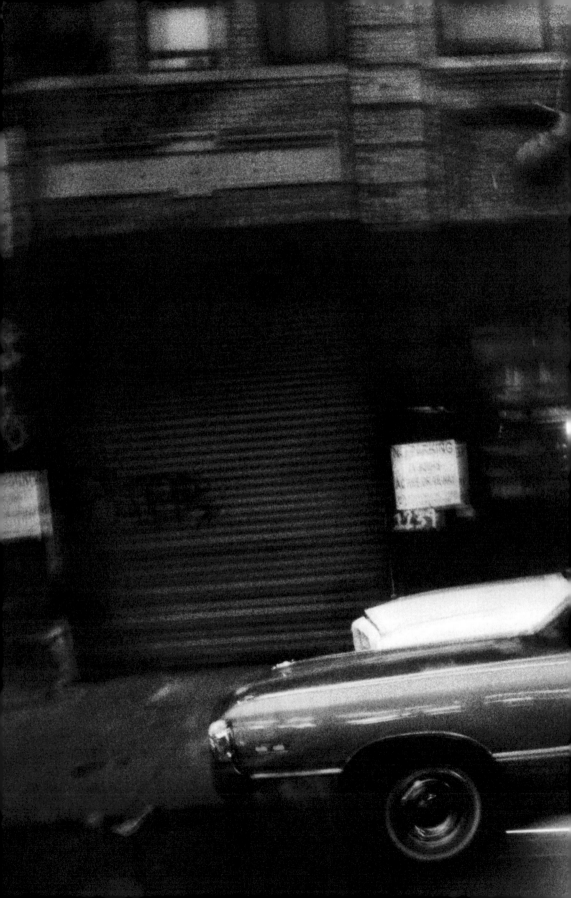

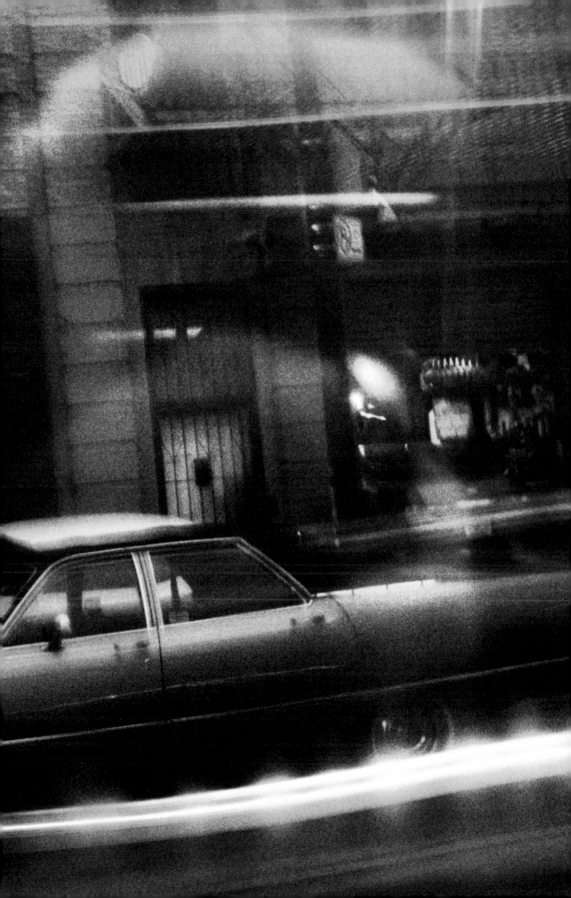

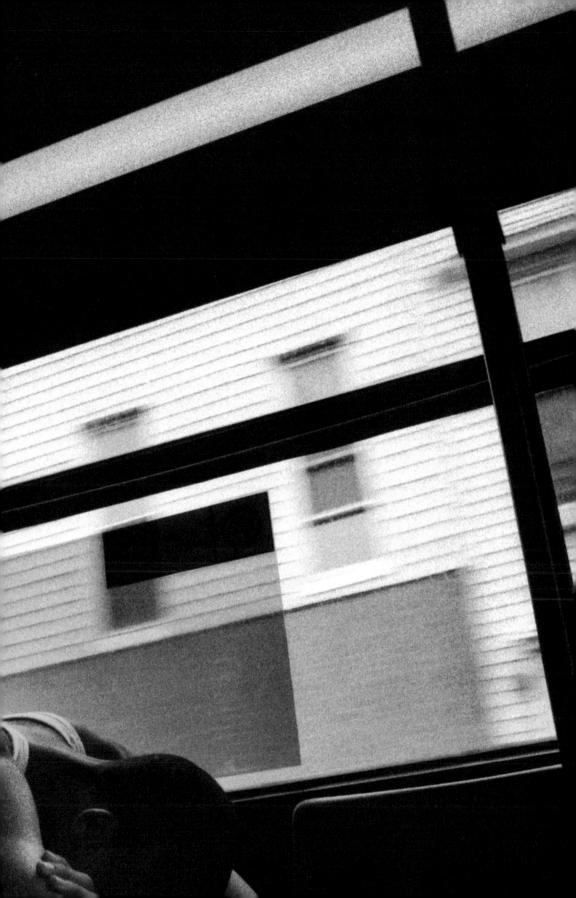

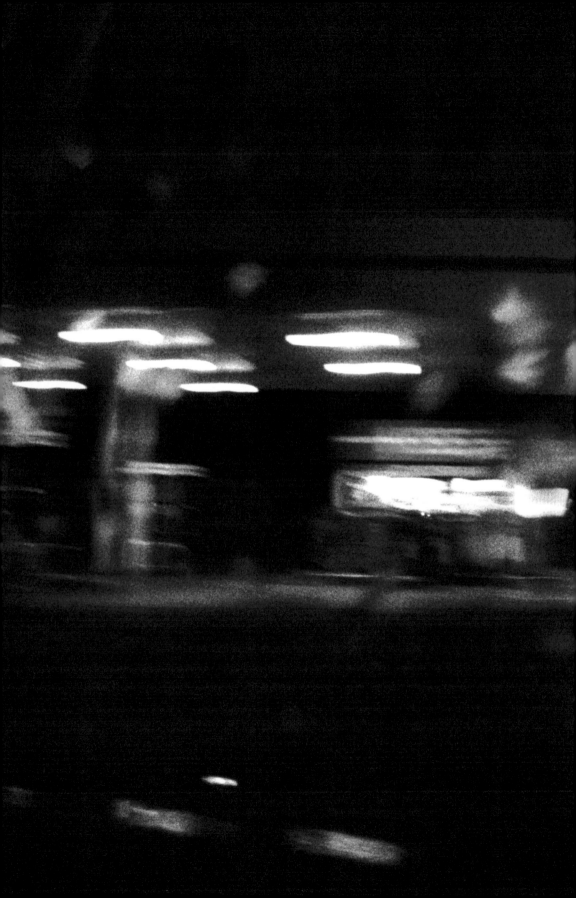

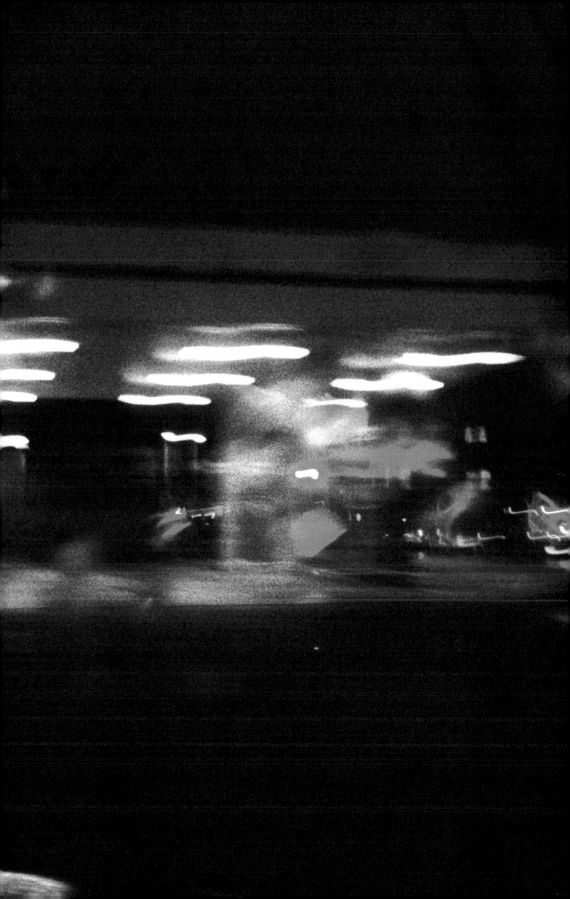

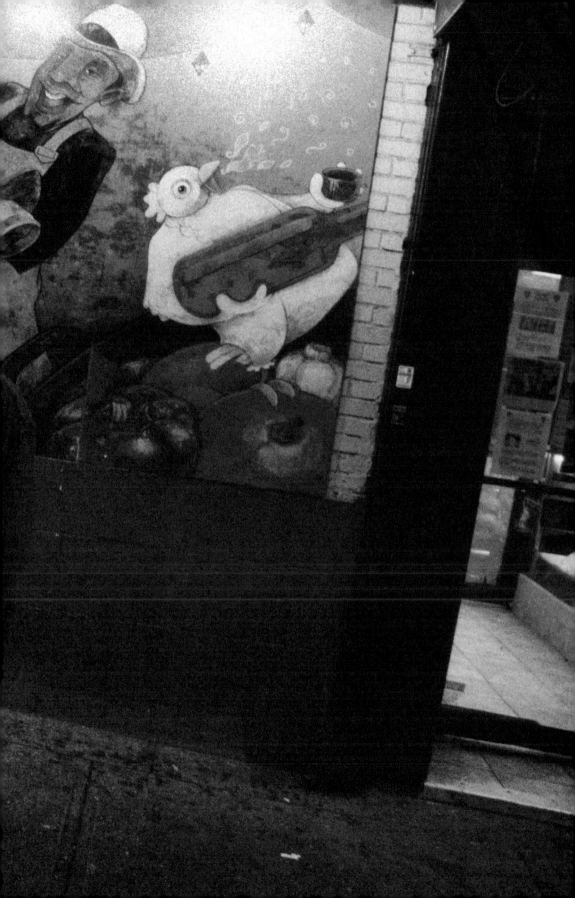

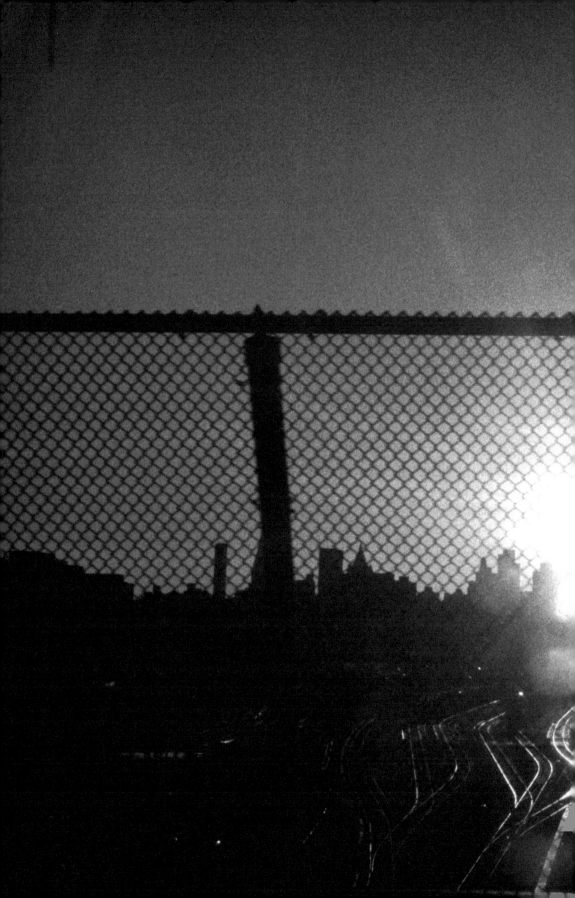

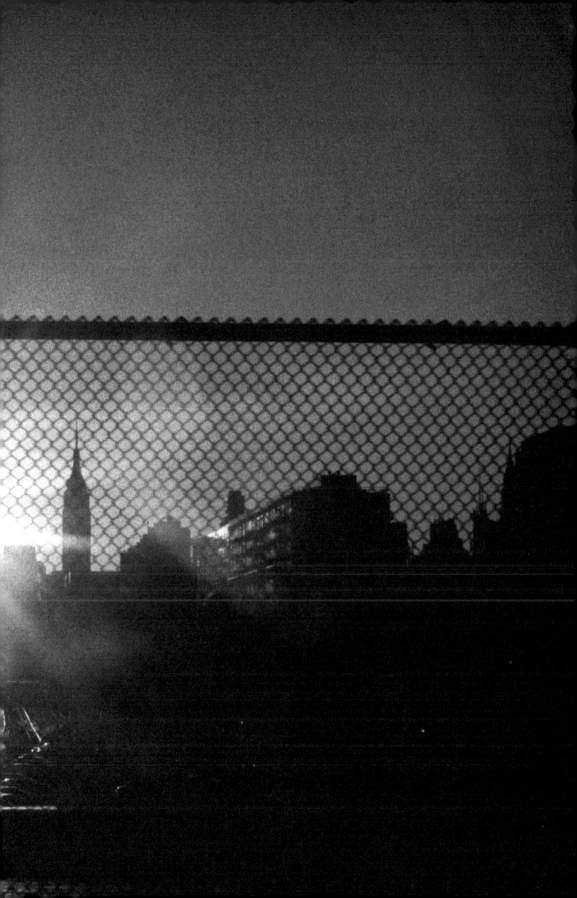

AMERICA'S OTHER: VOYAGE(S) TO THE PEOPLE
GAVIN KEENEY

> *A being is that which is, that which reveals itself in its truth, and, at the same time, it resembles itself, is its own image. The original gives itself as though it were at a distance from itself, as though something in a being delayed behind being [...] To contemplate an image is to contemplate a picture.*[1]

– Emmanuel Levinas

> *To live, by definition, is not something one learns. Not from oneself, it is not learned from life, taught by life. Only from the other and by death. In any case from the other at the edge of life. At the internal border or the external border, it is a heterodidactics between life and death.*[2]

– Jacques Derrida

I.

The speculation concerning the image (foremost the photographic image) that will not go away and keeps returning like a ghost is that the image is also an analogue for the subject, and for the human condition, an argument that is based on the fact that the image (painted, photographed, or otherwise) has, to a certain degree, the same agency as the human subject – a face or surface, a body or object status, plus an interior world or depth that confers upon it all of the indeterminate and sketchy presence of being itself. The human subject, conversely, has a surface, face, or body that acts, then, *like an emulsion*, allowing the conflation of the artistic image and subjective states – a long-established verisimilitude that underwrites all critiques of art as ultimately critiques of the human condition proper.

This argument appeared (or returned) in the mid-20th century, and was most force-fully addressed by André Bazin in relationship to cinema and photography, and in relation to ethics and intersubjective relations by Emmanuel Levinas. In Levinas' case, the 1948 essay "La réalité et son ombre" set up a critique of the image that only allowed for an ethics of the image through criticism and the application of First Philosophy, the latter also known as ontology (or speculation regarding first or founding causes). For the image this amounted to, in the case of Levinas, a whole set of prohibitions, signaling that difficult art requires criticism, whether embedded in the artwork or added to the artwork by the critic/philosopher. In the case of Bazin, the image always refers to an exterior reality that is not synonymous with reality as normally defined – or as "what is." It is equally addressed to "what might be." All of this has never been resolved, and all of this will never be resolved as long as art continues to act as a means of documenting both reality and its own privileged artistic resources. In the case of art's troubled autonomy, Levinas places the very idea under quarantine until the idolatrous image confesses that it is actually only a picture, and that *as picture* it has no real purchase on the world other than as a unique example of a sign that depicts not a missing object but a figure that mostly talks to itself (signs itself). While this autonomy of the man-made image has been a central tenet of modern art since "the beginning" of modern art (whenever and wherever one wishes to place that non-place), Levinas and Bazin more or less insist that the image also contain or accept the irreducible truth that self-consciousness is beyond its mandate as image, demolishing in essence the very idea that the mimetic act is co-equal to creation or revelation. In Bazin's case, with his 1945 essay "Ontologie de l'image photographique,"[3] all photographic images refer back to the Shroud of Turin, which is obviously *not* a photograph – yet an image that appears from somewhere else, but without ever disclosing quite where.

The series of photographs entitled "Brooklyn Buzz," produced over four months by circulating through one of New York City's largest and most troubled boroughs by bus (also the first of the four outer boroughs added to the City of New York in 1898),

suggests the same conflict between art and its other (all that it might index or speak for). In the case of these images, what happens as one views them serially is that a very moving portrait of Brooklyn emerges slowly, repetitively, with a view toward what very few people ever see, but which most suspect exists anyway. This is not the view of Brooklyn the authorities wish to have broadcast widely, for sure. It is also a view that not a few New Yorkers also somehow manage to repress. Anyone who lives in New York City knows that Brooklyn is vast, and they also know that it effectively has "no-go" areas, or parts and corners even that one does not really want to know too much about. This repression is almost categorical, meaning that to be a New Yorker one must wear blinders on occasion to quite simply survive. As a psychological state, personal and/or collective, it is simply amazing to have the unconscious force of that view brought forward (brought to light) and displayed with panache and elegance – as homage to the great humanity and humility of the place. Gaia Light and Alessandro Cosmelli, as a result, while living and working in Brooklyn, have re-visited Brooklyn, almost as if they were walking or riding in Robert Frank's footsteps or tracks – traversing the same socio-economic terrain, enduring the same strange landscapes and the same return gazes Frank witnessed between 1955 and 1956. As Europeans in America, and as transplants to New York from Switzerland and Italy, both voyages by three photographers carry the inexorable weight of a confrontation with the unknowable other. What transpires in the echoes of Frank's journey re-staged within the microcosm of Brooklyn by Gaia Light and Alessandro Cosmelli is a return voyage to America's Other – the Other being the very figure that Levinas always returns to, in any and all excursions into the arts or into First Philosophy. Always at the heart of the Levinasian project was the unknowable humanity of the Other, and the almost overwhelming and unbearable responsibility for the same that ensues.

Photography has a truly odd relationship to the world. Since its origin in the early- to mid-1800s, photography has been expected to be truthful (the daguerreotype was especially brutal in this regard), when in fact it distorts everything it comes into contact with. Giving the image back its truth-telling potential, beyond merely recording the scarred and flawed or sometimes beautiful surface of the world, is Levinas' point (and he reserves a particularly caustic reading for the term *beauty* that suggests it is a double bind, insofar as it idealizes the world of appearances, effectively correcting but corrupting all that is misshapen and real). But he also thinks that the artistic image is essentially incapable of doing justice to truth due to its inherent formalist qualities that make its own apparitional qualities its chief merit. The image is stuck, then, in a land of shadows. Levinas' parallel forays into the theory of the human face (or what a face reveals and/or hides) are instructive of what an image reveals and/or hides.

The photographs inserted into "Brooklyn Buzz" come from perhaps hundreds of photographs taken during that four months of wandering around Brooklyn in 2010. Merely choosing which to show is an act of criticism, or an act of editing. The past 40 years have shown that so-called documentary photography is, after all, mostly about itself. Even the great photography agencies such as Magnum or the pre- WWII Alliance Photo Agency (founded in Paris in 1934 and lasting until 1940), understood this truth. It is also for this reason that news photos are almost (or secretly) always editorial statements, especially the choice of an image to illustrate a story. There is no true objectivity in documentary photography (as there is no real critical distance in documentary filmmaking). With the transition from the Bechers' documentary school of photography, established at the Kunstakademie in Düsseldorf, to the late-modern masters of the post-documentary photograph, such as Thomas Struth, Thomas Ruff, Thomas Demand, Andreas Gursky, and Candida Höfer (all students of the Bechers), we are left with the uneasy feeling that the photographic image's strength is not at all in an approach to truth-telling as such, but, instead, in its immense value as interpretive tool – a tool that does indeed require criticality, however that might be provided. (For this very reason the globe-wandering scholar Vilém Flusser developed a theory of the photograph as the first post-industrial artifact, an articulate and potentially dangerous product of an incredibly pernicious apparatus that absolutely must be criticized to prevent its abuse in service to the production of forms of ideology or false consciousness.[4])

What Levinas was not willing to admit is that the artist might provide that critical inquiry, which is absolutely necessary to photography and the production of images. This all began to be the case anyway with conceptual art; and it is conceptual and speculative intelligence that Levinas wishes to attach to the suspect privileges of images. His answer, *as philosopher*, is – however – to reserve that critical function *for* philosophy, mistrusting art to speak for itself, and mistrusting the artist to speak anything resembling the truth. Yet things have changed, and things have remained the same. What has changed is that the conceptual and technical apparatuses of art have moved forward and no one really trusts them anymore anyway other than as a means of producing elegant or inelegant, cooked or uncooked interpretations of the world. What has not changed, and what Levinas unfairly failed to acknowledge, is that there have always been artworks and artists that have an exceptional conceptual integrity or the gift for allowing the work to speak for itself (and to effectively say, with Mallarmé, the unsayable).

Therefore, what we see unfold in "Brooklyn Buzz" is an immense spectacle that honors everything Levinas demands of the image. Strangely, it is the face of the human subject that indexes what the images do say. It is the landscape and the urban scene that doubles what is said – and what is ultimately said by both is that this vast place is both a wasteland and a promised land, at once. As a borough saturated with immigrants, Brooklyn is a type of the biblical Promised Land. As wasteland, it is an utter embarrassment to the authorities who would prefer that such images not be circulated, as they fly in the face of the polished image of the modern metropolis as open, generous, welcoming haven for any and all takers. Of course this is a myth, or a utopian vision of the city. Yet the key measure of "Brooklyn Buzz" is the very word no one wishes to hear or say: "Poverty" (elective or enforced). And the antithesis of this, which is on display in nearly every image, is "Grace" – grace by way of an enormous humility combined with defiance in the face of collective disgrace. Even the most menacing images contain this promise of "Grace" – of redemption. This is only so in the case of the images as totality. For the overall work, as stunning panoramic (where we stitch together the various takes to produce a film within our own internal world), opens onto the proverbial and powerful "sea," where all differences melt away... Brooklyn is awash with humanity in its essence. Again, what nobody wants to hear or say, which is why the images say the unsayable, is that this sea of humanity is "Us." If these people are lost at sea, we are all lost at sea.

This little commentary is being penned in Australia, on Easter Day 2012, where almost every week another battered boatful of refugees sinks into the sea off of Christmas Island or is intercepted by the Australian authorities. The detention camp there is "full." The Australians would like to welcome these people, but they are being instructed by their masters (the political class) that Australia is "full," and that these people loaded onto boats by traffickers in human souls may be criminals and/or terrorists. What Australia is full of is myths. Everyone in Australia is an immigrant, including the displaced aboriginals. The overloaded, dilapidated boats depart Indonesia and attempt landfall at any possible cost, on any reachable spit of Australian soil. The refugees come from all over the world – Sri Lanka, Afghanistan, China, Pakistan, Iran, etc. They come from places that are unstable. The instability is generated by identifiable forces – postcolonial, post-9/11, neo-liberal capitalist forces. New York City (and Brooklyn) is no different than any other beckoning city in the world. Everyone is an immigrant. Yet assimilation often means forgetting. In Brooklyn everyone will one day forget where they came from, most especially once and if they manage to leave for elsewhere. If they stay, they will tell stories. The stories will build new mythic reserves for the telling of truths (which are often best told through myth). At the heart of all of these various myths is the "escape" – the escape from all manner of compromising situations. To arrive to new compromising situations requires a particular potent form of myth-telling. How does one explain that the Promised Land was also a wasteland or prison-house?

Hopefully these stories (always to be told in retrospect) will be told from the comfort of an elegant armchair, by wizened elders to smiling, amazed grandchildren. Perhaps they will be told from Brooklyn, flipping through the pages of the very book

you now hold in your hands, when – in some foreseeable future time – the city has overcome its own collective bad conscience and sorted out the economic and political travesties that allow Brooklyn and the other lesser boroughs to molder, while Manhattan basks in its eternal, self-anointed glory. Perhaps these tales will involve the intercession of benevolent masters, who will one day say, *"This is intolerable."* Perhaps the de facto apartheid that exists in the US will one day be banished, and there will not be such a gulf between the rich and the poor, the elite and the dispossessed. Perhaps all of these new tales and new myths are contained in the multiple, simultaneous times that inhabit the images of "Brooklyn Buzz." Perhaps, as with the great non-documentary documentary photographer (the non-documentary, documentary filmmaker, and the great humanitarian and 91-year-old master of conceptually inflected image-making) Chris Marker, we might detect in the trembling images assembled by Gaia Light and Alessandro Cosmelli "a touch of red in the air."[5] That is to say, perhaps the benevolent masters will never arrive, and the retrospective tales told one day will include the necessary revolt, one that was first detected in the canyons of Wall Street in late 2011 – spiraling outward through the five boroughs of greater New York City. How many of the faces in "Brooklyn Buzz" were at Liberty Square, or how many were turned toward that event? How many were watching, when the Occupy Wall Street demonstrators marched toward Brooklyn Bridge last fall, to be led onto the bridge by the police, herded like animals, and arrested en masse? That, and *more*, is indexed by these photographs of Brooklyn. The *more* includes every story hidden behind every pair of eyes that meets and does not meet the camera. And, as the point of criticism is to be *critical*, there can be no apologies for pointing out the obvious (as well as the recondite). Levinas' recourse to calling the image a shadowy parallel world includes the brutal fact that often the image does, indeed, index something obscure. As Marker ventriloquized through an interlocutor in his 1993 film *Le tombeau d'Alexandre*, "The world is a war and the artist must take sides."[6] Utopia and the Promised Land must be fought for – notably, all future inhabitants will be immigrants. Ineluctably, the unsayable also says *that*. "Brooklyn Buzz" says many things all at once, including things people would prefer to stop up their ears and not hear. One can only hope this book somehow reaches the benevolent masters we all wish to believe exist somewhere, and – moreover – that they are capable of hearing *this* particular unsayable something else, before it is too late.

II.

As with all works of art that contain self-criticism (and are, therefore, critical – notwithstanding Levinas' objections), "Brooklyn Buzz" has within itself its own immunities to hypocritical criticism. Some will say (have said) it is "too black," "too poor," "too bleak." Such objections are possible only if one wishes to minimize the grandeur of that "too black," "too poor," "too bleak" tableau that the images survey. Such objections are never valid. Yes, Brooklyn still has its splendid Park Slope, etc., but Walt Whitman's "Brooklyn, New York" is long gone (lost), as is Thoreau's "Concord, Massachusetts" – in the American Republic, all "Leaves of Grass" have long since been sold out for a "Coney Island of the Mind."[7]

"Brooklyn Buzz" bears an eerie resemblance to Chris Marker's "Passengers," a series of photographs exhibited at Peter Blum Gallery, New York, New York, in 2011. The images have the same pulse-taking qualities. Marker's images were taken on the Paris Métro, but with a hidden camera, primarily out in the so-called *banlieues*, circling the city proper; they are precise evocations of a world slightly gone awry. It is possible to say "slightly" only because we have become inured to the spectacle of urban decay and urban anomie over the course of the last 40 to 50 years, as if all attempts to sort out the inequalities of the world are doomed. Interestingly, Marker gave up photography for film in the late 1950s and early 1960s because he realized he would never be as good a photographer as Robert Frank. (He never stopped taking photographs, but instead used them to make films.) More interestingly, he returned to photography in 2007 with "Staring Back," an exhibition of stills he mostly extracted from his films. From 2007 to 2011, with "Staring Back," "Quelle heure est-elle?," and "Passengers," he slowly returned to privileging very still photography. Marker's question, to "no one in particular," in *Le fond de l'air est rouge* (1977),

"Why, sometimes, do images begin to tremble?" is considered a mostly unanswerable question, even if he answers it provisionally with, "Because the hand of the cameraman trembles." Or, as he says elsewhere, "Because you never know what you are filming..." Thus, this question without a singular answer meant then, as it means now, that the future is contained in the image of the present. "Brooklyn Buzz," as Frank's "The Americans," contains this aspect of "trembling." One could guess that all of the possible objections to "Brooklyn Buzz" were also leveled at Frank's "The Americans." Complaints will come from both the Left and the Right, a political dialectic and intellectual cold war that is morally bankrupt in this day and age. When one moves far enough to the left, one pops up on the right (and vice versa). In many ways, this was Karl Marx's most prescient insight. What is held in common (as common trust) is that everything must change. Art in many ways invokes Marx's "perpetual revolution." In the final analysis, what "Brooklyn Buzz" says is, "Here is the beginning of the same." In many ways it also says the same thing, though through different means, that E.B. White's *Here is New York* said in 1949, with its beautiful metonym of a willow tree near Turtle Bay standing in for all that New York offers and all that is at risk every day. That willow tree signified the utter fragility of life in New York City, arguably the world's greatest city, and the necessity that life be rooted in actually existing ground. Actually existing ground, in turn, is a metaphor for real life, versus the simulacra that have been imposed by the powers that be. Foremost in the production of simulations of life is the empty signifier "money," which seems to have become the be-all and end-all of life in New York City. As the City proper (Manhattan) is turned into a playground for the rich and the privileged, presided over by a billionaire mayor, the dispossessed are pushed further and further from that playground, while they are permitted to participate in the circus as guest workers. It is a perverse economy of signifiers that rules New York City. "Brooklyn Buzz" also says (*sotto voce*), in its explicit homage to Frank's "The Americans" (a snapshot taken in 1958 when Brooklyn was effectively annexed by Manhattan), "*Has anything changed?*"

Gavin Keeney
Easter 2012

[1] Emmanuel Levinas, "Reality and Its Shadow," pp. 129-43, trans. Alphonso Lingis, in *The Levinas Reader*, ed. Séan Hand (Oxford: Blackwell, 1989), pp. 135-36. First published "La réalité et son ombre," *Les temps modernes* 38 (1948): pp. 771-89.

[2] Jacques Derrida, *Specters of Marx: The State of Debt, the Work of Mourning, and the New International*, trans. Peggy Kamuf (London: Routledge, 1994), p. xviii. First published *Spectres de Marx* (Paris: Éditions Galilée, 1993).

[3] André Bazin, "Ontologie de l'image photographique," in *Les problèmes de la peinture*, ed. Gaston Diehl (Paris: Confluences, 1945).

[4] See Vilém Flusser, *Towards a Philosophy of Photography*, trans. Martin Chalmers (London: Reaktion, 2000). First published *Für eine Philosophie der Fotografie* (Göttingen: European Photography, 1983).

[5] "A touch of red is in the air" is a rough approximation of the untranslatable *Le fond de l'air est rouge* (title of Chris Marker's 1977 film and summary judgment on the historical self-castration of the Left in the late 1960s and early 1970s), and an expression that is similar in spirit to the poetical, "A touch of spring is in the air."

[6] Appropriately, this film coincides with Jacques Derrida's *Spectres de Marx* (1993). Both Marker's film and Derrida's book were, of course, a partial response to the collapse of the Soviet Union, but foremost a response to Capitalism Triumphant, or the arrogance of the apparent victor of the Cold War; an arrogance to be further measured by the response to 9/11.

[7] See Stanley Cavell's *Senses of Walden* (New York: Viking Press, 1972) for what was lost over the course of a very short one hundred years, in the ongoing history of the American Republic, and for what Thoreau's train whistle portended. Even Coney Island has been sold by the City, recently, for a spruced-up, neo-liberal version that includes a thoroughly sanitized boardwalk. As a result, we can hardly blame Belgian immigrant Luc Sante for leaving New York City, nor can we seriously disparage Brooklyn-born, rock-star photographer Lou Reed for privileging images of New York City at night (or at such times when New York turns truly spectral and utterly beautiful, as under darkness or snowfall, and when one can hardly see the nose in front of one's face, let alone the forest for the trees). See Lou Reed, *Lou Reed's New York* (Göttingen: Steidl, 2005).

ACKNOWLEDGMENTS

To our respective families, Silvia, Massimo, Alberto, Luise, Sergio and Luca, we offer our heartfelt gratitude for your love and confidence over the years.

To our enlightened publisher, Andrea Albertini, who continues to set new standards of excellence in the art-book world, we send perpetual thanks. A special thank you, as well, to Angelo Aquaro for being such a generous matchmaker in this regard, and to Eleonora Pasqui and all the staff at Damiani.

We extend thanks to Alberto Cosmelli and Massimo Gattabrusi, for invaluable support in the birth process of this publication, and to Gavin Keeney, Jamie Wellford and Marion Durand for understanding the critical significance of this portrait of Brooklyn.

A special note of thanks to 10B Photography, foremost the incomparable Claudio Palmisano and Francesco Zizola, for your kind and generous support over the years.

This book would never have been completed without the encouragement and support of our friends.

Special Thanks to:

Nina and Leon Espinosa, Sofia Forti, Fabrizio Lazzeretti, Cristiana Falcone, Marzio Mian, Marco Mathieu, Tiziana Faraoni, Nicola Scevola, Tiziana Gazzini, Deanna Richardson, Ilex Photography, Chiara Oggioni Tiepolo, James Price, Enrico Bossan, Elisabeth Biondi, NY Photo Festival 2011, Whitney Johnson, Elissa Curtis, Marcel Saba, Roberto Sbolci, Nina and Naomi Rosenblum, Lawrence Klepner and The Art of Leadership, Kathryn and Ulrich Hiesinger, Judy and Ray McGuire, Aislinn and Ruadh McGuire, Donald Wolfson, Anthony Bellini, Stefano De Luigi, Angelo Turetta, Camilla Invernizzi, Anna Lombardi, Federica De Paolis, Michael Oneal, Stephen Chu, Cristina Ottolini, Mauro Speziale, Nicola Guarneri, Gillian Arthur, Nicole Gagne, Frederic Fasano, Sebene Selassie, Daphne Tesei, Manuela Sparta', Marco Baldovin, Davide Monteleone, Maurizio Garofalo, Eva Zamboni, Roberto Alfano, Laura de Marco, Spazio Labo'.

Special regards to Robert Frank for being such a constant and precious inspiration, and to Brooklyn – our city and home. We are especially grateful to the many anonymous individuals depicted here who unknowingly made this book possible.

To all of you (known and unknown) who have contributed to this project, this is your book.

Gaia Light & Alessandro Cosmelli

BIOGRAPHIES

JAMES WELLFORD

James Wellford is a photo editor at Newsweek Magazine in New York City.
Born in Richmond, Virginia in 1961, he lives in Brooklyn with his 4 children and wife
Emmanuelle. He has collaborated on a number of award winning photography
projects selected by the Overseas Press Club and the World Press. He is also a
curator of exhibitions, a co-founder of the organization SeenUnSeen, and teaches
at the International Center of Photography in NYC.

MARION DURAND

Marion Durand has been a photo editor for Newsweek International for the past 6
years, after working with VII in Paris and New York.
She tries to get the best of the French, Spanish and American cultures with various
degrees of success.

GAVIN KEENEY

Gavin Keeney is Director of Agence 'X', an editorial and artists' and architects'
re-representation bureau founded in New York, New York, in 2007. His most recent
books are Art as "Night": An Art-Theological Treatise (CSP, 2010) and "Else-where":
Essays in Art, Architecture, and Cultural Production 2002-2011 (CSP, 2011). He is
currently at work on Dossier Chris Marker: The Suffering Image, a series of essays
on the work of the nonagenarian French filmmaker-artist Chris Marker, due to be
published in late 2012.

ALESSANDRO COSMELLI

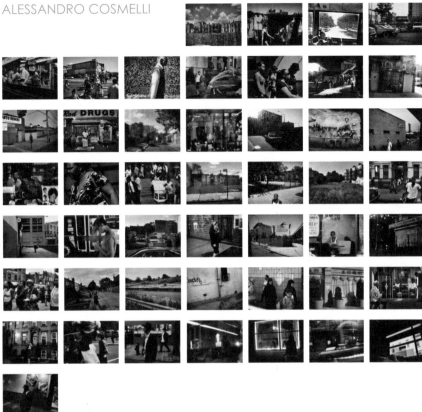

GAIA LIGHT

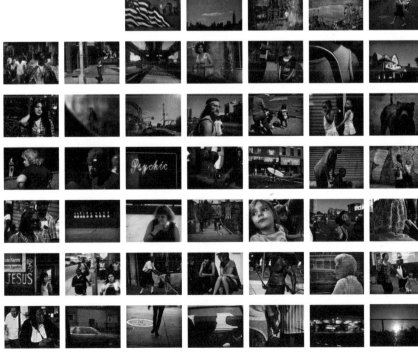

Alessandro Cosmelli | Gaia Light
Brooklyn Buzz

© Damiani 2012
© Photographs, Alessandro Cosmelli | Gaia Light
© Text, James Wellford
© Text, Marion Durand
© Text, GK/Agence 'X'

Editing, Gaia Light | Alessandro Cosmelli
Design, Alessandro Cosmelli | Gaia Light
Images Toning, Claudio Palmisano | 10b Photography

Robert Frank's Quote: *Robert Frank: Moving Out*, by Sarah Greenough et al.
Washington, DC: National Gallery of Art, 1994

⌐DAMIANI⌐

Damiani
via Zanardi, 376
40131 Bologna, Italy
t. +39 051 63 56 811
f. +39 051 63 47 188
info@damianieditore.com
www.damianieditore.com

www.alessandrocosmelli.com
www.gaialight.com

Printed in May 2012 by Grafiche Damiani, Bologna, Italy.

ISBN 978-88-6208-241-9